A catalogue of works
by Jewish artists
and of Jewish interest
in the possession of the
Ben Uri Art Society,
London

# Jewish Artists
# THE BEN URI COLLECTION

Paintings, Drawings, Prints
and Sculpture

Edited by Walter Schwab and Julia Weiner

Published by
**Ben Uri Art Society**
in association with Lund Humphries Publishers Ltd
London 1994

# Acknowledgements

The publication of this catalogue has been made possible by generous donations from the following:

Manfred Altman
Tom Bendhem
Audrey Burton
Neville and Carole Conrad
Ralph and Muriel Emanuel
Jack Goldhill
Mr and Mrs K. Gradon
Henny Handler
Peter Held
Arnold Horwell
Rosalind Jacobs
Jacob Charitable Trust
Sally Kesten
Mr and Mrs N. Kesztenbaum
Mr and Mrs D. Kut
Robert Lewin

David Lewis
Marcus Margulies
Alicia Melamed Adams
Leslie and Lesley Michaels
The Hon Mrs Ewen Montagu
Alisa Moussaieff
Dr and Mrs S. Peltz
The Ferdinand and Edith Porjes Charitable Trust
Dame Simone Prendergast
Lord Rayne
Mr T. Reitman
J. Rothschild Group Charitable Trust
Walter and Alice Schwab
Samuel Sebba
The Sidonie Weiner Memorial Fund

This volume is dedicated to Edith and Ferdinand Porjes

Copyright © 1987, 1994
The Ben Uri Art Society

First edition 1987  Second edition 1994
Published by
Lund Humphries Publishers Ltd
Park House, 1 Russell Gardens,
London NW11 9NN
in association with
The Ben Uri Art Society
21 Dean Street, London W1V 6NE

*British Library Cataloguing in Publication Data*
A catalogue record for this book is available from the British Library

ISBN 0-85331-655-4

Catalogue designed by Graham Johnson

Filmset and printed in Great Britain by
BAS Printers Limited
Over Wallop, Stockbridge, Hampshire

Collection photographed by
Michael Barnett
with the exception of numbers:
2, 14, 18, 19, 31, 39, 45, 49, 50, 54, 62, 66, 93, 99, 128, 139, 176, 190, 191, 199, 200, 393, 428
which are by Prudence Cuming Associates, numbers 452 onwards which are by Gareth Winters and 620 which is by Sïan Bonnell and George Meyrick

FRONT COVER
A detail from Emmanuel Levy
*Two Rabbis with Scrolls of the Law* (cat.218)

BACK COVER
David Bomberg *Ghetto Theatre* (cat.46)

# Contents

Acknowledgements                                                          2

Preface by Leslie Michaels                                               4

Introduction to the revised edition by Walter Schwab and Julia Weiner    5

Introduction to the first edition 1987 by Walter Schwab                  7

The Ben Uri Art Society and its Collection
by Barry Fealdman                                                         8

Jewish Art or Jewish Artists: a problem of definition
by Monica Bohm-Duchen                                                    12

CATALOGUE                                                                16

Index                                                                  159

**Colour Plates**                                                *facing pages*

I    Martin Bloch *House in Normandy (or Vavangeville)*                  32

II   Samuel Hirszenberg *The Sabbath Rest* (detail)                     33

III  Amy Drucker *For He had Great Possessions*                         48

IV   Mark Gertler *Nude*                                                49

V    Zygmund Landau *Interior*                                          64

VI   Lily Delissa Joseph *Self Portrait with Candles*                   65

VII  Simeon Solomon *Night Looking Upon Sleep Her Beloved Child*        80

VIII Scottie Wilson *Happy Village*                                     81

IX   Patrick Hayman *The Gods Look Down on Us*                         128

X    Julie Held *Commemoration*                                        129

XI   Dora Holzhandler *Jewish Family in the Snow*                      144

XII  Lesser Ury *Two Girls Walking along the Street*                   145

# Preface

It is six years since the Ben Uri Art Society last published a catalogue of its collection, during which time the collection has almost doubled in size, largely through donations, either from our many supporters, or directly from artists.

Over this period there has been a growing interest in the work of the Society, which has mounted an active programme of exhibitions and other cultural events. As a result, the last edition of the catalogue, which was in any event out of date, has now completely sold out.

I am therefore delighted that this new, fully-revised edition is now available.

I would like to express my personal thanks to all those people who have given new works to the collection, to those who have generously donated towards the cost of the catalogue and to those who have participated in its production. In particular, I would like to pass on my special thanks to our joint editors, Julia Weiner and Walter Schwab.

Walter, a past Chairman of the Society, edited the previous edition. His unswerving commitment to the Ben Uri and he and his wife Liesel's encyclopaedic knowledge of the world of art have been fundamental to the successful production of this edition. Julia, the Curator of the Society, has researched, reviewed, checked, cajoled and organised with her usual unceasing energy and dedication. We owe both editors a considerable debt of gratitude.

The publication of our new catalogue is a further landmark in the distinguished history of the Ben Uri Art Society. I look forward to even greater achievements in the future.

**Leslie Michaels**
*Chairman*
May 1994

# Introduction to the second edition

## Walter Schwab and Julia Weiner

The original edition of the Society's catalogue was widely acclaimed and the complete edition of 1000 copies rapidly exhausted. Since that volume was published, the Society's collection has been increased by the addition of no fewer than 250 items, so that rather than reprint the original edition as it stood, it has been decided to incorporate all the new additions into a separate section, retaining the original numbering of individual items.

As a consequence and for ease of reference, an index of artists has been added at the end of the volume, since individual artists may appear in either one or both sections. Although the collection consists in the main of works by Jewish artists, there are a very few exceptions since, from time to time, works by non-Jewish artists of relevance to the collection have been accepted. It has not been considered desirable nor necessary to exclude these from the catalogue. The Society also owns two prints by Rembrandt and Dürer bequeathed to us by Miss Stephanie Ellen Kohn.

The opportunity has been taken to correct errors that appeared in the original edition and to add information where previously lacking, if available. Nevertheless, it has not been possible to find information about certain artists whose works are represented in the collection. Should readers of this catalogue have information about any of these artists, we would be glad to hear from them.

The increased size of the collection has put a great strain on our storage space. Strenuous efforts are being made to overcome this difficulty and to improve the storage conditions. We are very grateful to respresentatives from AMSSEE (the Area Museums Service for South East England) for all their advice and help in this matter. We must also thank the Kennedy-Leigh Charitable Trust who have agreed to sponsor a major part of the costs of conserving the collection.

There are, of course, many lacunae in the collection which the Society would like to fill. However, costs of acquisition are usually very high and the Society lacks the funds to compete in the open market. We must, therefore, rely on benefactors to provide funds or to donate suitable pictures to add to the collection. All offers will be very welcome and carefully considered.

Our thanks are once again due to Lund Humphries Publishers Ltd, who have always been ready to give advice and who have seen this volume through the press. Our thanks are also due to all those staff and members of the Society who have devoted time and effort to acquire new works for the collection and to see that this revised edition has come to fruition. In particular, we must mention Alice Schwab, the Honorary Curator, Lois Peltz, Chair of our Permanent Collection Committee and Carole Berman, Chair of the Art Committee. We are much indebted to Judith Glass, Administrator of the Society, who spent many hours typing up the manuscript, and who, together with Harriet Goldhill and Debbie Sellman, provided much-needed support at all stages of the project. James Hyman gave a great deal of his time to help us build up the number of contemporary Anglo-Jewish artists represented in the collection for which

we are most grateful. In addition, our thanks to Isabelle Pleskoff-Bargues from the Musée d'Art et d'Histoire du Judaïsme, Paris and to Susan Goodman, Emily Whittemore and Irene Schenk from the Jewish Museum, New York for providing new information about French and American artists, and to David Mazower whose knowledge of the early history of the Society proved invaluable. We owe an enormous debt to Neta Dor, Archivist at the Tel Aviv Museum, who took great pains to provide us with biographical details about the Israeli artists represented in the collection. Finally, a special vote of thanks to Barry Fealdman, former Curator of the Society, who once more gave us the benefit of his extremely wide knowledge of Jewish art and artists.

We trust that this revised edition will be as welcome to its readers as was its predecessor.

January 1994

# Introduction to the first edition 1987

Walter Schwab

Art collections. as with libraries, are only as good as their catalogues. Packed away in store-rooms and only selections emerging on rare occasions to public gaze, they may engender a pride of possession, but their true value and usefulness is largely denied to the public, to art historians and to those who undertake research into the development of our cultural heritage. The publication of this catalogue will for the first time reveal what the Ben Uri Art Society has managed to accumulate by generous benefactions, discriminating purchases and the voluntary gifts of artists during the many decades of its existence.

The idea of publishing a catalogue of the collection had been my ambition ever since I became associated with the work of the Society. But the original initiative which set the long and somewhat tortuous wheels in progress came from my wife Alice (Liesel), Chairman of the Society's Art Committee. She instigated the first independent inspection and valuation of the collection in 1982 by Christie's who have always been generous and helpful towards the Society. Until then a manuscript catalogue had been maintained, but over the years and through pressure of other activities, it had become deficient and incomplete. We have to thank Sally Kesten and the late Freddy Wells for their zeal and labours in preparing individual record sheets for each item in the collection and for the many willing hands which made it possible to check each item individually. The preparation of the catalogue based on this record has been a team effort.

Yael Hirsch, the Society's former Curator, drew all the threads together and enlisted the assistance of numerous friends and relations in the onerous task of hauling items in and out of our inadequate store for closer inspection. Roberta Milston prepared the actual catalogue entries ably assisted by Sam Kramer who did all the fetching and carrying. Muriel Emanuel has prepared the biographies and material about the artists represented in the collection—no easy task since a considerable amount of research was needed. Our grateful thanks are also due to Monica Bohm-Duchen and Barry Fealdman for their contributary essays. But all of us owe an incalculable debt of gratitude to Barry Fealdman, at one time the Society's Curator, whose knowledge of the collection and of Jewish art in general is unrivalled.

The proposal to publish a catalogue was welcomed by the Society's Council but a decision was deferred for lack of funds. The financial problem of publication was, however, overcome by a generous donation from the Cecil Roth Trust since, in the words of Mrs Irene Roth, 'this is a project that would have been dear to the heart of the late Professor Roth who had such an abiding interest in Jewish art'. Other generous benefactions came from a few friends and acquaintances and I am deeply grateful to them all for their most willing assistance which has made publication possible without any drain on the society's slender financial resources.

Finally, I have edited this volume as best I can. Inaccuracies, omissions and errors must be laid at my door.

December 1987

# The Ben Uri Art Society and its Collection

**Barry Fealdman**

For almost eighty years, the Ben Uri Art Society has been at the heart of the artistic and cultural life of Anglo-Jewry. It has built up an important collection of paintings, drawings and sculpture by Jewish artists—one of the most extensive of its kind. It has organised significant exhibitions which have attracted the acclaim of both critics and the public at large. It has pioneered the concept of an arts centre catering for a wide range of cultural activities.

The roots of the Society are to be found in the East End of London among the Yiddish-speaking working people—tailors, cabinet-makers, furriers, watchmakers, market traders and pedlars, mainly immigrants, who thirsted for a wider cultural experience than they had enjoyed in their homelands.

During the early decades of the century, groups of like-minded friends met in the cafés and restaurants centred around Whitechapel and discussed far into the night plans for a Jewish cultural renaissance, fired through lectures by and contacts with leading figures in art, literature, drama and music. Among the projects envisaged was 'a Jewish art society which would enrich and ennoble the Jewish population'.[1]

Inspired by the urgings of a dynamic young Polish-born decorative artist, Leon Berson, who had arrived in London via Brussels and Paris, the Ben Uri came into existence in July 1915. The name 'Ben Uri' was derived from Exodus 31, which mentions the craftsman-builder of the Tabernacle—Bezalel Ben Uri. The Society at first rejoiced in the grandiloquent title 'The Jewish National Art Association (London) "Ben Ouri"'. Only since World War II has it assumed its present designation.

The founders of the Society aspired to form a collection of works by Jewish artists and to house them in a permanent gallery—an aspiration that has now been partially realised. In pursuing this objective, however, they were not in any way motivated by a spirit of sectarianism, but rather by the need to demonstrate to the wider public the important contribution Jews had made and were making to world art. At the same time they wanted to foster the appreciation of art within the Anglo-Jewish community.

During its formative years, the Society conducted its affairs in Yiddish, maintained close links with other Yiddish cultural societies and even until the 1970s provided a venue for the meetings of the Friends of Yiddish under the chairmanship of the poet, A. N. Stencl. Inevitably, as younger, British-born members joined the Society, English became the predominant language, though as late as 1930 the first catalogue of the collection was published in both English and Yiddish editions.

The Society soon attracted into its ranks mature artists like Alfred Wolmark and Leopold Pilichowski as well as David Bomberg, Jacob Kramer and other up-and-coming artists. Wolmark in particular played a prominent part in the Society's affairs and acted as adviser on purchasing policy.

[1] Judah Beach. Ben Uri Catalogue 1930

The first important acquisition was made in 1919 with the purchase of a group of fifteen drawings by Simeon Solomon. This was possible only because of the help given by the jeweller, poet and sculptor, Mosheh Oved—one of the Society's major benefactors who, over the years, donated several important works to the Society and also came to its rescue in its frequent financial crises.

From its inception, the Society was concerned not only to acquire works of art, but also to organise lectures, concerts and poetry readings which, by all accounts, attracted large audiences. These events took place at the Whitechapel Art Gallery, at Toynbee Hall and at other venues in the East End. Selections from the collection were exhibited on these occasions, but the complete collection was normally kept at the Hampstead home of one of the Society's founders, Judah Beach. The Society did in fact succeed in opening its own gallery in Great Russell Street, opposite the British Museum in 1925, but was forced to close it the following year owing to lack of support. A new home for the collection was found in 1930, when it was moved to the Jews' Temporary Shelter in Mansell Street, whose superintendent, Adolph Michaelson, was the Society's long-serving chairman.

In 1920, the Society acquired four pictures by David Bomberg, including his masterly *Ghetto Theatre*—a painting much in demand for exhibitions organised by the Arts Council, the Royal Academy and similar bodies. The following year saw the purchase of sculptures by Henry Glicenstein, among them a maquette of the Society's first president, Israel Zangwill. Added to the collection in the same year were three paintings of Palestine by Isaac Lichtenstein, and two years later, a major painting *The Sabbath Rest* by the Jewish genre artist Samuel Hirszenberg was purchased. In 1928, another outstanding painting by Bomberg *Mt Zion with the Church of the Dormition: Moonlight* was purchased from his exhibition of Palestine paintings at the Leicester Galleries. Purchases in 1930 included two oils by Wolmark and a drawing by Kramer and there were gifts of an Epstein bronze given by Mosheh Oved, and a small collection of works by various Jewish artists, mainly from Eastern Europe, but also including an etching by Jozef Israels.

By 1930, the collection had grown to some 80 works, reflecting the taste of the Society's members which was, on the whole, somewhat conventional. Pictures that were not only by Jewish artists, but also had a Jewish content were favoured. Opportunities were passed up for acquiring works by Chagall, Soutine, Kisling, Pascin, Lipchitz, Zadkine and other artists of the so-called Jewish School of Paris, which at that time could have been bought for comparatively modest sums. Two years later, the Society, once more without a home, became the guest of the United Synagogue in the newly opened communal centre at Woburn House, which also incorporated the Jewish Museum. Several outstanding exhibitions were organised, and among the new works acquired were Jacob Kramer's *The Day of Atonement*, a seascape by Mané-Katz, a drawing by Modigliani and landscapes by Issachar Ryback and Zygmund Landau. A still life by Mark Gertler, presented by Israel Sieff, also entered the collection, which now numbered some 150 works.

Another forced removal in 1936 brought the Society into the Anglo-Palestine Club in Great Windmill Street, where it remained until the outbreak of World War II. The collection was then stored in a place of safety deep beneath the pavements of London's West End.

Since the late 1930s, the character of the Society had changed, the Yiddish-speaking founding fathers having largely given way to a new generation born in this country. The leadership during the difficult war years passed to Mrs Ethel Solomon and to Cyril Ross, both of whom were immensely generous in their support for the Society. Through their efforts the Ben Uri was able, in 1944, to acquire its own home—a fine Georgian house in Portman Street, in the heart of the West End. It was now possible to put on view selections from the collection on the first floor of the premises, while reserving the ground floor for loan exhibitions and one-person shows.

The rise of the Nazis to power brought a steady flow of Jewish artists into Britain, several of whom joined the Society and took an active part in its affairs. Their advice on acquisition policy was to prove particularly valuable. Works by artists of what the art historian, Helen Kapp, called 'The Continental British School of Painting' were added to the collection, among them paintings and drawings by Jankel Adler, Martin Bloch, Fred Feigl, Josef Herman, Erich Kahn, Adèle Reifenberg, Julius Rosenbaum, Fred Uhlman and sculpture by Else Fraenkel and Max Sokol.

Purchases in the immediate post-war years also included a monumental painting *Moses* by Alva, two superb works on paper by Bernard Meninsky and a fine drawing by Barnett Freedman. Among the gifts were two Epstein bronzes given by Mosheh Oved, a large interior by Lily Delissa Joseph given by Mrs Ethel Solomon, a landscape by Abraham Mintchine given by Gimpel Fils, a drawing by Ludwig Meidner given by Cyril Ross and a gouache by Mané-Katz given by Dr Richard Gainsborough.

The most important accession to the collection at the time, however, was Mark Gertler's masterpiece *Merry-Go-Round*, which, due to the Ben Uri's dire financial straits, was recently sold, after much agonising, to the Tate Gallery, where it is now exhibited in all its splendour. The Ben Uri, once established in its own home, became principally an exhibiting society, though efforts were still being made through purchase, gift or bequest to add to the collection in order to make it more representative. A most welcome gift was a charming pen and ink drawing by Camille Pissarro given by Alexander Margulies, the Society's chairman for over twenty years, and one of its most caring and most generous supporters. Among other gifts were works by Max Liebermann, Michel Kikoine and Maurice Blond. Purchases included *The Broken Aqueduct* from Bomberg's Palestine period, a late nude by Mark Gertler and paintings by Archibald Ziegler and Kalman Kemeny. The years from 1944 to 1960 were among the most fruitful of the Society's existence. A full programme of activities in the arts took place within its premises on six days of the week, and the collection increased to a total of some 250 works.

In 1959, a substantial sum was offered to the Society to vacate Portman Street, the lease of which was in any case due to expire in 1965. The offer was accepted, and in April 1960 the Society was once again homeless. The collection was put in store and activities continued at various West End venues. Negotiations were put in hand with the West End Great Synagogue to participate in the erection of a building at 21 Dean Street which would include a purpose-built gallery for the Society. The negotiations were brought to a successful conclusion and in 1961 the Society joined with the Synagogue in renting temporary premises

in Berners Street which it occupied until it took possession of its present gallery in January 1964.

The collection, which has more than trebled in size during the past twenty-five years, has been immeasurably enriched by the acquisition of works by leading contemporary Anglo-Jewish artists such as Frank Auerbach and Leon Kossoff. In addition, many artists who have exhibited in the Gallery in recent years have been generous in donating examples of their work to the Society. In 1990, the Ben Uri received an important collection of seven works bequeathed by Miss Stephanie Ellen Kohn in memory of her parents Franz and Margarethe Kohn (née Schottlander) and her brother Ludwig who perished in the Holocaust. This included important paintings by Lesser Ury and Eugen Spiro and an etching by Max Liebermann.

The print run of the first edition of this catalogue was exhausted in 1992, and a major fund-raising drive launched to secure the funds to reprint it in a revised and extended form. At the same time, approaches were made to artists and collectors and as a result, the Society has received many generous donations including works by R. B. Kitaj, Sonia Delaunay, Jules Pascin, E. M. Lilien, and Sandra Fisher, artists hitherto unrepresented in the collection.

There are, regrettably, still many gaps in the collection. Israeli artists, for instance, are very under-represented and there are no examples of paintings by distinguished American-Jewish artists like Ben Shahn, Mark Rothko, Mark Tobey, Barnett Newman or Jack Levine. Efforts will be made to secure works by these artists in the future.

The collection is, nevertheless, a tribute to the foresight and perseverance of a group of people who, in founding the Ben Uri, were looked upon as 'zealots and dreamers who were aiming at something to which only millionaires and powerful nations can aspire'.[2] It is indeed remarkable that the Society has accomplished so much during its eight decades of existence despite an almost continuous struggle to survive. What makes the collection so important is not only the treasures it contains, but the fact that gathered together in one place is an extensive concentration of works by Jewish artists, reflecting their undoubted achievements in the field of visual art. Having raised the money to republish the catalogue of this important collection, it is to be hoped that the Society will next be able to secure the funds to provide an exhibition space where selections from the collection can be exhibited on a permanent basis.

[2] Judah Beach. Ben Uri Catalogue 1930

# Jewish Art or Jewish Artists: a problem of definition

**Monica Bohm-Duchen**

*This essay formed part of the original catalogue and is reprinted here.*

Prior to the late eighteenth century, there was little doubt as to what constituted Jewish art. Whether we consider the third century CE synagogue of Dura Europos, an illuminated Hebrew manuscript from the medieval period or an embroidered Torah wrap of several centuries later, it is clear that the function of these—visually disparate—objects was essentially the same. Largely the work of anonymous craftsmen, Jewish art before the modern period meant art made for Jewish purposes, intended to form an integral part of Jewish life and worship, in which the talent of the individual was subsumed under the desire to make art serve God. Even the briefest survey of such art will reveal that the taboo on the 'graven image' to be found in the Biblical Second Commandment[1] held considerably less sway over the centuries than is popularly imagined. Moreover, when at certain historical junctures figuration was avoided, it was usually as much for political and social reasons as for religious ones. It also soon becomes apparent that Jewish art has at all times been profoundly susceptible to stylistic influence from the art of the 'host' culture.

Yet while today[2] nobody could deny the existence of a long and rich tradition of Jewish ritual artefacts, the artistic status of these objects is still open to question. Stylistic borrowings were often lacking in sophistication, largely owing to the fact that Jewish craftsmen were on the whole denied access to the training available to their non-Jewish counterparts. With the best will in the world, it would be difficult to accord them a major place in the history of Western art—especially when one considers the persistence of this tradition into the post-medieval period, a period which produced a Leonardo, a Michelangelo, a Rembrandt. If a parallel is needed, it is to the more modest achievements of the Christian Middle Ages that we must look.[3]

The reasons for this are, of course, complex in the extreme, having far more to do with religious, social, economic and political constraints on Jewish life than with any intrinsic lack of sympathy for the visual image. Only with the advent of Jewish Emancipation and so-called Jewish Enlightenment or *Haskalah* in the eighteenth century, could all this change; only when (in the memorable words of Moses Mendelssohn) Jews were able to leave 'the narrow labyrinth of ritual-theological casuistry' and enter 'the broad highway of human culture', could they become fully-fledged artists in the post-Renaissance sense of the word. And

---

[1] One needs, in any event, to bear in mind the specific historical circumstances which gave rise to the taboo. For a society seeking for the first time to establish the disembodied monotheistic principle, the idolatrous habits of its neighbours would clearly have been anathema, and a potentially dangerous distraction.

[2] It is important to remember that the existence of a Jewish artistic tradition was 'discovered' only at the end of the nineteenth century. The sixth-century CE synagogue of Bet Alpha, for example, was discovered only in 1928; and Dura Europos as late as 1932.

[3] Some people may feel that the underlying ethos of medieval art is in fact far healthier than that of post-Renaissance art. Many important modern artists have themselves shared this sentiment.

ironically, it was only from this time onwards that the issue of Jewish identity in art (as, indeed, in anything else) became at all problematic.

In the modern period, then, there have been more Jewish artists than ever before, and many of them have acquired considerable reputations. One of the first of these may have been the well-known portraitist and painter of theatrical scenes, Johann Zoffany (1734/5–1810), born (like most of the earliest Jewish artists to emerge in this period) in Germany, the home of the *Haskalah*, but resident in England for most of his career. That his Jewish origins are not wholly certain is hardly surprising: as for all Jewish artists in this early period, publicising those origins would hardly have furthered his career.[4] The first unequivocally Jewish artist to be elected a full member of London's Royal Academy of Arts was Solomon Alexander Hart (1806–81). Hart was made Academician in 1840; but a full sixty-six years were to elapse before another Jew was to be thus honoured. (This was Solomon J. Solomon, in 1906.) The only other Anglo-Jewish artists to make a real mark on the nineteenth-century English art world were the remarkable Solomon family of painters: Abraham (1824–62), Rebecca (1832–86) and the notorious Simeon (1840–1905). Moreover, the following anecdote makes Hart's anomalous position all too bitterly clear: following his election, he was introduced to the children of his friend, Sir William Collins, thus: 'This is Mr Hart whom we have just elected Academician ... Mr Hart is a Jew, and the Jews crucified our Saviour, but he is a very good man for all that, and we shall see something more of him now.'[5]

The question of Jewish identity in modern art refuses to go away: again and again, writers on art, Jews and non-Jews alike (anti-semitism can, alas, prompt an interest in the subject just as effectively as can Jewish pride), have felt it necessary to attempt a definition of Jewish art in the modern period. A detailed examination of the field suggests to me that there are essentially three possible definitions of the term. Firstly, there is the claim made by certain writers that all art produced by Jews deserves the name Jewish art. Peter Krasnow, for example, writing in 1925, claimed: 'The Jewish artist produces an essentially Jewish art, independent of subject'. If by this it is implied that in all art produced by artists who happened to be Jews a distinctive *style* should be discernible, the claim is clearly a simplistic one that cannot be supported by the evidence. To suggest the perennial presence of certain 'essential' Jewish qualities is an ambitious and dangerously ahistorical claim to make; although as I shall make clear at a later stage of this essay, it remains a seductive idea. If, however, we take a position more firmly grounded in historical facts, an investigation into the specific context in which a particular modern Jewish artist has worked can provide valuable insights, both into the case in question and into the possibility of historically recurring problems and prejudices facing a Jewish artist which are specific to that Jewishness.

A second point of view might stipulate that it is subject-matter and/or intention which alone qualifies art to be considered Jewish. Guido Schoenberger, for

[4] Most Jewish artists working in the eighteenth and early nineteenth centuries were obliged to convert to Christianity as a prerequisite for artistic success. The first Jewish artist to succeed as precisely that was the German painter, Moritz Oppenheim (1799–1882).

[5] *Reminiscences of A. S. Hart*, 1882, ed. A. Brodie; quoted in *Jewish Artists of Great Britain 1845–1945*, Belgrave Gallery, London 1978, p. 7.

example, has suggested that 'Art can be considered Jewish even if it is produced by a non-Jewish artist, as long as it is made for a Jewish purpose'. Stephen Kayser corroborates this view by claiming that 'Jewish Art is art applied to Judaism'. If applied to the pre-*Haskalah* period this view poses few problems (and indeed, Jewish ritual objects quite often were produced by non-Jewish craftsmen). Even in the modern period, artefacts continue to be produced for use in synagogue and home, which happily qualify for the title. When, however, one considers the question of Jewish iconography in paintings or sculptures without functional purpose, the issue becomes more complex. What, then, of the many Christian artists who over the centuries have painted Old Testament subjects?[6] Are these works of art Jewish? And what of works by non-Jews alluding to that most pivotal of twentieth-century Jewish experiences—the Holocaust? The artist's attitude towards and involvement with his or her subject-matter needs to be considered too. What of those Jewish artists who painted not a single Jewish subject in their lives, but whose work continues to be perceived, to a greater or lesser extent, in terms of its Jewishness? (Chaim Soutine, whose *œuvre* is often considered the very embodiment of Jewish *angst*, is the most notable example here.) And what of Jewish artists such as the Russian-American painter Max Weber or the Anglo-Jewish painters Alfred Wolmark and William Rothenstein (to name just three) who have depicted aspects of Jewish life in one phase of their careers or in some of their works, but not in others?

A third line of thought might suggest that there are indeed certain difficult to define but none the less distinctive qualities that mark certain—but by no means all — works of art made by Jews as characteristically Jewish. Conspicuous among these qualities might be: an emphasis on spiritual, rather than material values; a nervously expressionistic handling of paint and line indicative of a lack of concern for academic propriety and a tradition that is not their own; a strong social conscience and moral seriousness, and a reluctance, if not inability to accept the idea of 'art for art's sake' (the modern equivalent, perhaps, of the Biblical fear of idolatry); a distinct tendency to melancholy and an empathy for all forms of human suffering; a suspicion of hedonistic sensuousness, especially when it comes to the depiction of the female nude;[7] and finally, a predisposition to abstraction as the purest expression of the divine principle.[8] Clearly, it is quite impossible to embrace *all* art produced by Jews under all these headings; some of these features might even seem to be mutually exclusive. Nevertheless, the frequency with which these characteristics appear in art produced by Jews in quite disparate environments, should at least make us pause for thought.

Attempts have indeed been made both by individuals and by groups of artists to create a specifically and explicitly Jewish art. The two most important group

---

[6] The great Rembrandt is a case in point here. Interestingly, many Jewish artists have hailed him as a kindred spirit, and would doubtless have agreed with the Israeli artist Moshe Castel's view that 'Not without reason do we [Eretz Israel and Jewish painters] love Rembrandt, whose works reflect the holy spirit, having transformed the plasticity of the flesh into a biblical holiness as a pure Jew'.

[7] Amedeo Modigliani's nudes of 1917/18 are, it seems to me, very much the exception that proves the rule. Yet even they, for all their extraordinary voluptuousness, have an unusual tenderness. Marc Chagall's many female nudes are likewise endowed with a curious moral chasteness.

[8] It is certainly striking how many of the pioneering American Abstract Expressionist painters were Jewish; of these, several (notably Barnett Newman) spoke quite explicitly about their wish to express Jewish mystical ideas through their art.

ventures of this kind, in Russia around the time of the 1917 Revolution and in Palestine in the early part of the twentieth century (centred around artists such as Lissitsky, Altman and Ryback, and the Bezalel Art School and the figure of Boris Schatz respectively), were both fired by a profound utopianism; both, as a result perhaps, doomed in their different ways to be short-lived. In 1902 Martin Buber (originally trained as an art historian under Alois Riegl and Frank Wickhoff) stated categorically: '. . . a national art needs a soil from which to spring and a sky towards which to rise . . . a national style needs a homogeneous society from which it grows and for whom it exists'. Ironically, the process of normalisation in Israeli society has itself proved inimical to the very notion of a specifically Jewish art: and even if Israeli artists are troubled by identity problems (which many of them undoubtedly are, whether they acknowledge the fact or not), their response has tended to be to stress their identity as Israelis at the expense of their Jewishness.

Crises of identity, however, artistic and otherwise, lie at the very heart of modern existence: not for nothing did James Joyce choose a Dublin Jew as his central character in *Ulysses*. The Jewish quest for identity has come to be seen as a metaphor for the *malaise* afflicting the whole of Western society; in the quest, rather than the expectation of a definitive answer, lies the heart of the matter. Let Martin Buber have the idealistic last word: to him, Jewish art was the 'awakened longing for the beautiful . . . the birth of the power to create. . . . What we call national art is not that which exists but what develops and may come into being. Not fulfilment but a beautiful possibility.'

## Select Bibliography

**Books**

Z. Amishai-Maisels. *Depiction and Interpretation: The Influence of the Holocaust on the Visual Arts*, Pergamon Press, Oxford 1993

J. Blatter and S. Milton. *Art of the Holocaust*, Pan Books Ltd, London 1982

A. Kampf. *Jewish Experience in the Art of the Twentieth Century*, Bergin & Garvey Publishers Inc., South Hadley, Mass. 1984

E. Roditi. 'The Jewish Artist in the Modern World' in *Jewish Art: An Illustrated History* edited by C. Roth, New York Graphic Society Ltd, Greenwich, Connecticut 1971

J. Sonntag (ed.). *Ben Uri, 1915–1965: Fifty Years Achievements in the Arts*, Ben Uri Art Society, London 1966

**Exhibition Catalogues**

*Art in Exile in Great Britain 1933–1945*, Camden Arts Centre, London 1986

*Chagall to Kitaj: Jewish Experience in 20th Century Art*, Lund Humphries/Barbican Art Gallery, London 1990

*Jewish Artists in England 1656–1956*, Whitechapel Art Gallery, London 1956

*Jewish Artists of Great Britain 1845–1945*, Belgrave Gallery, London and Cartwright Hall Art Gallery & Museum, Bradford 1978

*The Immigrant Generations: Jewish Artists in Britain 1900–1945*, Jewish Museum, New York 1983

**Articles**

M. Kozloff. 'Jewish Art & the Modern Jeopardy', *Artforum*, April 1976

R. Pincus-Witten. 'Six Propositions on Jewish Art', *Arts Magazine*, Dec. 1975

H. Rosenberg. 'Is there a Jewish Art?', *Commentary*, July 1966

# Catalogue

Biographical material has been included in the catalogue for most artists. Where such material is lacking, only the artist's name and details of work in the Society's collection are given, as no biographical information has been obtained despite diligent research.

All dimensions are shown height before width.

The catalogue is in two parts:
Pages 17–110  The original catalogue (1st edition 1987) with some corrections and additional material
Pages 111–158  New acquisitions arranged in alphabetical order

For ease of reference, an index of artists' names has been added to the end of the catalogue.

**List of Abbreviations**

| | |
|---|---|
| Bezalel | Bezalel School of Arts and Crafts, Jerusalem |
| Central School | Central School of Art and Design (formerly Central School of Arts and Crafts), London |
| RA Schools | Royal Academy Schools, London |
| RCA | Royal College of Art, London |
| St Martin's | St Martin's School of Art, London |
| Slade | Slade School of Fine Arts, London |

# Albert Abramovitz

1 *The Negress*
signed
woodcut 18.5 × 13.5 cm
purchased 1933

## Jankel Adler
b.1895 Tuszyn, Poland
d.1949 Aldebourne, Wiltshire

Left Poland for Berlin after serving in
the Russian Army during World War I;
later studied at the Akademie der Kunst,
Dusseldorf where he became a lecturer,
moving in the circle of Paul Klee and
Max Ernst. After many of his paintings
were destroyed by the Nazis, he settled
in France and later enlisted in the Free
Polish Army. He was evacuated to
Scotland and remained in Glasgow until
1943 when he settled in London.

**Selected Exhibitions**
1946 Palais des Beaux-Arts, Brussels
1951 New Burlington Galleries, London
1957 Ben Uri Art Society, London
1969 Israel Museum, Jerusalem
1976 Camden Arts Centre, London
1981 A.M. Adler Fine Arts, New York
1985–6 Kunsthalle, Dusseldorf

**Selected Bibliography**
Stanley William Hayter. *Jankel Adler*,
London 1948
Paul Fierens. *Jankel Adler*, London 1948
Stefan Themerson. *An Artist seen from one of
many Possible Angles*, London 1948
Anna Klapheck. *Jankel Adler*,
Recklinghausen, West Germany 1966
(in German)
Ulrich Krempel and Karin Thomas. *Jankel
Adler*, Cologne 1985 (in German, English
and Polish)

2 *Still Life*
mixed media 73 × 61 cm
purchased 1937
Exhibited:
The Arts Council Adler Memorial
Exhibition London 1951, no.8

2 Jankel Adler *Still Life*

## Valerie Adler

b.South Africa
lives in London

Came to London at the age of seventeen and studied interior design at the Inchbald School of Interior Design. She went to Jerusalem in 1977 where she studied History of Art at the Hebrew University, and later painting and drawing under Asher Rodnitsky. She returned to London in 1982 and studied at the Chelsea School of Art.

**Selected Exhibitions**
1986 Galleria Spania Nuovo, Venice
1987 Solomon Gallery, London

3 *An Old House*
oil on board 41 × 50 cm
presented by the artist 1987
Exhibited:
Solomon Gallery, London 1986
Galleria Spania Nuovo, Venice 1987

## Eva Aldbrook

b.1925 Hamburg
lives in Tuscany

Family settled in London in 1938 where Eva studied ballet and costume design. She danced in London and the provinces until 1943. After war service she worked as a costume designer for four years and as a fashion illustrator. Studied painting at Camden Arts Centre. Appointed Vice-Chairman, Hampstead Artists Council 1975.

**Selected Exhibitions**
1975 & 1985 Camden Arts Centre, London
1980 Hamilton Gallery, London
1982 Ben Uri Art Society, London

4 *Portrait of Rosemary Friedman*
signed (with monogram)
oil on canvas 76 × 63 cm
presented by the artist 1987

## Hazel Alexander

b.Newcastle upon Tyne
lives in London

Studied briefly in her youth and as a mature student at the Camden Art Institute, London. Her sculptures have been exhibited at the Ben Uri Art Society and numerous galleries in London and in Israel.

5 *The Dead Horse*
bronze height: 30 cm
presented by Mr and Mrs Klausner 1986

## John Allin

b.1934 London
d.1990 London

Almost entirely self-taught, Allin began painting seriously in the mid 1960s producing street scenes of London's East End. In his 'teens he joined the Merchant Navy and travelled the world; served in the Army in North Africa, then had various jobs including long-distance lorry driving. More recently he spent three years with a circus team producing a series of paintings on circus life. His first book, produced with Arnold Whesker, *Say Goodbye: You May Never See Them Again*, was published in 1974. His work is shown frequently at the Portal Gallery, London.

6 *East End Series*
signed and dated 1975
lithographs, set of eight, all 9/250
various sizes
presented by Jonathan Stone 1982

## Manfred Altman

b.Salzburg, Austria
lives in London

Altman's family moved to Trier, Germany where he studied law. He reached England in 1939 losing most of his family in the Holocaust. He has sketched and painted from his early days and attended courses in art in Holland and in this country.

7 *Rock Dynamics From the Sea*
pastel 30.5 × 46 cm
presented by the artist 1987

## Alva

b.1901 Berlin
d.1973 London

Solomon Siegfried Allweiss, of Austrian parentage, originally studied music in Berlin, adopting the pseudonym Alva in 1925. He travelled extensively in Europe and the Middle East (including Palestine) and spent five years in Paris. He settled in England in 1938.

**Selected Exhibitions**
1948 Leicester Galleries, London
1956 Musée d'Aix-la-Chapelle
1966 Modern Nordiskkonst, Goteborg, Sweden

**Selected Bibliography**
Alva. *Paintings and Drawings*, Introduction by Maurice Collis, London 1942
Alva. *Recent Paintings and Drawings*, London 1951
R. V. Gindertael. *Alva*, Paris 1955
Alva. *With Pen and Brush*, London 1973 (autobiography)

8 *Moses*
signed
oil on canvas 127 × 76 cm
purchased 1949
Exhibited:
Camden Arts Centre, London 1985

9 *Prophets*
signed
lithographs (set of 6)
53 × 36 cm
presented by Mosheh Oved 1949

## Arie Alweil

b.1901 Galicia
d.1967 Tel Aviv

Alweil grew up in Vienna and first visited Palestine in 1920. On his return to Vienna, he studied at the Academy of Art. He travelled around Europe in 1925–26 and then emigrated to Israel settling in Shefraya.

**Selected Exhibitions**
1933 Tel Aviv Museum
1949 Tel Aviv Museum

10 *Hill Town in Israel*
signed
oil on canvas 49.5 × 37 cm
presented

8 Alva *Moses*

## Amid

11 *A Cottage and Tree in a Hilly Landscape*
signed
oil on canvas 49.5 × 69.5 cm

## Isaac Amitai

b.1907 Jerusalem
lives in Safed

Amitai studied at Bezalel 1929–31 and
then in Paris at the Ecole Supérieure de
la Ville de Paris. He taught at Ein Harod
1944–47 and settled in Safed in 1953.

**Selected Exhibitions**
1940 Katz Gallery, Tel Aviv
1950 Ben Uri Art Society, London
1957 Tel Aviv Museum

12 *Synagogue*
signed
gouache on blue paper 39 × 53 cm

## John Henry Amshewitz RBA

b.1882 Ramsgate, Kent
d.1942 South Africa

Son of a scholar at Montefiore College,
Amshewitz moved to London in 1887. He
was apprenticed to a furniture designer,
but his desire to study art took him to
Edinburgh where he was awarded a
scholarship at the Art Academy; later he
studied at the RA Schools 1902–7. He
was elected a member of the Royal
Society of British Artists in 1914. He had
a brief acting career in South Africa,
where he lived from 1916–22 and from
1936 until his death.

**Selected Exhibitions**
1943 City Hall, Johannesburg
1954 Stuttaford's Gallery, Johannesburg

**Selected Bibliography**
Sarah Briana Amshewitz. *The Paintings of
J. H. Amshewitz*, London 1951

13 *The Wedding*
signed and inscribed
etching 26 × 26 cm
See: S. B. Amshewitz. *J. H. Amshewitz*,
London 1951, p.45

10 Arie Alweil *Hill Town in Israel*

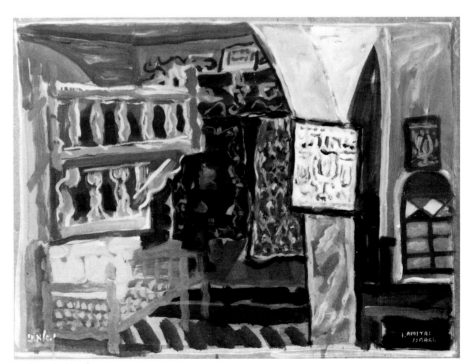

12 Isaac Amitai *Synagogue*

19

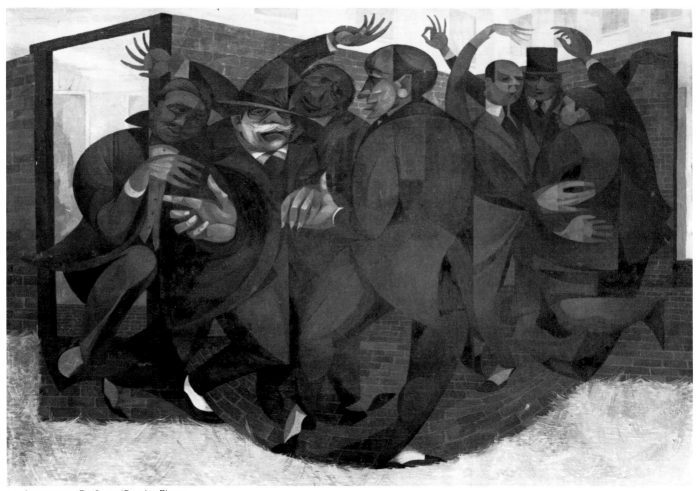

14 Anonymous *Conference/Dancing Figures*

## Anonymous

14 *Conference/Dancing Figures*
oil on canvas 64.5 × 95.5 cm
(verso: *Man Seated by River with Boats*)

15 *Head of a Negro Man*
charcoal 36 × 30 cm

16 *Rejection*
pencil drawing 26.5 × 36 cm

## Isidor Ascheim

b.1891 Marqurin, Germany
d.1968 Jerusalem

Studied at the Art Academy, Breslau and
taught at the Jewish school in Breslau
before emigrating to Palestine in 1939,
where he continued teaching at Bezalel.
He won the Dizengoff prize in 1952 and
showed at the Biennale di Venezia in
1956.

17 *Judean Hills*
(verso: *Portrait of Martha Price*)
*c.*1948 (verso: *c.*1930)
oil on canvas  69 × 53.5 cm
purchased 1979

## Frank Auerbach

b.1931 Berlin
lives in London

Auerbach's family, who perished in the
Holocaust, sent him to England in 1939.
He studied under David Bomberg at the
Borough Polytechnic and later at St
Martin's and the RCA. He has taught at
various schools including the Slade and
Camberwell. He was awarded the Golden
Lion Prize (jointly with Sigmar Polke) at
the Biennale di Venezia, 1986.

**Selected Exhibitions**
1956–63 Beaux-Arts Gallery, London
    since 1965 Marlborough Fine Art,
    London
1969 Marlborough Gerson Gallery,
    New York
1974 Municipal Gallery, London and
    Fruit Market Gallery, Edinburgh
1982 Marlborough Gallery, New York
1986 Kunstverein, Hamburg
1986 XLIII Biennale di Venezia
1989 Rijksmuseum Vincent Van Gogh,
    Amsterdam
1990 Marlborough Fine Art, London

**Selected Bibliography**
Robert Hughes. *Frank Auerbach*, London
1990

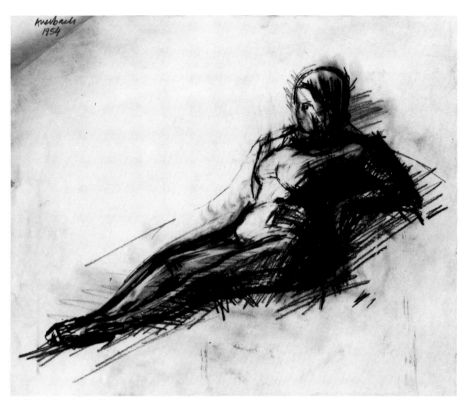

18 Frank Auerbach *Nude*

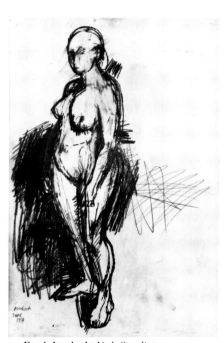

19 Frank Auerbach *Nude Standing*

18 *Nude*
signed and dated 1954
charcoal  46 × 55 cm
presented

19 *Nude Standing*
signed and dated June 1954
pencil and red crayon  55 × 38 cm
purchased

## David Azuz

b.1941 Tel Aviv
lives in Tel Aviv and Paris

Studied in Tel Aviv at the studio of Josef
Schwartzman, 1951–55 and the Avni
Institute, 1955–58. He continued his
studies in Paris at the École des Beaux-
Arts and La Grande Chaumière, 1958–63.
A major exhibition of his work was held
in Haifa in 1958. He was also exhibited
in Europe and the United States.

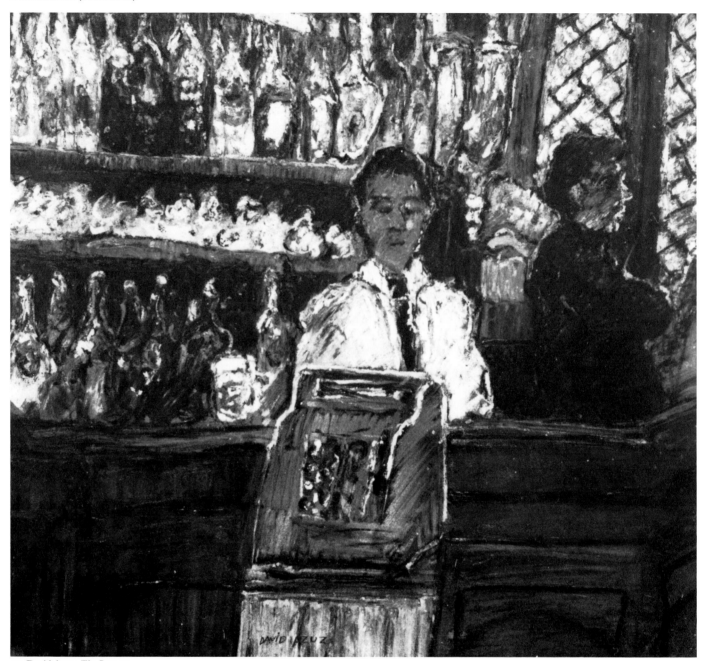

20  David Azuz  *The Barman*

**20**  *The Barman*
signed *c*.1950
oil on paper  46 × 50.5 cm
presented by Dr I. Bierer 1982

## Yehuda Bacon

b.1929 Ostrava, Czechoslovakia
lives in Jerusalem

Deported to Theresienstadt in 1942 and
to Auschwitz in 1943, Bacon settled in
Palestine after the war and studied in
Jerusalem until 1951. Following a year in
London at the Central School, he
travelled and studied in Italy and the
United States. His teaching career began
in Jerusalem in 1951 at the Brandeis
School; he has been on the staff of Bezalel
since 1959.

### Selected Exhibitions
1956 Phoenix Gallery, Lavenham, Suffolk
(with Hammond Steele and John Nash)
1973 Galerie Williams, Helsinki
Since 1978 at Henny Handler,
St John's Wood, London
1980 Arts Gallery 38, London

21 *Variations on a Theme*
signed and dated 1957
ten coloured etchings 66 × 77 cm
presented by Dr Israel Feldman 1957

22 *Stone Building*
signed (in English and Hebrew)
pen, ink and wash 25 × 34 cm
presented by Alice Schwab 1987

## Howard Baer

b. Philadelphia, Pennsylvania
lives in New York

Baer settled in New York in 1930 after
studying at the Carnegie Institute of
Technology, Pittsburg. He became an
Official War Artist with the United
States Army in the Far East in 1944. He
spent three years in Paris, 1948–51, and
settled in London in 1960. He has
illustrated numerous books and his
cartoons have appeared in many
periodicals.

### Selected Exhibitions
1960 Trabia Gallery, New York
1963 & 1965 Toninelli Arte Moderna, Milan
1965 & 1972 Ben Uri Art Society, London

23 *Memory of Venice*
signed and dated 1967
oil on canvas 51 × 76 cm
presented by the artist

24 *Outside a City IV*
signed and dated 1963
oil on canvas 25.5 × 30.5 cm
presented by the artist

## Peter Baer

b.1928 Berlin
lives in London

Arrived in London in 1937 after some
time in Switzerland and one year in
Spain. He studied at the Central School,
1952–55 and lithography as an
apprentice at Curwen Studios. Since
1970 he has taught printmaking and is
presently on the staff of the Chelsea
School of Art.

### Selected Exhibitions
1966–73 Curwen Gallery, London
1980 Ben Uri Art Society, London
(with Edith Greenwood)
1981 & 1987 Camden Arts Centre, London
1986 Ben Uri Art Society, London
(with Annette Rowdon)

25 *Walking About*
signed and dated 1985
lithograph A/P 72 × 57 cm
purchased 1986

## Léon Bakst
## (Lev Samoilovitch Rosenberg)

b.1866 Grodno, Russia
d.1924 Paris

Soon after his birth the family moved to
St Petersburg where he studied at the
Academy of Fine Art. From 1891
onwards he spent long periods of time in
Paris and finally settled there, becoming
an established portrait painter. At the
beginning of the twentieth century he
became involved in the theatre.

### Selected Exhibitions
1909 Galerie Bernheim, Paris
1912–27, 1973 & 1976 Fine Art Society,
London
1938 Arthur Tooth and Sons, London
1966 State Theatrical Museum, Leningrad
1967 Galleria del Levante, Milan

### Selected Bibliography
Arsène Alexandre and Jean Cocteau. *L'Art
Décoratif de Léon Bakst*, Paris 1913
André Levinson. *The Story of Léon Bakst's
Life*, New York 1922
Charles Spencer. *Léon Bakst*, New York 1973
Irena Pruzhan. *Léon Bakst*, Moscow 1975

26 *La Peri*
signed
lithograph 49 × 34 cm
presented by Fred Davidson 1948

## Rose Baron

Painter who worked in the East End of
London between 1940 and 1960.

27 *The Chicken Plucker*
signed
oil on canvas 75 × 50 cm
presented by the artist 1937

## Abu-Rabia Bashir

b.1955 Kaffif

An Israeli Arab Bedouin, Bashir studied
at the Avni Institute of Art, Tel Aviv and
the Ecole des Beaux Arts, Paris. He now
works as a film director. His work was
exhibited at the Ben Uri Gallery in 1975.

28 *Man on a Horse*
signed and dated 1974
etching 20.5 × 26.5 cm
presented by the artist

## Mati Basis

b.1932 Tel Aviv
lives in London

Basis studied at the Avni Institute of
Art, Tel Aviv and at the Hornsey
College of Art, London.

### Selected Exhibitions
1960 Tshemerinsky Gallery, Tel Aviv
1976 Oxford Gallery, Oxford
Margaret Fisher, London
1977 Ben Uri Art Society, London
(with Dalia Amos Weislib)
1982–83 National Theatre, London
1993 Crocodile Gallery, London

29 *Reflections*
signed and dated 1976
etching 7/75 46 × 37 cm
purchased

## Zeev Ben Zvi

b.1904 Poland
d.1952 Jerusalem

Studied at the Academy of Art in Warsaw
before emigrating to Palestine in 1924,
where he continued his studies at Bezalel.
He lived in England 1937–39 and after his
return to Jerusalem he became a lecturer
at Bezalel. He was well known in Israel
for his portrait sculptures.

30  *Head of Belisha* (Lord Hore Belisha)
signed
bronze  height: 36.2 cm
(excluding marble base)
presented

## Jack Bilbo (Hugo Baruch)

b.1907 Berlin
d.1967 Berlin

In 1939 Bilbo arrived in England, via
France and Spain. After World War II
he travelled a great deal making frequent
visits to France. In 1943 he founded the
Modern Art Gallery in London which he
continued to run until 1948. He returned
to Berlin in 1957.

**Selected Exhibitions**
1939  Arlington Gallery, London
1940  Zwemmer Gallery, London
1950  Galerie Bénézit, Paris
1963  Galerie Springer, Berlin
1967  Galerie Europa, Berlin
1983  Ben Uri Art Society, London
      (with Lotti Reizenstein and
      Henry Sanders)

**Selected Bibliography**
Merry Kerr-Woodeson. *Jack Bilbo and the
Modern Art Gallery : A Wartime Adventure in
Art*, London 1985 (unpublished dissertation)

31  *Miriam*
signed and dated 1963
gouache  65 × 45 cm
presented by Merry Kerr-Woodeson
1987

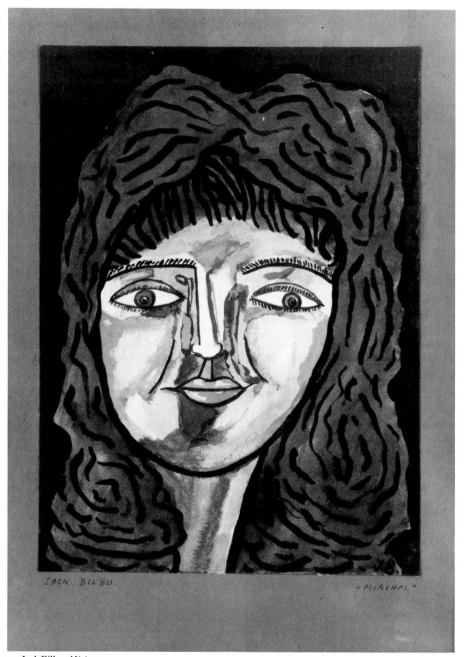

31  Jack Bilbo  *Miriam*

## Pearl Binder
## (Lady Elwyn Jones)

b.1904 Fenton, Staffordshire
d.1990 Brighton

Pearl Binder studied in Manchester and at the Central School, where her main interest was lithography. She was also an author and illustrator, having designed costumes for her own plays and musicals. From 1938 she was involved with programme designs for BBC Television and travelled extensively.

32 *Immigrants*
signed and dated 1960
lithograph 13/30  22 × 31 cm
presented by the artist

## Simon Black

b.1958 Manchester
lives in London

Studied at Manchester and Wolverhampton Polytechnics; spent some months in Mulhouse, France and in 1976 one year on a kibbutz in Israel. Further travels through Europe brought him back to Israel; he returned to Manchester in 1983. In 1985 he received the Lloyds Bank Award of the Manchester Academy of Fine Art. He settled in London in 1986.

**Selected Exhibitions**
1985  Pictures Gallery, Manchester
1986  Ben Uri Art Society London
    with Cheryl Aaron, Michèle Franklin and Ernst Gottschalk)
    Leo Solomon Gallery, Rochdale, Lancashire
1993  Five Dryden Street Gallery, London

33 *Damascus Gate Coffee Shop*
signed and dated 2/9/85
etching A/P
purchased by the Society

## Harry Blacker (Nero)

b.1910 London
lives in London

Blacker, well known as the cartoonist Nero, was apprenticed to an engraver at the age of sixteen. He attended evening classes at the Sir John Cass College of Art, being too poor to take up a scholarship to art school.

**Selected Exhibitions**
1981  Lauderdale House, London
1986  Ben Uri Art Society, London

**Selected Bibliography**
Harry Blacker. *Just Like it Was: Memoirs of the Mittel East*, London 1974

34 *It Gives Me Great Pleasure*
signed
felt tip pen  17.75 × 20.5 cm
presented by the artist

## Naomi Blake

b.1924 Mukacevo, Czechoslovakia
lives in London

Naomi Blake was deported to Auschwitz in 1944; after the liberation she spent a year in Rome before emigrating to Palestine in 1946 where she fought, and was wounded, in the War of Independence. After a year in Milan she arrived in London and studied at the Hornsey School of Art, 1955–61. In 1979 she was elected an Associate of the Royal Society of British Sculptors.

**Selected Exhibitions**
1974  Museum of the City of Leicester
1975  Engel Gallery, Jerusalem
1981  Campbell and Franks, London
    Bristol Cathedral and Swansea University
1986  Heffer Gallery, Cambridge
1987  Henny Handler, St John's Wood, London

35 *Emergence-A*
bronze  height: 30 cm (excluding base)
presented by the artist 1987

## Martin Bloch

b.1883 Neisse, Germany
d.1954 London

After studying in Berlin and Munich, Bloch spent two years in Paris, 1912–14. During World War I he was in Spain and after his return to Berlin in 1920 he opened a painting school. He left Germany in 1934 and eventually reached England where he founded the School for Contemporary Painting and Drawing. He travelled in the United States in 1948 and was guest teacher at Camberwell School of Art in 1949.

**Selected Exhibitions**
1911  Paul Cassirer Galerie, Berlin
1939  Lefevre Gallery, London
1949  Ben Uri Art Society, London
    (with Josef Herman)
1957  South London Art Gallery
1958  New Shakespeare Gallery, Liverpool
1963  Ben Uri Art Society, London
1974  Crane Kalman Gallery, London
1984  South London Art Gallery

36 *Svendborg Harbour, Denmark*
signed and dated 1934
oil on canvas  68.5 × 78.5 cm
purchased

COLOUR PLATE I

37 *House in Normandy (or Vavangeville)*
signed (verso) and dated 1939–43
oil on canvas  64 × 80 cm
presented by Alexander Margulies 1987
Exhibited:
1956 Whitechapel Art Gallery, London
1957 Arts Council of Great Britain
    (Leeds, Nottingham, Dumfries, Aberystwyth, Newcastle, Leicester)
1963 City of Leicester Museum

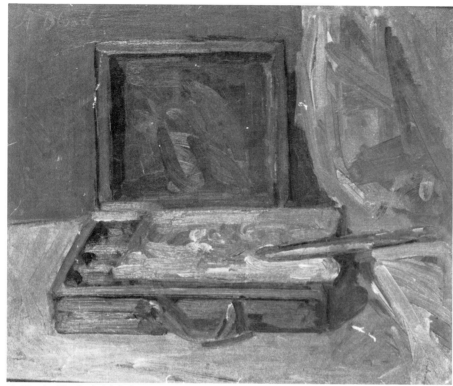

38 Maurice Blond *Artist's Palette*

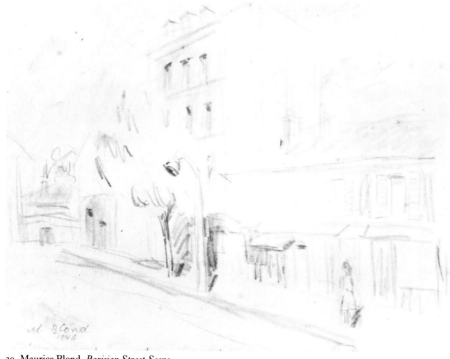

39 Maurice Blond *Parisian Street Scene*

## Maurice Blond
b.1899 Lodz, Poland
d.1974 Paris

After completing his studies in Warsaw, Blond travelled to Berlin. He settled in Paris in 1924 and lived there until his death.

**Selected Exhibitions**
1950 Galerie Zak, Paris
1952 Cowie Galleries, Los Angeles
1954 & 1962 Adams Gallery, London
1955 Municipal Art Gallery, Wolverhampton
1958 Crane Kalman Gallery, London
1968 & 1969 Galerie Agora, Paris

**Selected Bibliography**
Maximilien Gauthier. *Maurice Blond*, Paris 1957

38 *Artist's Palette*
signed
oil on board 37 × 45 cm
purchased

39 *Parisian Street Scene*
signed and dated 1945
pencil drawing on beige paper
31.5 × 40.5 cm
presented by J. Spreiregen

40 *Seated Man*
signed and dated 1950
pencil drawing 36.5 × 27.5 cm
presented by J. Spreiregen

## Sandra Blow RA
b.1925 London
lives in London

Accepted at St Martin's at the age of fifteen, studied there 1941–45 then at the RA Schools 1945–47 and at the Accademia di Belle Arti, Rome 1947–48. She then travelled in Spain and France, returning to England in 1950. Since 1950 she has taught at the RCA and was appointed Royal Academician in 1979.

**Selected Exhibitions**
1951–60 Gimpel Fils, London
1957 Saidenberg Gallery, New York
1967–79 The New Art Centre, London
1979 & 1994 Royal Academy of Arts, London
1991 Francis Graham-Dixon Gallery, London

**41** *Composition*
signed and dated 1957
seriagraph A/P 49.5 × 70.5 cm
presented by John Coplans 1958

**42** *Drawing No 21*
signed
mixed media 18 × 14 cm
purchased

## David Bomberg
b.1890 Birmingham
d.1957 London

Bomberg's early childhood was spent in
London's East End. Prior to his two
years at the Slade, 1911–13, he attended
evening classes, practising drawing at the
British Museum during the day. He
travelled frequently in Europe and spent
four years in Jerusalem. In 1947,
together with his wife, the painter, Lilian
Holt (*q.v.*), he founded the 'Borough
Group', a teaching community; in 1954
he settled in Spain.

**Selected Exhibitions**
1928 Leicester Galleries, London
1958 Arts Council Gallery, London
1967 Tate Gallery, London
1971 Reading Museum and Art Gallery
  (with Lilian Holt)
1979 Whitechapel Art Gallery, London
1981 Anthony d'Offay, London
  Ben Uri Art Society, London
  (with his family)
1984 Israel Museum, Jerusalem and Ben Uri
  Art Society, London
1985 & 1987 Fischer Fine Art, London
1988 Tate Gallery, London
  Museo de Arte Contemporaneo, Seville
  Yale Center for British Art
1990 Bernard Jacobson Gallery, London
1991 City Museum and Art Gallery,
  Plymouth

**Selected Bibliography**
William Lipke. *David Bomberg: A Critical
Study of his Life and Work*, London 1967
Richard Cork. *David Bomberg*, London 1987

**43** *At the Window*
signed and dated 1919
oil on canvas 75 × 49 cm
purchased
Exhibited:
City Museum and Art Gallery Plymouth
1991, cat.83

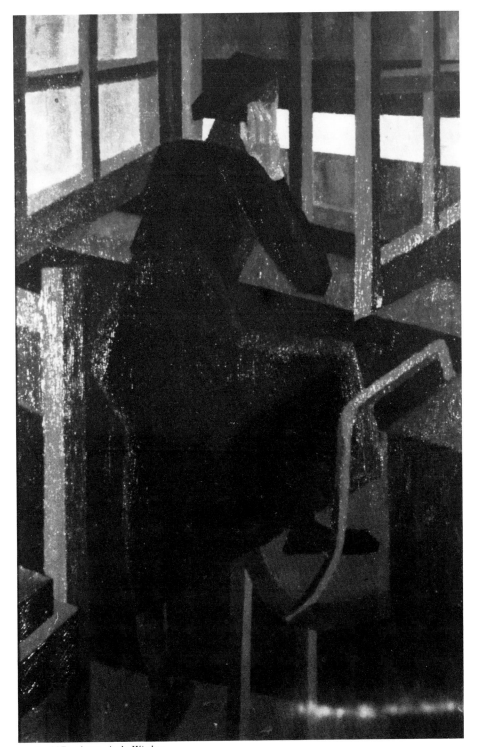

43 David Bomberg *At the Window*

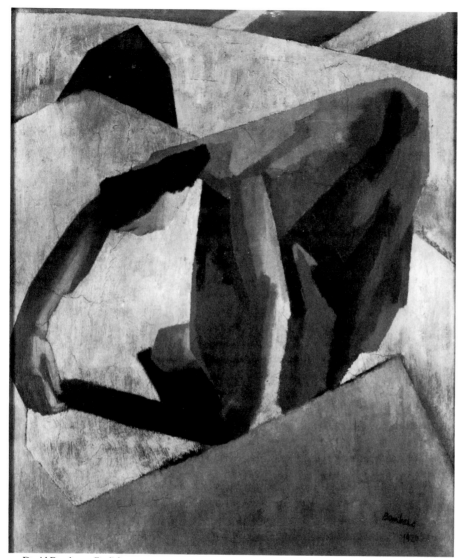

45 David Bomberg *Englishwoman*

**David Bomberg** (continued)

**44** *The Broken Aqueduct, Wadi Kelt near Jericho*
signed and dated 1926
oil on canvas 51.5 × 41.5 cm
purchased 1954
Exhibited:
Leicester Galleries, 'David Bomberg', London 1928, no.33
City Museum and Art Gallery, Plymouth 1991, cat.88

**45** *Englishwoman*
signed and dated 1920
(signed again and inscribed verso)
oil on canvas 59.5 × 49.5 cm
Provenance: 1920 collection of Louis Golding sold to H. Rose 1959
presented by Mr and Mrs H. Rose 1960
Exhibited:
Herbert Art Gallery, Coventry 1960, no.18

Tate Gallery, London and tour 1988, cat.70
Barbican Art Gallery, London 1990, cat.78
City Museum and Art Gallery, Plymouth 1991, cat.86
ILLUSTRATION ON BACK COVER

**46** *Ghetto Theatre*
signed and dated 1920
oil on canvas 75 × 62.5 cm
purchased 1920
Exhibited:
Whitechapel Gallery, London 1927
Heffer Gallery, Cambridge 1954
Tate Gallery, London 1967
The Jewish Museum, New York 1975
Royal Academy, London 1978
Camden Arts Centre, London 1985
Art Historians Conference, Brighton 1986
Royal Academy, London 1987
Staatsgalerie, Stuttgart 1987
Tate Gallery and tour 1988, cat.71
Barbican Art Gallery 1990, cat.79
City Museum and Art Gallery, Plymouth 1991, cat.85
Leeds University Art Gallery 1992, cat.71

**47** *Mt Zion with the Church of the Dormition: Moonlight*
signed and dated 1923
oil on canvas 40.5 × 50.5 cm
purchased 1928
Exhibited:
Leicester Galleries, 'David Bomberg', London 1928, no.39
Jewish Art Exhibition, Cape Town 1951, no.5
Heffer Gallery, Cambridge 1954, no.8
Arts Council, London 1958, no.13
Tate Gallery, London 1967, no.41
Tate Gallery and tour 1988, cat.81
Barbican Art Gallery 1990, cat.11
City Museum and Art Gallery, Plymouth 1991, cat.87

**48** *The Studio*
signed and dated 1919
oil on canvas 75 × 50 cm
purchased 1920
Exhibited:
City Museum and Art Gallery, Plymouth 1991, cat.80

49 David Bomberg *Ghetto Theatre ; study*

**49** *Ghetto Theatre ; study*
signed
thinned oil and pencil on paper  31 × 41 cm
presented by Lilian Holt 1959
Exhibited:
City Museum and Art Gallery, Plymouth
1991, cat.84

50 Jacob Bornfriend *Blue Grey Fishes*

## Jacob Bornfriend

b.1904 Zborov, Czechoslovakia
d.1976 London

Studied at the Academy of Fine Arts,
Prague; he left Czechoslovakia for
England in 1939 leaving much of his
work behind. During World War II he
worked as a diamond-cutter and taught
Czech art students. He travelled in
Europe and visited Israel in 1967.

**Selected Exhibitions**
1963  Gummesons Konstgallerie, Stockholm
1974  Ben Uri Art Society, London
     (with Alfred Harris)
1980  Bedford Way Gallery
1984  Kunstmuseum, Bochum,
     West Germany

50  *Blue Grey Fishes*
    signed and dated 1960
    oil on canvas  62 × 50 cm
    presented by Alexander Margulies 1987

51  *Composition*
    signed and dated 1961
    oil on canvas  50 × 60.5 cm
    bequest of Dr Robert Spira

52  *Composition*
    signed and dated 1965
    gouache  25 × 33 cm
    bequest of Dr Robert Spira

53  *Jewish Festivals*
    signed and dated 1957
    portfolio of mixed media prints
    5/250  36 × 27 cm
    set of 6 lithographs and two cover
    lithographs in portfolio
    presented by the artist

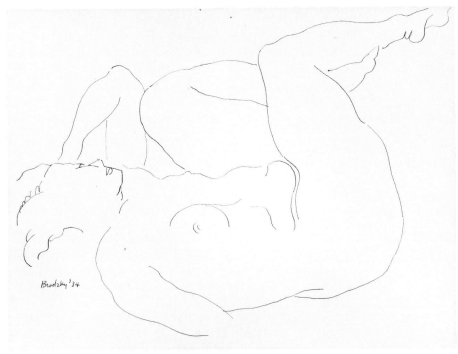

54 Horace Brodzky *Nude*

## Horace Brodzky
b.1885 Melbourne, Australia
d.1969 London

Studied in Melbourne and arrived in
London in 1908 where he continued his
studies at City and Guilds Art School.
He spent eight years in New York,
1915–23. He was also a writer, producing
monographs on Gaudier-Brzeska and
Jules Pascin.

**Selected Exhibitions**
1965  Ben Uri Art Society, London
1973  Fieldborne Galleries, London
1974  Parkin Gallery, London
1989  Boundary Gallery, London

**Selected Bibliography**
James Laver. *40 Drawings by Horace
Brodzky*, London 1935

54 *Nude*
signed and dated 1934
pen and ink  27 × 36 cm
purchased

## Stanislau Brunstein
b.1914 Warsaw
lives in London

Studied in Warsaw and Paris and
worked as a cartoonist and as a scenic
designer for the Jewish Theatre in
Warsaw. He was imprisoned by the
Russians in 1940 and later served in the
Polish Army. After World War II he
spent a year in Rome. He arrived in
England in 1946.

**Selected Exhibitions**
1984  Ben Uri Art Society, London

55 *Blowing the Shofar*
signed and dated 1983
watercolour  13.5 × 19.5 cm
presented by the artist 1983

## Trude Bunzl
b.1904 Austria
d.1982 London

Studied medicine and music in Vienna
before emigrating to England in 1938
where she took up sculpture and entered
the Chelsea School of Art to study under
Bernard Meadows. She later attended
St Martin's. Her sculptures have been
exhibited in London, the provinces and
in Vienna.

56 *Moses*
bronze  height: 73 cm
presented by Ruth Reidl

## David Camrass
b.1939 London
lives in London

Emigrated to Israel in 1949 where he
studied at the Technical School,
Jerusalem. In 1962 he returned to the
United Kingdom to work with Benno
Schotz in Glasgow, and settled in
London in 1966.

**Selected Exhibitions**
1964  Royal Glasgow Institute of Fine Art
1965  New Charing Cross Gallery, Glasgow

57 *Torso*
welded steel  height: 76.2 cm
presented by Mrs Neville Blond

## Carliss

58 *Venetian Byway*
signed and inscribed
etching  22.5 × 18 cm
purchased 1935

## Moshe Elazar Castel

b.1909 Jerusalem
d.1991 Jerusalem

Son of a rabbi, who was also an artist, Castel studied at Bezalel 1922–25 and at the Académie Julien, Paris, where he lived from 1927–36, before settling in Safed. He moved to Tel Aviv in 1948, but travelled frequently to New York and Paris where he had studios. A museum for his work is being set up near Jerusalem.

**Selected Exhibitions**
1942–73 Tel Aviv Museum of Art
1952 Feigl Gallery, New York
1963 & 1965 Galerie Flinker, Paris
1966 Lefevre Gallery, New York

**Selected Bibliography**
Howard Morley Sachar. *Castel*, Neuchâtel, Switzerland 1968

59 *Father and Son*
signed and dated 1928
oil on canvas 80 × 64 cm
purchased

60 *Oriental Jew*
signed and dated 1926
oil on canvas 64 × 50 cm
purchased

61 *Portrait of a Girl*
signed (verso: signed again)
oil on canvas 81.5 × 59.5 cm
purchased

62 *Two Jews*
signed and dated 1926
oil on canvas 62.5 × 50 cm
purchased

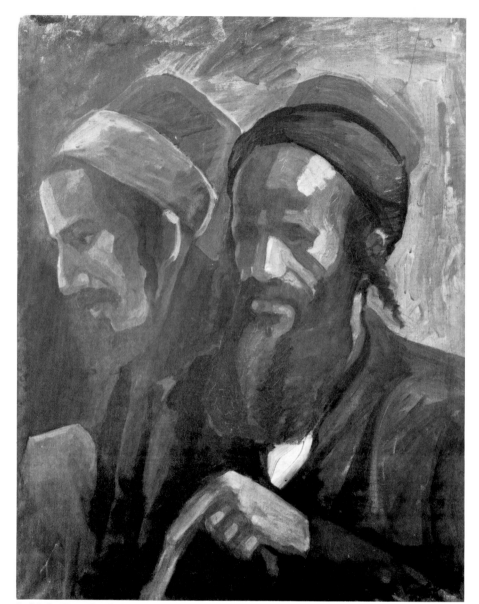

62 Moshe Elazar Castel *Two Jews*

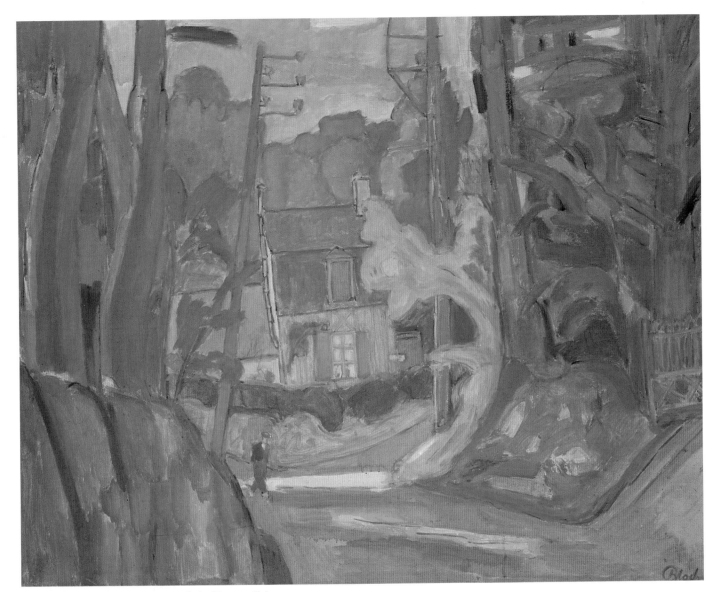

PLATE 1  Martin Bloch  *House in Normandy (or Vavangeville)* cat.37

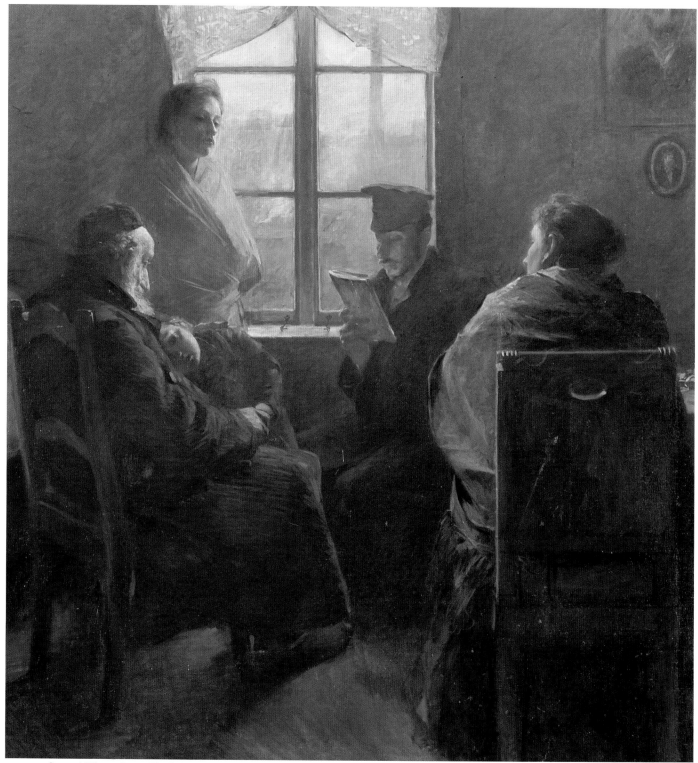

PLATE II  Samuel Hirszenberg  *The Sabbath Rest* (detail)  cat.148

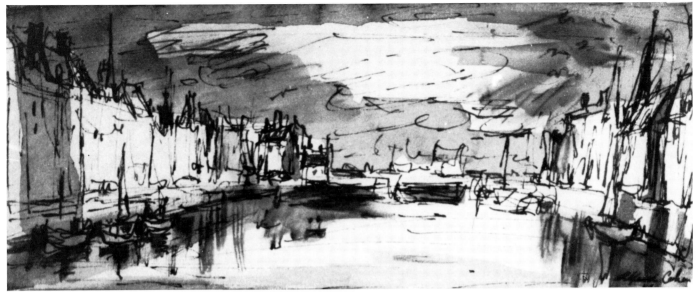

65 Alfred Cohen *Harbour Scene*

## Marc Chagall

b.1887 Vitebsk, Russia
d.1985 Vence, France

Studied privately and at the Imperial
School for the Protection of Arts,
St Petersburg. After some years
travelling in Europe, he returned to
Russia and founded the Vitebsk
Academy. Later he lived in Moscow,
then Berlin and Paris, visited Palestine in
1931 and spent the war years in New
York. On his return to Europe he settled
in Vence, Southern France.

**Selected Exhibitions**
1932 Stedelijk Museum, Amsterdam
1946 Museum of Modern Art, New York
    and Art Institute, Chicago
1959 Haus der Kunst, Munich
1969 Grand Palais, Paris
1978 Palazzo Pitti, Florence
1985 Royal Academy of Arts, London

**Selected Bibliography**
Michael Ayrton. *Chagall*, London 1950
Lionello Venturi. *Chagall: A Biographical
and Critical Study*, Geneva 1956
Marc Chagall. *Marc Chagall: My Life*,
Paris 1957
Horst Keller. *Marc Chagall: Life and Work*,
New York 1978
Charles Sorlier (ed.). *Chagall*, London 1979
Susan Compton (ed.). *Chagall*, London 1985

63 *Le Cheval et L'Âne*
signed *c.*1927
etching on Montval paper 69/100
42 × 33.5 cm

Plate 69 from the set of 100 etchings to
illustrate *Les Fables* by La Fontaine,
Ambroise Vollard, Paris, 1927.
Unpublished by Vollard. Published by
Tériade, Paris 1952. One of the edition
of 100 on this size paper.
presented by Ralph N. Emanuel 1987

## Joseph Chaplin

b.1914 Russia
lives in Israel

Studied at the Ecole des Beaux-Arts,
Paris, and emigrated to Palestine in 1934.
Lives on Kibbutz Massada

**Selected Exhibitions**
1969 Uri & Rami Gallery, Ashdod
1978 Kibbutz Painting & Sculpture Gallery,
    Tel Aviv

64 *Mother and Child*
signed and dated 1962/3
oil on canvas 64.5 × 48 cm

## Alfred Cohen

b.1920 Chicago
lives in Norfolk

Studied at the Art Institute, Chicago and
travelled in Europe, attending the
Académie La Grande Chaumière, Paris
in 1949. In 1953 he returned to Paris
where he lived for seven years. He
settled in England in 1960 living first in
Kent, later moving to Norfolk.

**Selected Exhibitions**
1958 Galerie René Drouet, Paris
1959 Ben Uri Art Society, London
1964 Galerie Dresdenère, Montreal
1981 HTS Gallery, Tokyo
1985 Arts Council Gallery, Belfast
1986 Solomon Gallery, London

65 *Harbour Scene*
signed and dated 1957
brush and grey wash 12.5 × 28.5 cm
presented by the artist

## Bernard Cohen

b.1933 London
lives in London

Studied at South West Essex Technical
College 1949–50, St Martin's 1950–51
and at the Slade 1951–54. He taught
painting at the Slade from 1967, accepting
a full-time appointment in 1969. From
1980–87 he was Head of Painting at
Wimbledon School of Art, and in 1988
was appointed Slade Professor and
Director of the Slade School.

**Selected Exhibitions**
1958 & 1960 Gimpel Fils, London
1962 Molton Gallery, London
1963, 1964 & 1967 Kasmin Gallery, London
1972 Hayward Gallery, London
1973 Galleria Annunciata, Milan
1974 & 1990 Waddington Galleries, London
1976 Tate Gallery, London

**66** *Untitled 1959*
signed and dated 1959
mixed media on paper 55 × 74 cm
presented by
Mr and Mrs Michael S. Josephs 1987

66 Bernard Cohen *Untitled 1959*

## Ruth Collet

b.Barley, Hertfordshire
lives in London

Studied at the Slade under Henry Tonks
and Wilson Steer, 1927–30; also studied
etching with William Hayter in Paris
where she spent three years, 1932–35.

**Selected Exhibitions**
1950 Ben Uri Art Society, London
 (with Julius Rosenbaum and Adèle
 Reifenberg)
1978 Ben Uri Art Society, London
 (with Lotti Reizenstein and Frances
 Baruch)
1982 Annexe Gallery, Wimbledon, London
1984 George Large Gallery, Redbourne,
 Hertfordshire
1987 Sue Rankin Gallery, London

**67** *Pear Tree After Picking*
oil on canvas 91 × 64 cm
presented by the artist 1950

**68** *Roofs*
signed
oil on canvas 60.5 × 50.5 cm
presented anonymously

70 C.W. *Travemünde (By the Sea)*

**69** *Veuillée, France*
dated 1982
watercolour 40.5 × 28 cm
presented by the artist

**C.W.**

**70** *Travemünde (By the Sea)*
signed (with monogram) and dated 1883
oil on canvas  21 × 29 cm
presented by W. L. Goldstein

## Arnold Daghani

b.1909 Suczawa, Rumania
d.1985 Hove, Sussex

Daghani had little formal training, but
attended art classes in Munich in the
1920s. A Holocaust survivor, he
emigrated to Israel in 1958 but left for
France after one year and settled in
Vence. In 1970 he moved to
Switzerland. He arrived in England in
1977 and settled in Hove where he lived
until his death. He has exhibited in
Rumania, Israel and France.

**Selected Exhibitions**
1984  Brighton Polytechnic, Sussex
1992  Barbican Centre and Ben Uri Art
        Society, London

**Selected Bibliography**
Julian Freeman and Lucille Smith. *Arnold
Daghani: A Relentless Spirit in Art 1944–84.*
Exhibition Catalogue, Brighton, Sussex 1984
Monica Bohm-Duchem. *Arnold Daghani,*
Diptych, London 1987

**71** *Love*
signed
series of 10 lithographs, 61/150
various sizes
presented by Carola Grindea 1986

## Helena Darmesteter

b.*c.*1850 London
d.after 1912 France?

Helena Darmesteter must have gone to
Paris as a student, for she trained there
with Gustave Courtois. She became an
established portrait painter exhibiting in
the Salons and in the Universal
Exhibition in Paris in 1900. She was a
member of the Société des Artistes
Français and of the Société Nationale.
Her paintings were exhibited at the
Royal Academy Summer Exhibitions in
1907 and 1908.

**72** *Reflection in a Mirror*
signed
oil on canvas  90 × 60 cm
presented by Sir Phillip Hartog 1942

72 Helena Darmesteter *Reflection in a Mirror*

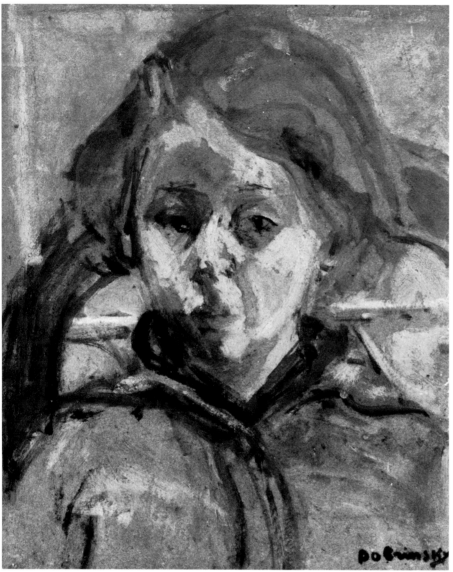

74 Isaac Dobrinsky *Head of a Girl*

## Ernst Degasperi

b.1927 Merano, Italy
lives in Vienna

At the age of twelve moved with his family to Nuremberg; settled in Vienna in 1942. He studied at the Academy of Applied Arts, Vienna, 1948–52, and has travelled extensively in Europe and the Far East including frequent visits to Israel.

**Selected Exhibitions**
1968  Ausstellungsräume, Munich
1969  International Culture Centre for Youth, Jerusalem
1970  Palais Palffy, Grillparzersaal, Vienna
        Arab Jewish Cultural Centre, Haifa
1972  The Crypt, St John's Church, Smith Square, London
1979  Ben Uri Art Society, London

73  *Tror —a Mythical Creature*
signed and dated 1978
etching 16/70  29 × 40.5 cm
presented by the artist 1979

## Isaac Dobrinsky

b.1891 Vilna, Lithuania
d.1973 Paris

Dobrinsky began his artistic life in Kiev as a sculptor and settled in Paris in 1912. He was in hiding in Southern France during World War II returning to the capital in 1945.

**Selected Exhibitions**
*c.*1952  Renel Gallery, London
        (with Maurice Blond and Pinchus Kremègne)
1975  Galerie Passali, Paris

74  *Head of a Girl*
signed
gouache on canvas  33 × 27 cm
presented by Mrs Goldstein 1945

75 Enid Dreyfus *Welsh Chapel*

77 Amy Drucker *The Village of Dor, Palestine*

## Enid Dreyfus

b.1906 London
d.1972

Enid Dreyfus (née Abrahams) studied at the RA Schools where she later had her work exhibited. The Leicester Galleries, London also showed her paintings.

75 *Welsh Chapel*
signed and dated 1928
pastel 37.5 × 31 cm
(verso: *Two Sleeping Soldiers*
brown wash)
presented by Alice Schwab 1986

## Amy Drucker

b.1873 London
d.1951

After studying in Lambeth, Amy Drucker had a studio in Bloomsbury. She travelled extensively in the Far East, South America and in Abyssinia and in 1920 spent some months in Palestine.

COLOUR PLATE III

76 *For He had Great Possessions*
signed and dated 1932
oil on canvas 49 × 60 cm
presented by Dr Geoffrey Konstam 1952

77 *The Village of Dor, Palestine*
signed
mixed media 18.5 × 28.5 cm
bequeathed to the Society

78 *Old Man*
lithograph 44.5 × 30.5 cm
bequeathed to the Society

79 *Portrait of a Man with a White Neckscarf*
signed
lithograph 45.5 × 32.5 cm
bequeathed to the Society

## Benno Elkan OBE

b.1877 Dortmund, Germany
d.1960 London

Elkan studied languages in Lausanne before embarking on his art studies in Munich and Karlsruhe, 1898–1902. He had no formal training in sculpture. He was in Paris and Rome until 1911 when he returned to Germany, living first in Alsbach and later in Frankfurt a/M until 1933 when he emigrated to England. He travelled in the United States in 1947 and 1951 and made two visits to Germany in the 1950s. He was awarded the Order of the British Empire in 1957. One of his major works is the candelabrum outside the Knesset in Jerusalem.

**Selected Exhibitions**
1936 Knoedler Gallery, London
1950 Wildenstein and Company, London
1956 Tate Gallery, London
1968 Nationalgalerie, Berlin
1977 Wallraf-Richartz Museum, Cologne

**Selected Bibliography**
Hans Menzel-Severing. *Der Bildhauer Benno Elkan*, Dortmund 1980

80 *Chief Rabbi Dr J. H. Hertz*
dated 1933
bronze height: 43.18 cm
on permanent loan from Rabbi
Dr Solomon Schonfeld

85 Henri Epstein *Forest of Rambouillet*

## Frank Lewis Emanuel

b.1865 London
d.1948 London

Frank Emanuel studied at the Slade and
at the Académie Julien in Paris. He
travelled in Europe, South Africa and
Ceylon and, on his return to London,
became Instructor of Etching at the
Central School. In 1920 he co-founded
the Society of Graphic Artists, with
whom he exhibited on numerous
occasions.

81 *Wharves*
etching 30.5 × 26.5 cm
presented by Alfred Wolmark 1946

## English School

82 *Portrait of Lord Balfour*
oil on canvas 70 × 55 cm
presented by Alexander Margulies

83 *Figure*
bronze height: 59.69 cm

84 *Industry and Agriculture*
clay relief 69.85 × 52 cm

## Henri Epstein

b.1891 Lodz, Poland
d.1944 (in concentration camp)

After studying in Munich, Epstein
settled in Paris in 1912 where he lived
until deported in 1944. An exhibition of
his work was held in Paris in 1946.

### Selected Bibliography
Waldemar George. *Henri Epstein*, Paris 1932

85 *Forest of Rambouillet*
signed
oil on canvas 52 × 72 cm
purchased

## Sir Jacob Epstein

b.1880 New York
d.1959 London

Son of Russian/Polish parents, Epstein
spent his childhood on the Lower East
Side of New York. Besides sculpture, his
evening studies included painting and
drawing and his days were spent working
in a bronze foundry. He studied further
in Paris and settled in London in 1905.
He was knighted in 1954.

### Selected Exhibitions
1952 & 1961 Tate Gallery, London
1959 & 1980 Ben Uri Art Society, London
1976–7 Smithsonian Institution,
        Washington, D.C.
1987 Leeds City Art Gallery and
      Whitechapel Art Gallery, London

### Selected Bibliography
*Epstein: An Autobiography*, London 1955
Robert Black. *The Art of Jacob Epstein*,
New York 1942
Geoffrey Ireland. *Epstein: A Camera Study
of the Sculptor at Work*, London 1950
Richard Buckle. *Jacob Epstein*, London 1963
Evelyn Silber. *The Sculpture of Epstein*,
Oxford 1986

86 *Alexander Margulies*
bronze height: 44.45 cm
(excluding marble base)
presented by Alexander Margulies
See: R. Buckle. *Jacob Epstein*, London
1963, p.274, no.420

87 *Edouard Good (Mosheh Oved)*
bronze height: 40.64 cm
presented by Mosheh Oved 1946
See: R. Buckle. *Jacob Epstein*, London
1963, p.151, no.230
Exhibited:
Camden Arts Centre, London 1985
Barbican Art Gallery, London 1990
cat.141

88 *Lydia*
bronze height: 51 cm
bequest of Ethel Solomon

89 *Professor Samuel Alexander* O.M.
bronze height: 53.5 cm
presented by Mosheh Oved 1946
See: R. Buckle. *Jacob Epstein*, London
1963, p.142, no.217

86  Sir Jacob Epstein  *Alexander Margulies*

**Sir Jacob Epstein** (continued)

90  *Shulamite Woman (Arab Girl)* 1935
bronze  height: 53.35 cm
presented by Mosheh Oved 1947

# Erno Erb

b.1878 Lemberg
d.1943

A painter of Jewish genre scenes who
perished in the Holocaust.

**Selected Bibliography**
*Almanach Zydowski*, Lemberg 1937

91  *The Rabbi*
signed
oil on panel  33 × 47 cm
purchased

# Hermann Fechenbach

b.1897 Wurttemberg, Germany
d.1986 Denham, Buckinghamshire

Fechenbach was severely wounded,
losing a leg, in World War I. He studied
in Stuttgart, Munich and Florence
before settling in Stuttgart in 1925. He
emigrated to England in 1939, spending
the last years of his life in
Buckinghamshire. Fechenbach produced
a number of books, including an
illustrated Book of Genesis and a history
of the Jewish community in his home
town, Bad Mergentheim.

**Selected Exhibitions**
1942  Oxford
1944 & 1948  Anglo-Palestine Club, London
1945 & 1947  Ben Uri Art Society, London
1985  Blond Fine Art, London

**Selected Bibliography**
Hermann Fechenbach. *Die Letzen
Mergentheimer Juden*, Stuttgart 1972

92  *Portrait of Lillie Adler*
signed
oil on board  50 × 41 cm
presented by Lillie Adler

92a  *Lenin*
signed and dated 1943
woodcut  22 × 16 cm
presented by Alfred Wolmark 1948

91  Erno Erb  *The Rabbi*

93  Hans Feibusch  *The Dance*

## Hans Feibusch

b.1898 Frankfurt
lives in London

Studied medicine in Munich before
settling in Berlin in 1920 where he began
his art studies. He studied and travelled
in Italy and France emigrating to
England in 1933. He has worked on
book-jackets and poster designs,
illustrated books and church murals. In
the 1970s he took up sculpture because
of his failing eyesight.

**Selected Exhibitions**
1934 Lefevre Gallery, London
1970 Ben Uri Art Society, London
1978 Galerie Haas, West Berlin
        Holland Park Gallery, London

93  *The Dance*
    gouache  48.5 × 75 cm
    on permanent loan

## Frederick (Friedrich) Feigl

b.1884 Prague
d.1965 London

Studied briefly at the Academy of Arts,
Prague, at the Antwerp Academy, 1904–
05, and in Paris. He was in Hamburg in
1910 and spent a year in Palestine in
1932. In 1933 he returned to
Czechoslovakia, but left for England in
1939 and settled in London.

**Selected Exhibitions**
1912 J. B. Neumann Graphisches Kabinett,
        Berlin
1934 Galerie Hugo Feigl, Paris
1940 Wertheim Gallery, London
1944 Czechoslovak Institute, London
1959 & 1964 Ben Uri Art Society, London

94  *Near Richmond*
    signed
    oil on canvas  61 × 80 cm
    purchased 1950

95  *The Restaurant*
    signed
    gouache  35.5 × 50 cm
    purchased

94  Frederick Feigl  *Near Richmond*

95  Frederick Feigl  *The Restaurant*

## Sylvia Feldman

Worked in London, was shown in a mixed exhibition at the Ben Uri Art Society.

**96** *Flowerpiece*
signed
oil on canvas  53 × 41.5 cm
presented by the artist 1949

## Sylvia Finzi

b.1948 London
lives in London

After graduating from the Slade, Sylvia Finzi moved to West Germany where she spent nine years. Since 1977 she has been visiting lecturer at the Volkshochschule, Munich and, after her return to London in 1979, taught drawing at Heatherley School of Art. In 1983 she was visiting artist at Westfield College, University of London.

### Selected Exhibitions
1977  Bibliothèque Municipale, Chartres
1979  Goethe Institute, Paris
1980  Westfield College, London
1984  Morley College, London
1985  Ben Uri Art Society, London
    (with Agathe Sorel)
1986–7  Kellergalerie im Schaezlerpalais,
    Augsburg, West Germany

**97** *Untitled*
signed and dated 1984
etching and aquatint 1/40  30 × 15 cm
purchased 1985

## Zena Flax

b.1930 London
lives in London

Studied at Chelsea School of Art, 1949–53 concentrating on illustration; from 1960 she also attended etching classes, continuing her studies at the Central School, 1953–55. For some time she has worked as a graphic designer and has been a member of Printers Inc. Workshop since 1968.

### Selected Exhibitions
1990  Ben Uri Art Society, London (with
    members of Printers Inc. Workshop)
1991  Sternberg Centre for Judaism, London

99  Charles Fliess  *Cambridge, View from Fen Causeway*

**98** *Forest*
signed
lithograph 3/30  44.5 × 29.5 cm
presented by the artist

## Charles Fliess

b.1899 Germany
d.1956

Fliess came to England in 1939. An exhibition of his work was shown at Derby Art Gallery in 1954.

**99** *Cambridge, View from Fen Causeway*
signed and dated 1953
oil on canvas  51 × 66 cm
presented by Dr Robert Fliess

**100** *Portrait of a Woman*
signed and dated 1949
oil on canvas  51 × 35 cm
presented by Dr Robert Fliess

**101** *Three Studies*
pencil, brown and black
chalk 39 × 30.5 cm
presented by Dr Robert Fliess

100  Charles Fliess  *Portrait of a Woman*

102 Else Fraenkel
*Head of the Haham Dr Moses Gaster*

## Else Fraenkel FRSA

b.1892
d.1975

Fraenkel was elected Fellow of the Royal Society of Arts in 1954. She showed at the Royal Academy Summer Exhibition in 1936 and 1941–43.

102  *Head of the Haham Dr Moses Gaster*
signed and dated 1936
bronze with silver patina  height: 37 cm
purchased 1947

101 Charles Fliess *Three Studies*

103 Eva Frankfurther *Portrait of a Woman*

# Eva Frankfurther

b.1930 Berlin
d.1959 London

Arrived in England with her family in 1939 and studied at St Martin's, 1947–52. She moved to the East End of London where she lived and worked. She was teaching social work at the London School of Economics when she took her own life in 1959.

**Selected Exhibitions**
1962 Ben Uri Art Society, London

**Selected Bibliography**
Eva Frankfurther. *People* (introduction by Mervyn Levy), London, n.d.

103 *Portrait of a Woman*
oil on paper  71 × 55.5 cm
presented by
Mr and Mrs P. Frankfurther

104 Michèle Franklin *Banished*

## Michèle Franklin

b.1958 Putney, Vermont
lives in London

Michèle Franklin's family settled in England in 1966 and she studied at Camberwell School of Art, London and etching in Venice. She won First Prize for Oil Painting at the Mall Galleries in 1983 and has been involved with specialised teaching in the arts with the London Borough of Camden.

**Selected Exhibitions**
1982 Peter Potter Gallery, Edinburgh
1984 Wapping Wall Studios, London
      Assisi, Italy
1986 Ben Uri Art Society, London
      (with Simon Black, Cheryl Aaron and
      Ernst Gottschalk)
      Charterhouse School, Godalming,
      Surrey
1987 The Zanzibar, Covent Garden, London
      Holland Park Gallery, London

**104** *Banished*
signed and dated 1985
watercolour 65 × 47 cm
purchased with the assistance of
Alexander Margulies 1985

## Barnett Freedman CBE RDI

b.1901 London
d.1958 London

Born in London's East End, Freedman was the son of Russian immigrants. After attending evening classes at St Martin's he gained a scholarship to the RCA where he studied from 1922–25. His early work for the Curwen Gallery and Baynard Press involved designing posters, book-jackets and cards and he went on to illustrate numerous books. During World War II he was appointed Official War Artist for the Royal Air Force and later for the Admiralty. He taught at the Ruskin School of Drawing, Oxford and at the RCA. He was awarded the CBE in 1946 and in 1949 was elected Royal Designer for Industry.

**Selected Exhibitions**
1958 Arts Council Gallery, London
1984 Gillian Jason Gallery, London

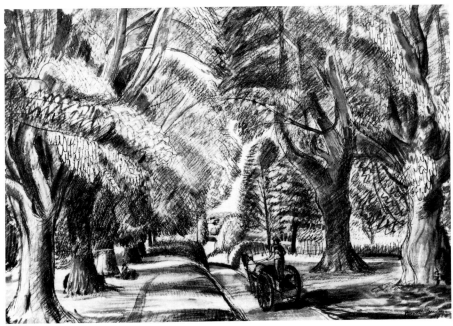

105 Barnett Freedman *Country Lane*

**Selected Bibliography**
Jonathan Mayne. *Barnett Freedman*, London 1948

**105** *Country Lane*
signed and dated 1926
pen and wash 39 × 50.5 cm
presented by Mary Cohen 1948

## Naum Gabo

b.1890 Briansk, Russia
d.1977 Middlebury, Connecticut

Naum Neemia Pevsner adopted the name Gabo in 1915. He studied medicine and engineering in Munich, 1910–12 and also attended history of art lectures. During World War I he was in Scandinavia and returned to Russia in 1917. He settled in Berlin in 1922, but left Germany for Paris ten years later. He moved to England in 1935 and finally emigrated to the United States in 1946. He was appointed Professor at Harvard University Graduate School of Architecture.

**Selected Exhibitions**
1926 Little Review Gallery, New York
      (with Antoine Pevsner and
      Theo van Doesberg)
1938 Wadsworth Atheneum, Hartford,
      Connecticut
1948 Museum of Modern Art, New York
      (with Antoine Pevsner)
1965 Stedelijk Museum, Amsterdam
1966 Tate Gallery, London
1971 Musée de Peinture et de Sculpture,
      Grenoble
      Musée National d'Art Moderne, Paris
      and Nationalgalerie, Berlin
1976 Tate Gallery, London
1986–7 Dallas Museum of Art, Texas
1987 Annely Juda Fine Art, London
      Tate Gallery, London

**Selected Bibliography**
Alexei Pevsner. *A Biographical Sketch of my Brothers Naum Gabo and Antoine Pevsner*, Amsterdam 1964
Steven A. Nash and Jörn Merkert. *Naum Gabo—Sixty Years of Munich Constructivism*, 1985

**106** *Blue Lithograph*
signed c.1960
lithograph (edition of 100) 45 × 31 cm
presented by Miriam Gabo 1987

## Abram Games, OBE RDI

b.1914 London
lives in London

Games received no formal training in art. He became a free-lance poster designer at the age of twenty-one, after working in a London studio. He was drafted to the War Office as first official poster designer whilst serving in the Infantry in 1941 and since 1946 he has received numerous awards for posters, emblems and stamps. He was awarded the OBE in 1957.

**Selected Exhibitions**
1946  Palais des Beaux-Arts, Brussels
1952  Ben Uri Art Society, London
1953  Museum of Modern Art, New York
1961  Visual Arts Centre Gallery, Chicago
1972  Imperial War Museum, London
1991  Camden Arts Centre, London
      Ben Uri Art Society, London

**Selected Bibliography**
Abram Games. *Over My Shoulder*, London 1960
Joseph Darracott and Belinda Loftus. *Second World War Posters*, London 1972
A. Games. *60 Years of Design*, Howard Gardens Gallery 1990

**107** *Design based on Jeremiah 29 12:14*
lithograph  61 × 43 cm
presented by the artist

**108** *Design for Encyclopedia Judaica No 5*
signed and dated 1969
silkscreen print A/P  32 × 44 cm
presented by the artist 1982

## Mark Gertler

b.1891 London
d.1939 London

Son of Austrian immigrant parents, Gertler spent his childhood in London's East End. He attended art classes at Regent Street Polytechnic, London and was apprenticed to a firm of stained-glass manufacturers before winning a scholarship to the Slade in 1908. He settled in Hampstead after World War I, during which he was a pacifist and was introduced to the Bloomsbury Group by

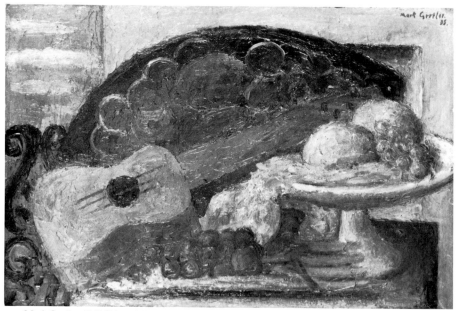

115  Mark Gertler *Still Life with Guitar*

Lady Ottoline Morrell. He suffered from tuberculosis and spent long periods in a sanatorium; eventually he took his own life.

**Selected Exhibitions**
1937  Lefevre Gallery, London
1941  Leicester Galleries, London
1944 & 1982  Ben Uri Art Society, London
1949  Whitechapel Art Gallery, London
1957  Ben Uri Art Society, London
      (with Jankel Adler and
      Bernard Meninsky)
1971  The Minories, Colchester, Essex
1982  Ben Uri Art Society, London
1991  Camden Arts Centre, London

**Selected Bibliography**
Gilbert Cannon. *Mendel* (novel based on Gertler's life), London 1916
John Woodeson. *Mark Gertler: Biography of a Painter, 1891–1939*, London 1972

COLOUR PLATE IV
**109** *Nude*
signed and dated 1938
oil on canvas  44 × 59 cm
purchased 1951

**110** *Portrait of a Girl*
(the artist's sister Sophie)
c.1907
oil on canvas  58 × 48.5 cm
on permanent loan from L. J. Morris

**111** *Portrait of a Man*
signed and dated 1921
oil on panel  41 × 32.5 cm
presented

**112** *Portrait of a Man with a Bow Tie*
oil on canvas  42.5 × 32.5 cm
presented

**113** *Still Life*
signed and dated 1911
oil on canvas  47.5 × 40 cm
on permanent loan from L. J. Morris

**114** *Still Life with a Bottle of Benedictine*
signed and dated 1908
oil on canvas  39.5 × 47 cm
on permanent loan from L. J. Morris

**115** *Still Life with Guitar*
signed and dated 1935
oil on panel  34 × 51.5 cm
purchased 1937

## Rodney Gladwell

b.1934 Didcot, Berkshire

Gladwell studied in Paris at the
Académie Callarossi.

**Selected Exhibitions**
1962 & 1963 University of Sussex, Falmer
1964 & 1965 Molton Gallery, London
1967 Lefevre Gallery, London
1967–71 Galerie Pallette, Zurich
1971 Archer Gallery, London
1974 J. P. Lehmans Gallery, London

**16** *Frieze*
signed and dated 1966 (verso)
oil on canvas 50 × 76 cm
bequest of Dr Robert Spira

**17** *Figure*
signed and dated 1965
acrylic on canvas 91 × 126.5 cm
presented by the artist's widow

## Henry (Enrico) Glicenstein

b.1870 Toureck, Polish/Russian border
d.1942 New York

Glicenstein studied in Munich and
Warsaw and on receipt of the Rome
Prize continued his studies in Rome. He
subsequently settled in the USA.

**Selected Exhibitions**
1905 Palais des Beaux-Arts, Paris
    (with Auguste Rodin)
1909 Galerie Cassirer, Berlin
1932 Art Institute, Chicago
1942 Metropolitan Museum, New York
1948 Petit Palais, Paris

**Selected Bibliography**
Jean Cassou. *Glicenstein: Sculptures*, Paris
1948
Alfred Werner. *Glicenstein*, Tel Aviv 1963 (in
English)

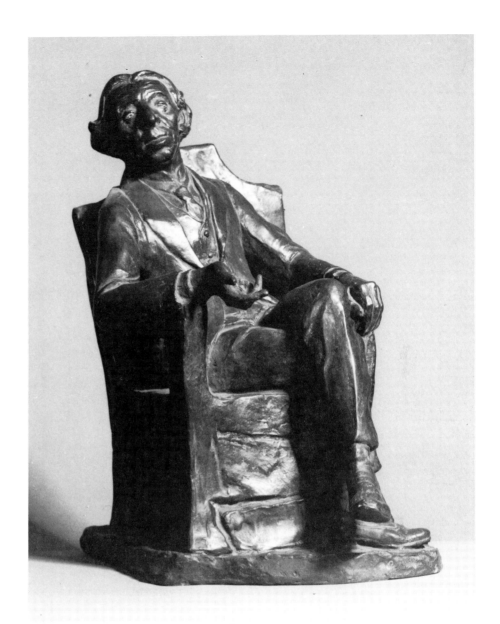

123 Henry Glicenstein *Portrait of Israel Zangwill*

**18** *The Musicians*
(Pilichowski and his teacher)
pencil drawing on grey paper 20 × 30 cm
purchased

**19** *Old Man*
signed
pen and ink 22 × 17 cm
purchased

**120** *The Vision*
signed
etching 17 × 20.5 cm
purchased

**121** *The Messiah*
bronze height: 70 cm
purchased 1921

**122** *Mrs Warburg*
Pentalicon marble & greystone
height: 70 cm
presented by Charles Warburg 1949

**123** *Portrait of Israel Zangwill*
signed and dated 1923
bronze height: 42 cm
purchased 1925

## Phyllis Gorlick King

b.1939 Syracuse, New York
lives in London

Self-taught and private study in
painting; post-graduate studies in New
York and London. Began making
woodcuts in 1974. Has exhibited widely
in group shows.

**Selected Exhibitions**
1974 Knightsbridge Gallery, London
1977 Dorland Advertising Agency

**124** *Tuscany by Train*
signed and dated 1978
acrylic on linen 85.5 × 85.5 cm

## Leopold Gottlieb

b.1883 Drohobycz, Poland
d.1934 Paris

Gottlieb studied in Cracow before
leaving Poland in the 1890s. He was, at
various times, in Munich, Vienna and
Paris and spent some months in
Jerusalem before serving in the Polish
Army during World War I. In 1926 he
settled in Paris.

**Selected Bibliography**
André Salmon. *Leopold Gottlieb*, Paris 1927

**125** *Portrait of the painter I. Hirszenberg*
signed
oil on canvas 73 × 61 cm
presented by L. Pilichowski 1930

**126** *Ecstasy*
signed
oil on canvas 33 × 30 cm
presented by L. Pilichowski 1930

125 Leopold Gottlieb *Portrait of the painter I.Hirszenberg*

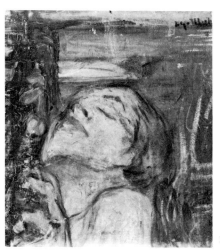

126 Leopold Gottlieb *Ecstasy*

## Leo Haas

b.1901 Opava, Czechoslovakia
d.1983 Berlin

Haas studied in Karlsruhe 1919–22, in
Berlin, and later in Austria. He returned
to work in Opava in 1926 from where he
was deported to Theresienstadt in 1939.
Many of the drawings he produced
during his time in the camps have
survived. He returned to Czechoslovakia
after the liberation and settled in Prague,
moving to East Berlin in 1955. In 1987
his work was included in an exhibition at
the Goethe Institute, Manchester.

**127** *Children on the way to Auschwitz*
signed and dated 1945/66
drypoint and aquatint 21.5 × 28 cm
presented
Exhibited:
Manchester City Art Gallery 1987

48

PLATE III  Amy Drucker  *For He had Great Possessions*  cat.76

PLATE IV  Mark Gertler *Nude* cat.109

## Stacha Halpern

b.1919 Zolkiev, Poland
d.1969 Australia

Halpern attended the School of
Commercial and Fine Art in Lvov from
1938–39 but on the invasion of Poland
he fled to Australia to join his brothers.
He settled in Melbourne and established
himself as a potter. He began to paint
seriously in 1949. In 1952 he moved to
Paris but returned to Australia in 1966

**Selected Exhibitions**
1952  Galerie Alphonse Chave, Venice
1958 & 1959  Galerie Apollinaire, Milan
1962  Galerie Birch, Copenhagen
        Galerie Blumenthal, Paris
1986  Nolan Gallery, Lanyon, Australia

**8**  *Untitled*
signed and dated 1959
oil on board   59 × 79 cm
presented by Alexander Margulies 1987

## Alfred Harris

b.1930 London
lives in London

Alfred Harris studied at the Willesden
School of Art and at the RCA. Since
1963 he has been lecturer in art
education at the Institute of Education,
London University. He was appointed
Head of Department in 1983.

**Selected Exhibitions**
1956  Ben Uri Art Society, London
        (with Renate Meyer and
        Lawrence Marcuson)
1959  Ben Uri Art Society, London
1965  Drian Gallery, London
1973  Orebro Museum, Sweden
        (with Jacob Bornfriend)
1974  Ben Uri Art Society, London
        (with Jacob Bornfriend)
1979  Bedford Way Gallery, London
1985  Royal West of England Academy,
        Bristol (with Bert Isaac and Stanislav
        Frankiel)
1990  Dixon Gallery, London

**9**  *The Wave*
oil on board   69 × 98.5 cm
presented by Miss P. Hanson in memory
of Amy Drucker 1956

128  Stachia Halpern  *Untitled*

130  Solomon Alexander Hart  *Exeter Cathedral*

## Solomon Alexander Hart RA

b.1806 Plymouth
d.1881 London

Hart studied engraving privately in
London before entering the RA Schools
in 1823. He was the first Jew to be
elected a member of the Royal Academy
in 1840 and became Professor of
Painting there in 1854. He was
appointed Librarian in 1864, a position
he held until his death.

**Selected Bibliography**
Alexander Brodie (ed). *The Reminiscences of
Solomon A. Hart*, London, n.d.

**130**  *Exeter Cathedral*
signed and dated May 1833
watercolour   24 × 16.5 cm
purchased 1982

## Franz Hecht

b.1877 Brunswick
d.London?

Trained in Munich and in Paris. Has graphics represented in the 'Ganymede Mappe' No.2

131 *Mountain Landscape*
watercolour  50 × 39 cm
presented by Alice Schwab 1987

## Joseph Hecht

b.1891 Lodz, Poland
d.1951 Paris

Hecht studied at the Academy of Fine Arts, Cracow until the outbreak of World War I. He spent the next four years in Norway and settled in Paris in 1920 where he lived until his death.

**Selected Exhibitions**
1926  Galerie Berthe Weil, Paris
1928  Wanamaker Galleries, New York
1944  Galerie Denise René, Paris
1954  Bezalel National Museum, Jerusalem
1966  Galerie Bernier, Paris
1968  Bibliothèque Municipale, Mulhouse, France
1969  Lumley Cazalet, London
1993  Robert Douwma, London

**Selected Bibliography**
Dominique Tonneau-Ryckelynk, Roland Plumart. *Joseph Hecht, Catalogue Raisonné de l'Oeuvre Gravé*, Gravelines 1992

132 *Still Life with Blue Tablecloth and Basket of Fruit*
signed and dated 1912
oil on canvas  67 × 70 cm
presented by W. L. Goldstein 1986

133 *Fawn*
signed and dated 1939
etching  5.5 × 4.5 cm
presented by W. L. Goldstein 1986

134 *Two Birds*
signed and dated 1939
etching  5.5 × 5 cm
presented by W. L. Goldstein 1986

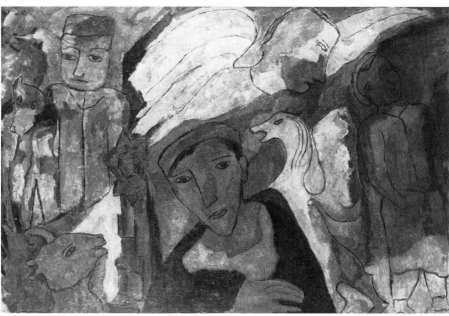

135 Martha Hekimi *La Grande Peur du Monde*

## Martha Hekimi

b.Poland

Martha Hekimi studied and worked in Paris, New York, Switzerland and Germany. In 1947 she shared an exhibition with Sophie Kormer at the Ben Uri Art Society.

135 *La Grande Peur du Monde*
signed and dated 1940–44
oil on canvas  89 × 130 cm
presented by the artist 1948

136 *Fantasies No 1–3*
signed and dated 1939–43
pen and ink on coloured paper
36 × 16 cm, 34 × 27 cm, 35 × 46.5 cm
presented

137 *La Catastrophe*
signed and dated 1944
pen and ink  41 × 30 cm
presented

138 *Le Rideau se Lève sur une Scène Angélique*
signed and dated 1944
pencil and ink  34 × 49.5 cm
presented

## Robert Helman

b.1910 Galati, Rumania
lives in Paris

Practised law before taking up painting. Settled in Paris in 1927 but fled to Barcelona in 1941 and stayed there for three years. Has had several one-man shows in Paris.

**Selected Exhibitions**
1961  XXe Siècle, Paris
1962  Galleria il Canale, Venice
1963  Galerie Hitt, Basle

**Selected Bibliography**
Philippe Soupault. *Helman*, Paris 1959
Max-Pol Fouchet. *Helman*, Paris 1975

139 *Untitled*
signed and dated 1957
oil on canvas  99 × 81 cm
presented by Alexander Margulies 1987
Exhibited:
Arts Council 1960

## Joseph Herman OBE RA

b.1911 Warsaw
lives in London

Son of a cobbler, Herman had private painting lessons and studied at the Warsaw School of Art and Decoration prior to working as a graphic designer until he left Poland in 1938. He arrived in Glasgow in 1940 and moved to London in 1943. For many years he lived and worked in a tiny Welsh village involving himself in the life-style of the miners and their families. He has travelled extensively and since 1955 has lived in London and Suffolk. He has received many major prizes and was awarded the OBE in 1981.

### Selected Exhibitions
1941 James Connell Gallery, Glasgow
1949 Ben Uri Art Society, London
      (with Martin Bloch)
1954 Geffrye Museum, London
      (with Henry Moore)
1956 Whitechapel Art Gallery, London
1969 Scottish National Gallery of Modern
      Art, Edinburgh
1975 Art Gallery and Museum, Glasgow
1980 Camden Arts Centre, London
1984 Ben Uri Art Society, London
      (with Moelwyn Merchant)

### Selected Bibliography
John Berger. *Josef Herman: A Welsh Mining Village*, Bridgewater, Somerset 1956
Basil Tyler. *Josef Herman: Drawings*, London 1956
Edwin Mullins. *Josef Herman: Paintings and Drawings*, London 1967

o *Peasant*
watercolour, pen and ink  17.5 × 22.5 cm
presented by Dr Henry Roland
Exhibited:
The Arches, Glasgow 1990

1 *Burgundian Peasants*
pen, ink and grey wash  20 × 25 cm
presented by Mrs Scott 1954
Exhibited:
The Arches, Glasgow 1990

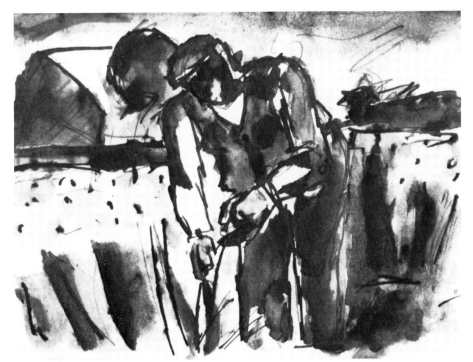

140  Josef Herman  *Peasant*

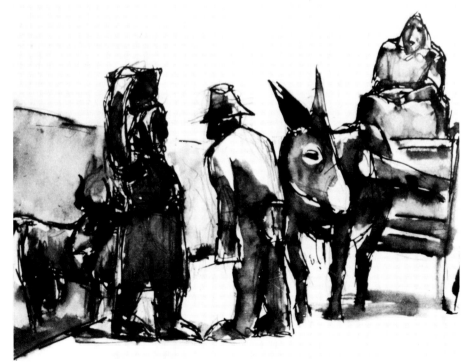

141  Josef Herman  *Burgundian Peasants*

## Walter Herz

b.1909 Czechoslovakia
d.1965 London

Herz practised as a lawyer in Czechoslovakia before emigrating to England in 1939. He worked as a commercial artist illustrating numerous books on Jewish subjects, many of them educational books for children. He also designed the Holocaust memorial for Leicester Synagogue. He was a bibliophile, donating his collection to the Hebrew University, Jerusalem.

142 *Samson*
signed and dated 1947
gouache on paper 67.5 × 83.5 cm
presented by V. V. Rosenfeld

## Alfred Herzstein

143 *Head of a Man*
oil on canvas 40 × 33 cm
presented

## George Him

b.1900 Lodz, Poland
d.1982 London

Studied briefly in Moscow before moving to Germany where he studied in Berlin, Bonn and Leipzig. He returned to Poland in 1933 and lived in Warsaw for six years before emigrating to England. In partnership with Jan Lewitt for many years, he designed posters, advertisements and exhibitions and illustrated numerous books. He taught at Leicester Polytechnic, 1969–77.

**Selected Exhibitions**
1976 London College of Printing
1978 Ben Uri Art Society, London

144 *Shikun Petach Tiqvah*
signed
watercolour 18.5 × 21.5 cm
purchased

142 Walter Herz *Samson*

144 George Him *Shikun Petach Tiqvah*

## Samuel Hirszenberg

b.1866 Lodz, Poland
d.1908 Jerusalem

Studied at the Alexander Wagner School
in Munich in 1888 and in Lodz, Cracow
and Paris from 1898–99. Settled in
Jerusalem in 1907 and taught at Bezalel
from 1907–08.

**Selected Bibliography**
B. Naphtalie. *Samuel Hirszenberg*, Berlin
1929

5 *In Brittany*
oil on canvas  44 × 57 cm
presented by L. Pilichowski 1930

6 *Landscape*
signed and dated 1895
oil on canvas  31 × 25 cm
presented by L. Pilichowski 1930

7 *Female Figure Study*
signed
oil on canvas  41 × 32.5 cm
presented

COLOUR DETAIL PLATE II
8 *The Sabbath Rest*
signed and dated 1894
oil on canvas  151 × 208 cm
purchased with the assistance of Mosheh
Oved 1923

9 *Inolodz*
signed with monogram
inscribed with title and dated (18)90
watercolour  21 × 25 cm
presented by L. Pilichowski 1930

0 *Sketch of 7 figures standing and seated*
signed
pencil drawing  24.5 × 29 cm
presented

148  Samuel Hirszenberg  *The Sabbath Rest*

149  Samuel Hirszenberg  *Inolodz*

## Lilian Holt

b.1898 London
d.1983 London

Lilian Holt studied at Putney Art School and, after serving in the Land Army during World War I, attended evening classes at Regent Street Polytechnic, London. She spent long periods in Spain with her husband, David Bomberg (q.v.). After Bomberg's death in 1957, she visited remote and rugged places in Mexico, Turkey, Spain and North Africa where she continued to draw and paint.

**Selected Exhibitions**
1971 Reading Art Gallery
(with David Bomberg)
Woodstock Gallery, London
1980 Ben Uri Art Society, London
1981 Ben Uri Art Society, London
(with Bomberg family)
1983 Gillian Jason Gallery, London

151 *Ronda in the Sun, Andalusia, Spain*
signed and dated 1955
oil on canvas 70 × 90.5 cm
presented by Dinora Davies-Rees 1983

## Shimshon Holzman

b.1907 Poland
d.1987 Tel Aviv

Holzman's family moved to Vienna and in 1922 emigrated to Palestine. He studied in Paris, 1929–34. He returned to Israel in 1936 where he lived until his death. He had two one-man shows at the Tel Aviv Museum and was twice awarded the Dizengoff Award.

152 *Synagogue Interior*
signed (in English and Hebrew)
watercolour 51 × 40 cm
presented 1983

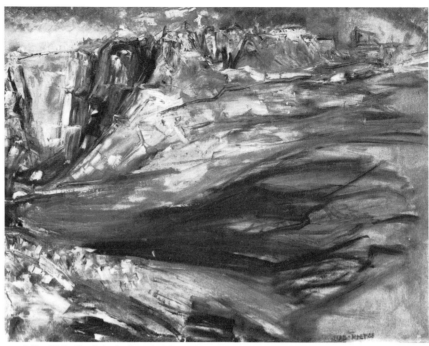

151 Lilian Holt *Ronda in the Sun, Andalusia, Spain*

## Henry Inlander

b.1925 Vienna
d.1983 London

Arrived in England in 1938 and studied at St Martin's, 1939–41 and at Camberwell and the Slade 1949–52. He was Art Advisor at the British School, Rome, 1955–56 and 1971–76. He spent two years in the United States on a fellowship and was visiting lecturer at Camberwell and visiting artist at the University of Calgary, Alberta.

**Selected Exhibitions**
1954 Galleria La Tartaruga, Rome
1955–69 Leicester Galleries, London
1961–63 Peridot Gallery, New York
1967–72 Rowland Browse and Delbanco, London
1973–84 The New Art Centre, London
1977 Stadtgalerie, Vienna

153 *Orang Utang*
signed and dated 1967
oil on canvas 82 × 118 cm
presented by the artist

154 *Composition*
watercolour and gouache 33.5 × 52.5 cm
purchased

## Jozef Israels

b.1824 Groningen, Holland
d.1911 The Hague

At the age of sixteen Jozef Israels entered the studio of Jan Adam Kruseman in Amsterdam and later attended the Academy of Fine Arts; studied in Paris, 1845–48. After many visits to Zandvoort, on the West coast of Holland, he settled there in 1863. He travelled extensively in Spain and North Africa.

**Selected Exhibitions**
1897 Goupil Gallery, London
1912 French Gallery, London
1929 Barbizon House, London
(with Johannes Bosboom, the Maris Brothers and Anton Mauve)

**Selected Bibliography**
J. Ernest Phythian. *Jozef Israels*, London 1912
C. L. Dake, *Jozef Israels*, Berlin, n.d. (in German)
Max Eisler. *Jozef Israels*, special edition of *The Studio*, London 1924

157 Jozef Israels *The Pipe Smoker*

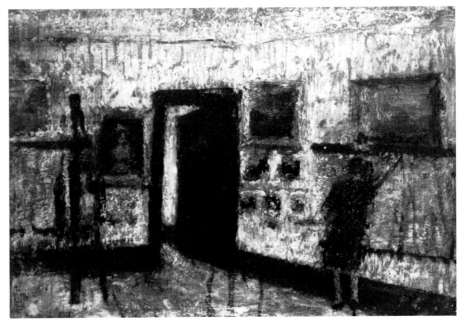

159 Lily Delissa Joseph *The Art Gallery*

155 *A Dutch Type*
signed
inscribed
etching 31 × 22 cm
presented by L. Pilichowski 1930

156 *Self Portrait*
etching 25 × 18 cm
presented 1937

157 *The Pipe Smoker*
signed
drypoint on vellum 37 × 25 cm
presented by Alfred Wolmark 1937

## Ruth Jacobson

b.1941 London
lives in London

Ruth Jacobson studied at the Slade from
1959–63, followed by a year at
Manchester University where she
obtained a teaching diploma. She moved
to Reading in 1965 and studied sculpture
at the Berkshire College of Art. From
1989–91 she studied stained glass at
Central St Martin's, at the end of which
she was awarded a fellowship. She has
travelled in Europe, the United States
and Mexico.

**Selected Exhibitions**
1972 Galerie Petit, London
1979 Crest Gallery, Totteridge
1981 Ben Uri Art Society, London (with
        Judy Bermant and Nigel Konstam)
1985 Camden Arts Centre, London
1986 Zionist Confederation House,
        Jerusalem

158 *Portrait of a Man*
signed
charcoal 51 × 38 cm
presented

## Lily Delissa Joseph

b.1863 London
d.1940 London

The sister of Solomon J. Solomon who
may well have given her the only
instruction in art she ever received. She
had a bungalow in Birchington, Kent
where she spent a great deal of time. An
early cyclist, motorist and pilot, she
travelled to Palestine by car in the 1920s.
She was deeply involved in the women's
suffrage movement, to the point of
missing one of her own exhibition
openings as she was detained in
Holloway Gaol on a charge connected
with the movement.

**Selected Exhibitions**
1924 Suffolk Street Galleries, London
        (with Mr Delissa Joseph)
1946 Ben Uri Art Society, London
        (with Solomon J. Solomon)

159 *The Art Gallery*
oil on canvas 34.5 × 48.5 cm
presented

COLOUR PLATE VI

160 *Self Portrait with Candles*
signed (with monogram)
oil on canvas 107 × 60 cm
presented by Mrs Redcliffe Salaman
1946
Exhibited:
Camden Arts Centre, London 1985
Martin Gropius Bau, Berlin 1992

161 *Teatime, Birchington*
oil on canvas 117 × 122 cm
presented by Ethel Solomon

## Erich Kahn

b.1904 Stuttgart, Germany
d.1980 London

Studied in Stuttgart, 1922–26 and in
Paris with Ferdinand Léger. After a period
in concentration camps he managed to get
to England and settled in London in
1939.

**Selected Exhibitions**
1956 Redfern Gallery, London
    (with Ceri Richards and Peter Oliver)
1960 Molton Gallery, London
    Institut für Auslandsbeziehungen,
    Stuttgart
1989 John Denham Gallery, London

162 *Composition*
    signed (with monogram)
    oil on canvas 125 × 100 cm
    presented

163 *Kneeling Female Nude*
    red chalk 47 × 29.5 cm
    presented

164 *Nude*
    red chalk 44 × 30.5 cm
    presented

165 *Seated Female Nude I*
    red chalk 46 × 28.5 cm
    presented

166 *Seated Female Nude II*
    red chalk 47 × 29 cm
    presented

167 *Figure Study*
    signed
    drypoint etching 18.5 × 13 cm
    presented

165 Erich Kahn *Seated Female Nude I*

166 Erich Kahn *Seated Female Nude II*

## Leo Kahn

b.1894 Baden, Germany
d.1983 Safed, Israel

Studied in Karlsruhe and in Holland
and spent some time in France working
with André Derain before settling in
Palestine in 1936. He lived in the artists'
colony in Safed for many years.

**Selected Exhibitions**
1929 Deutsches Museum, Munich
1954 Ben Uri Art Society, London

168 *Synagogue, Ramat Gan*
    signed
    watercolour 48 × 66 cm
    presented by the artist 1956

## Nata Kaplan

b.1920 Alexandria, Egypt
lives in Tel Aviv

Studied in London, New York and Tel
Aviv. She spent three years in London,
1936–39 and has travelled in Europe,
Australia and the United States.

**Selected Exhibitions**
1967 Ben Uri Society, London
1970 Strawberry Hill Gallery, Sydney
1975 O'Hana Gallery, London
1976 Saidye Bronfman Centre, Montreal
1979 Alexandrowitz Gallery, Tel Aviv

169 *Hills of Judea*
    dated 1967
    oil on canvas 72.5 × 115.5 cm
    presented by the artist

## Edmond Xavier Kapp

b.1890 London
d.1978 London

Kapp studied medieval and modern
languages at Cambridge, but early in his
student days began to draw seriously and
his work was exhibited in Cambridge in
1912. After serving in France during
World War I, he studied at the British
Academy, Rome, 1923–24 and, in 1934,
received a commission from the British
Museum and National Portrait Gallery
to execute lithographs of the members of
the League of Nations in Geneva. He
began painting in oils in 1923 and made
frequent visits to Southern France as
well as spending two years in Paris on a
UNESCO commission, 1946–47, before
settling back in London in 1960.

### Selected Exhibitions
1919  Little Art Rooms, Adelphi, London
1922–56 Leicester Galleries, London
1939  Wildenstein, London
1944  RBA Galleries, London
       (with Anna Mahler)
1961  Whitechapel Art Gallery, London
1984  Abbot Hall Art Gallery, Kendal,
       Cumbria
1985  Langton Gallery, London

### Selected Publications
*Personalities* 24 drawings, London 1919
*Reflections* 24 drawings, with an introduction
by Laurence Binyon, London 1922
*Minims* 27 abstract drawings, London 1925

170  *Sholem Asch*
signed
lithograph 2/25  50.5 × 38.5 cm
presented

## Helen Keats

b.1947 London
lives in London

Studied at Harrow School of Art,
1977–79 and at Wimbledon School of
Art, 1979–82, postgraduate work at
Wimbledon, 1982–84.

### Selected Exhibitions
1984  Kew Studios, Surrey
1985  New Art Gallery, Regent's Park,
       London
1987  Ben Uri Art Society, London (with
       Monica Winner)
1990  Ben Uri Art Society, London (with
       Ralph Pope)

171  *That's Masada*
signed and dated 1987 (verso)
lithograph A/P  54 × 74 cm
presented by the artist 1987

172  *The Wilderness of Zin*
signed (verso: dated 1987)
lithograph A/P  55 × 75 cm
presented by the artist 1987

173  *Wait Tara, I'm Talking to You*
signed (verso: dated 1985)
etching 4/25  64 × 45 cm
presented by the artist 1987

## Kalman Kemeny

b.1896 Nagy-Kanisza, Hungary
d.1994, London

Kemeny studied at the Academy of Fine
Art, Budapest until 1913 and in Vienna.
He travelled in Italy, 1926–27 and left
Hungary for England in 1938 settling in
London. He taught at Hammersmith
College of Art, 1947–79. His work has
been exhibited at numerous London
galleries, at the Royal Academy of Arts,
the Imperial War Museum and at the
Paris Salons. A retrospective exhibition
of his paintings and ceramics was held at
the Ben Uri Art Society in 1991.

174  *Portrait of Cyril Ross*
signed
oil on canvas  65 × 50.5 cm
commissioned by the Society in honour
of Cyril Ross

174  Kalman Kemeny  *Portrait of Cyril Ross*

175  Kalman Kemeny
*Portrait of Mrs Robert Solomon*

175  *Portrait of Mrs Robert Solomon*
oil on canvas  76 × 62 cm
commissioned by the Society as a prize
in a portrait-painting competition and
presented 1945

**Kalman Kemeny**
(continued)

176 *The Tobacconist*
signed
oil on canvas 50 × 40 cm
purchased 1957

176 Kalman Kemeny *The Tobacconist*

## Wolf Kiebel

b.1903 Grodziska, Poland
d.1938 Cape Town, South Africa

Before leaving Poland in 1923, Kiebel studied briefly with a painter, Applebaum, from London. He continued his studies with Professor Pick-Morino in Vienna, 1923–25. He moved to Palestine in 1925 where he lived for four years and settled in Cape Town in 1929.

**Selected Exhibitions**
1942 Memorial Exhibition, Cape Town
1947 Memorial Exhibition, Johannesburg
1950 South African National Gallery, Cape Town

**Selected Bibliography**
Frieda Kiebel and N. Dubow. *Wolf Kiebel*, Cape Town 1975

**177** *Mother and Child (Maternity)*
charcoal 24.5 × 14.5 cm

177 Wolf Kiebel *Mother and Child (Maternity)*

178 Michel Kikoine *Israeli Girl*

## Michel Kikoine

b.1892 Gomel, Russia
d.1968 Paris

Studied at the School of Art, Vilna, 1908–11 and, after settling in Paris in 1912, at the Ecole des Beaux-Arts and the Cormon Atelier. He served in the French Army during World War I. He spent several months each year in Burgundy from 1930 and was in Toulouse during the occupation. He returned to Paris in 1946.

**Selected Exhibitions**
1920 Galerie Marcel Bernheim, Paris
1930 Galerie Billet-Worms, Paris
1945 Galerie Chappe-Lauthier, Toulouse, France
1949 Galerie Brummer, New York
1951 Ben Uri Art Society, London (with Zechariahu Ehrlichman and Bruno Simon)
1955 Redfern Gallery, London
1961 Crane Kalman Gallery, London

**Selected Bibliography**
N. Betlex-Cailler. *Kikoine*, Geneva 1957
Edouard Roditi *et al.*: *Kikoine*, Paris 1973
Jean Cassou. *Michel Kikoine – Catalogue Raisonné*, Paris

**178** *Israeli Girl*
signed
watercolour 41 × 20.5 cm
presented by J. Spreiregen 1952

## Meyer Klang

b.1880
d.1948

Worked in the East End of London

**179** *Flowerpiece*
signed
oil on canvas 56 × 45.5 cm
presented 1948

180 Clara Klinghoffer *The Girl in the Green Sari*

## Clara Klinghoffer

b.1900 Szerzezec, Austria
d.1970 London

The Klinghoffer family settled in Manchester in 1903 and soon after moved to the East End of London. Clara studied at Sir John Cass College of Art, the Central School and at the Slade. From 1930–39 she was in Holland and she spent the war years in New York. She came back to London in 1946 where she spent the rest of her life, making frequent return visits to New York.

**Selected Exhibitions**
1920 Hampstead Art Gallery, London
1923 Leicester Galleries, London
1926–38 Redfern Gallery, London
1928 Nationale Kunsthandel, Amsterdam
1941 460 Park Avenue Galleries, New York
1968 Farleigh Dickinson University, Rutherford, New Jersey

1970 Instituto Mexicano-Norte Americano, Mexico City
1976 Belgrave Gallery, London
1981 Campbell and Franks Fine Art, London

180 *The Girl in the Green Sari*
signed and dated 1926
oil on canvas 176.5 × 90 cm
purchased 1935

## Harold Kopel ROI

b.Newcastle upon Tyne
lives in London

After studying at University College, London and completing a teacher training course entered the Central School. He served in the Royal Air Force in India and has been Senior Lecturer for the Inner London Education Authority's Further Education programme. He exhibits regularly with the Royal Institute of Oil painters at the Mall Galleries, London.

**Selected Exhibitions**
1974 Ben Uri Art Society, London
1993 The Coachhouse Gallery, Guernsey

181 *The Skiers*
signed
oil on board 34.5 × 60 cm

## Fred (Fritz) Kormis

b.1897 Frankfurt
d.1986 London

Studied in Frankfurt until 1915. In 1920 after five years as a prisoner-of-war in Siberia, he returned to Frankfurt and worked there until 1933 when he left Germany for Holland. He settled in England in 1934. His work has been exhibited in Amsterdam and in The Hague.

**Selected Exhibitions**
1934 Bloomsbury Galleries, London
1982 Fieldborne Galleries, London
1987 Sternberg Centre for Judaism, London

182 *Adam and Eve*
bronze resin height: 74 cm
bequest of the artist 1986

## Halina Korn

b.1902 Warsaw
d.1978 London

Halina Korn trained as a singer and was self-taught in art. All her family perished in the Holocaust, but she escaped and came to London. She married Marek Zulawski (*q.v.*) in 1948.

**Selected Exhibitions**
1948 Mayor Gallery, London
1953 Beaux-Arts Gallery, London
1962 Galerie Norval, New York
1981 Camden Arts Centre, London

183 *Macaw*
oil on canvas 32 × 23 cm
presented by W. L. Goldstein 1986

## Naphtali (Nathaniel) Kornbluth

b.1914 London
lives in London

Son of Polish immigrants, Kornbluth grew up in London's East End. He attended evening classes at Hackney Technical Institute where he studied etching, and in 1934 joined the evening etching class at Bloomsbury Central School where he also studied lithography and life drawing. Since 1970 he has concentrated on etching.

**Selected Exhibitions**
1980 Campbell and Franks Fine Art, London
1986 Sir John Cass College of Art, London

184 *London Views*
signed and dated 1934–1936
etchings, set of six (various sizes)
presented by the artist

182 Fred Kormis *Adam and Eve*

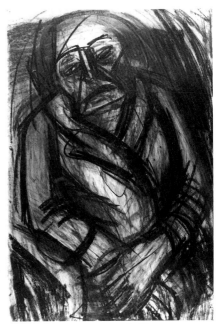

185 Leon Kossoff *Portrait of a Woman*

## Leon Kossoff

b.1926 London
lives in London

Kossoff served in the Jewish Brigade and Royal Fusiliers in World War II. He attended David Bomberg's evening classes at the Borough Polytechnic whilst studying at St Martin's (1949–53) and then studied at the RCA from 1953–56. From 1959–69 he taught at some of London's major art schools.

### Selected Exhibitions
1957–64 Beaux-Arts Gallery, London
1968 Marlborough Fine Art, London
1972 Whitechapel Gallery, London
1974–85 Fischer Fine Art, London
1981 Museum of Modern Art, Oxford and Graves Art Gallery, Sheffield
1983 Hirsch and Adler, New York
1988 Robert Miller, New York
1988 & 1993 Anthony d'Offay, London

185 *Portrait of a Woman*
charcoal 103 × 71 cm
purchased

186 *Two Seated Figures*
signed and dated '82
etching 2/75 41 × 37 cm
presented by the artist 1982

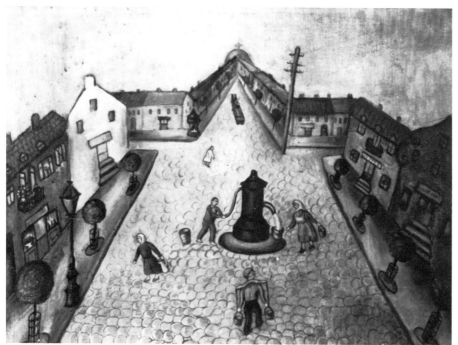

187 Chana Kowalska *Shtetl*

## Chana Kowalska

b.1904 Wlockawek, Poland
d.1943 Auschwitz

Daughter of a rabbi. School teacher at
age of 18; studied in Berlin and Paris
where she was an active Communist.
Exhibited in Paris after 1930. Arrested
as a resistance fighter in Paris and
deported to Auschwitz.

### Selected Bibliography
H. Fenster. *Unsere Farpainigte Kunster*
(Yiddish), Paris 1951

187 *Shtetl*
signed and dated 1934 (in Hebrew)
oil on canvas 45 × 60 cm
presented by Mosheh Oved

188 *The Bridge*
signed and dated 1937
oil on canvas 61 × 50 cm
presented by Mosheh Oved

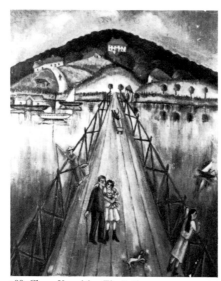

188 Chana Kowalska *The Bridge*

## Jacob Kramer

b.1892 Klincy, Ukraine
d.1962 Leeds

The Kramer family (father, a painter)
left Russia in 1900 and settled in Leeds
where Jacob had his early education and
art studies and lived for most of his life.
He spent a year at the Slade where his
fellow students included Bomberg and
Gertler. The Leeds College of Art,
where he lectured, was renamed the
Jacob Kramer College after his death.

### Selected Exhibitions
1912 Leeds School of Art
    (with Fred Lawson)
1919 Adelphi Gallery, London
1935 Leger Gallery, London
1960 Leeds City Art Gallery
1973 Park Gallery, London
1984 Ben Uri Art Society, London
1992 Leeds City Art Gallery and Leeds
    University Gallery

### Selected Bibliography
Millie Kramer. *Jacob Kramer: A Memorial
Volume*, London 1969
John D. Roberts (ed). *The Kramer
Documents*, Valencia, Spain 1983

189 *Portrait of Sam Nagley*
signed and dated 1922
oil on canvas 78.5 × 66 cm
presented by Ben Nagley 1949
Exhibited:
Leeds City Art Gallery 1960
Glasgow Art Gallery and Museum 1979
Jewish Museum, New York 1983

190 *The Day of Atonement*
signed and dated 1919
pencil, brush and ink 61.5 × 90 cm
purchased
Exhibited:
Jewish Art Exhibition, Capetown 1951
Jewish Museum of Art, Paris 1957
City Art Gallery, Leeds 1960
Glasgow Art Gallery and Museum 1979
Brighton Polytechnic 1986

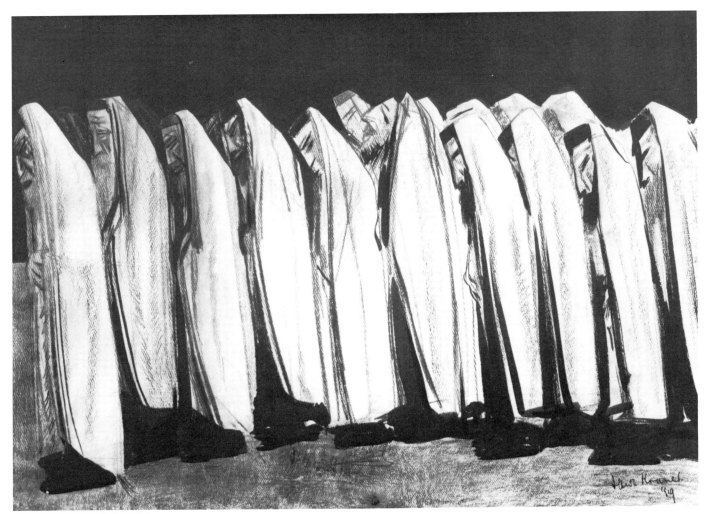

190 Jacob Kramer *The Day of Atonement*

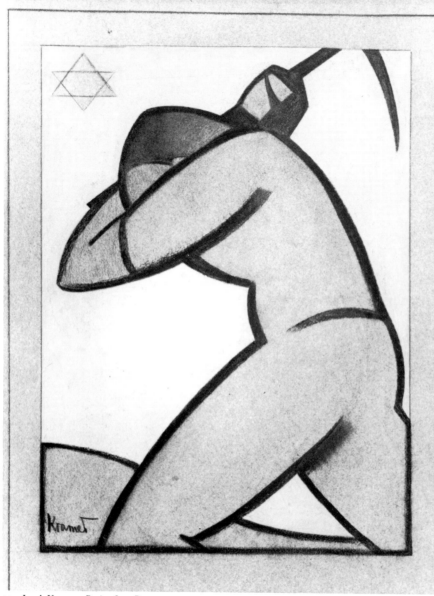

191 Jacob Kramer *Design for a Programme*

192 Jacob Kramer *Israel Zangwill*

**Jacob Kramer** (continued)

191 *Design for a Programme*
signed *c*.1920
gouache, charcoal and pencil on green
paper 38 × 30 cm
presented by Mrs E. Hurwitz

192 *Israel Zangwill*
signed *c*.1925
charcoal and white chalk on
paper 45.5 × 44 cm
purchased
Exhibited:
Hove Museum of Art 1954
City Art Gallery, Leeds 1960
Camden Arts Centre, London 1985

193 *Nude in Slumber*
signed *c*.1920
pencil drawing 42.75 × 25 cm
purchased

194 *Old Woman Knitting*
signed
pastel on grey paper 61.5 × 46.5 cm
presented by Mrs Mosheh Oved

195 *Portrait of Lord Rothschild*
signed
pastel 41 × 33 cm
purchased

196 *Portrait of Jacob Epstein*
signed *c*.1930
lithograph 63 × 50.5 cm
presented by Alice Schwab 1987

PLATE V  Zygmund Landau  *Interior* cat.202

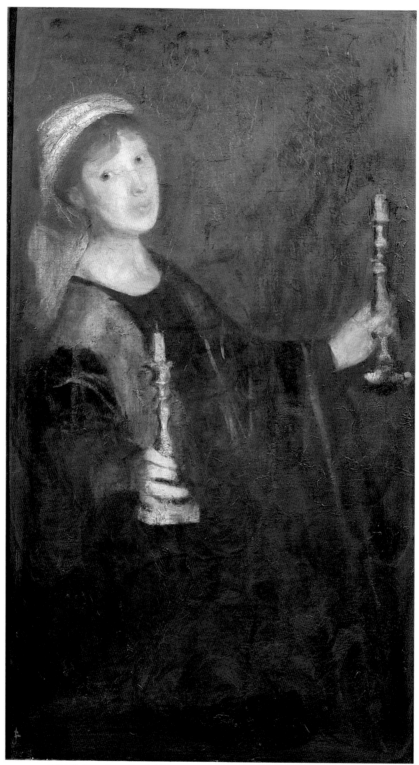

PLATE VI  Lily Delissa Joseph  *Self Portrait with Candles*  cat.160

194 Jacob Kramer *Old Woman Knitting*

195 Jacob Kramer *Portrait of Lord Rothschild*

## Ellen Kuhn

b.1937 Germany
lives in London

Family emigrated to the USA in 1939. Ellen Kuhn studied at the University of Wisconsin and at the University of California, Berkeley. Taught art in high school, in New York. Arrived in London in 1962 and worked at lithography and etching at the Print Workshop, 1962–68. In 1969–70 she was in Montreal where she began silkscreen printing.

### Selected Exhibitions
1981 Jordan Gallery
1983 Ben Uri Art Society, London
1991 Sternberg Centre for Judaism, London

197 *The Balcony*
gouache  54 × 35 cm

## K.W.P.

198 *Portrait of Israel Zangwill*
signed (with monogram)
bronze relief  48.25 × 40.5 cm
presented by Mrs R. Cowen 1933

## David Lan-Bar

b.1912 Rava-Russkaye, Poland
d.1987 Paris

Lan-Bar, born Lan-Berg, emigrated to Palestine in 1935 where he studied painting. In 1947 he moved to Paris and studied at the Ecole des Beaux-Arts. His work has been widely exhibited in the United States.

### Selected Exhibitions
1988 Musée de Vesoul, France
1991 Galerie Vannoni, Lyons

199 *Untitled*
signed (verso)
oil on board  101 × 53.5 cm
presented by Alexander Margulies 1987

200 *Untitled*
signed and dated 1965 (verso)
oil on canvas  117 × 90 cm
presented by Alexander Margulies 1987

199 David Lan-Bar *Untitled*

200 David Lan-Bar *Untitled*

65

# Zygmund Landau

b.1898 Lodz, Poland
d.1962 Israel

Landau studied at the Academy of Fine
Arts, Warsaw before settling in Paris in
1920. He was in St Tropez during World
War II after which he lived in Paris and
in the South of France, frequently
visiting Israel.

**Selected Exhibitions**
1934 Galerie Zak, Paris
1947 Stenman Gallery, Stockholm
1964 Ben Uri Art Society, London
1954 Galerie Mirador, Paris
1958 Bezalel National Museum, Jerusalem

201 *French Landscape*
signed
oil on canvas 54 × 70.5 cm
purchased 1937

COLOUR PLATE V
202 *Interior*
signed
oil on board 65 × 49 cm
presented by Alexander Margulies 1987

203 *Landscape*
signed (verso: signed again)
oil on canvas 35 × 38.5 cm
(verso: a second painting)
presented by Mosheh Oved

204 *Landscape, France*
signed and dated 1936
oil on canvas 54 × 65.5 cm
presented by Mosheh Oved

205 *Landscape with Trees*
signed (verso)
oil on canvas 60.5 × 79.5 cm
purchased 1937

206 *Three Figures*
signed
grey wash on beige paper 28.5 × 23 cm
purchased

204 Zygmund Landau *Landscape, France*

207 Phyllis Lawson *Figures in a Landscape II*

66

## Phyllis Lawson

b.1927 London
lives in Brussels

After studying at the Willesden School
of Arts and Crafts, London, Phyllis
Lawson spent a year in the United States
and four years in Bolivia. In 1964 she
settled in Brussels. She returns to
England occasionally where she has a
home in Kent.

**Selected Exhibitions**
1958  Salon Municipal de Exposiçiones,
      La Paz, Bolivia
1967  Galerie de l'Abbaye, Brussels
1969  Ben Uri Art Society, London
1972 & 1975  Galerie 7, Mons, France
1975  Fieldborne Galleries, London
1989  Pierre Hallet Gallery, Brussels

*Figures in a Landscape II*
signed (verso) and dated 1971
oil on canvas  79 × 89 cm
presented by the artist

## Israel Leibo

b.1912 Tallinn, Estonia
lives in London

Leibo left Estonia in 1929 for Berlin
where he studied with Max Liebermann
(*q.v.*). After travelling extensively through-
out Europe he arrived in England
in 1939 and settled in London.

**Selected Exhibitions**
1939  Lefevre Gallery, London
      (with Moise Kisling)
1976  Dr Immanuel Bierer, Harley Street,
      London

*Landscape with Plough*
signed and dated 1935
oil on canvas  45.5 × 65.5 cm
presented by Dr I. Bierer

208  Israel Leibo  *Landscape with Plough*

209  Hannah Lerner  *Pastorale*

## Hannah Lerner

b. Stratov, Russia
lives in Israel

Studied at the Warsaw Academy, settled
in Palestine in 1935. She is well known
in Israel as a mural painter.

**Selected Exhibitions**
1951  Kensington Art Gallery, London
1951  Kunstzaat Van Lier, Amsterdam
1952  Galerie 29, Paris
1954  Artists' House, Jerusalem
1965  Galerie Internationale, New York

**Selected Bibliography**
*Art in Israel*, published by the Tel Aviv
Museum, 1960

209  *Pastorale*
signed (in Hebrew)
oil on canvas  71.5 × 59.5 cm
presented by Dr Alec Lerner

210  *Pastorale*
signed (in Hebrew)
acrylic on canvas  91 × 84.5 cm
presented by Dr Alec Lerner

## Ben Levene RA

b.1938 London
lives in London

Levene studied at the Slade 1956–61. He
was awarded a Boise Scholarship and
spent the following year in Spain. Since
1963 he has been visiting lecturer at the
RA Schools. He was elected Royal
Academician in 1986.

**Selected Exhibitions**
1973–81 Thackeray Gallery, London
1988 & 1993 Browse & Darby, London

211 *Still Life*
signed and dated 1966 (verso)
oil on board 81 × 86 cm
purchased

## Alphonse Levy

b.1843 Marmoutier, France
d.1918 Algiers

Pupil of Gérôme. Exhibited at the Salon
in 1874; was an associate member of the
Salon de la Société Nationale des Beaux-
Arts from 1901.

212 *The Scribe*
signed and dated 1884
inscribed (in Hebrew)
drypoint etching and mezzotint
28 × 22 cm
presented by Mr and Mrs E. Cates 1948

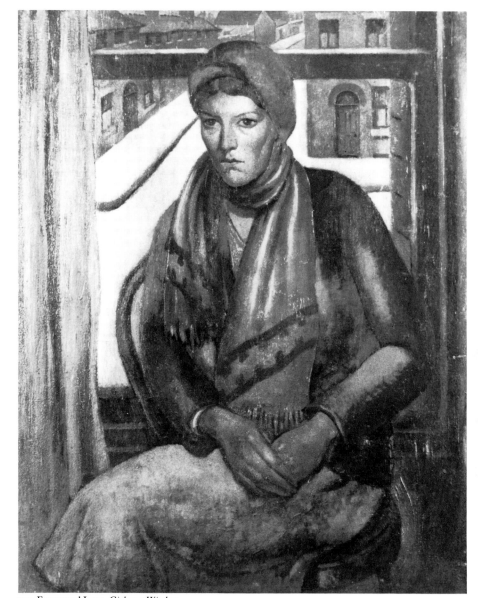

213 Emmanuel Levy *Girl at a Window*

## Emmanuel Levy

b.1900 Manchester
d.1985 London

Son of Russian immigrants who had
settled in Manchester towards the end of
the nineteenth century. He studied at
Manchester School of Art, in London
and Paris. Back in Manchester, he
taught life drawing at the School of
Architecture and became art critic for
the *Manchester City and Evening News*.
He lived in London from 1963 until his
death.

### Selected Exhibitions
1948  Salford City Art Gallery
1953 & 1978  Ben Uri Art Society, London
1961  Ben Uri Art Society, London
       (with Adèle Reifenberg and
       Eric Doitch)
1971 & 1976  Fieldborne Galleries, London
1979  Tib Lane Gallery, Manchester
1989  Ben Uri Art Society, London

3  *Girl at a Window*
signed
oil on canvas  75 × 63 cm
purchased

4  *The Gold Jacket*
oil on canvas  75 × 57.5 cm
purchased

5  *Man Reading*
signed
oil on canvas  76 × 50.5 cm
on permanent loan

6  *Portrait of a Girl*
signed
charcoal and chalk  37 × 27.5 cm
on permanent loan from
Judge Neville Laski

7  *Portrait of a Man*
signed
oil on canvas  75 × 49 cm

COLOUR DETAIL ON FRONT COVER
8  *Two Rabbis with Scrolls of the Law*
signed
oil on canvas  75 × 60 cm
presented by Alexander Margulies 1987
Exhibited:
Barbican Art Gallery, London 1990,
cat.210

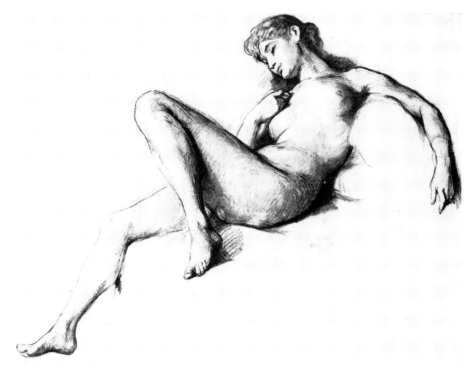

219  Henri Levy  *Nude*

## Henri Levy

b.1840 Nancy, France
d.1904 Paris

Levy studied at the Ecole des Beaux-
Arts, Paris in 1856. Well-known for his
historical subjects, he received the
Légion d'Honneur in 1872.

219  *Nude*
charcoal drawing  43 × 55.5 cm
presented

## Isaac Lichtenstein

b.1887 Lodz, Poland

Lichtenstein left Poland for Palestine
and studied in Jerusalem. He travelled
extensively in France and the United
States and settled in Israel in 1959.

220  *The Blind Fiddler*
signed (with monogram) and dated 1924
oil on canvas  89 × 63 cm
purchased 1925

221  *Head of a Yemenite Woman*
signed and dated 1921 (verso)
oil on canvas  55 × 40.5 cm
purchased 1921

222  *Ruth II*
signed
oil on canvas  93 × 56 cm
purchased 1925

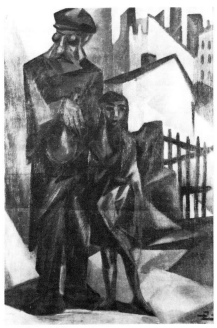

220  Isaac Lichtenstein  *The Blind Fiddler*

69

## Max Liebermann

b.1847 Berlin
d.1935 Berlin

Liebermann studied philosophy at the
University of Berlin, 1866–68, but
turned to art and entered the
Kunstakademie, Weimar, 1868–73.
Most of his life was spent in Berlin, but
he travelled frequently to Paris, Holland
and Rome. As leader of the 'Secession',
he was a prominent member of the
German Impressionists. He was
president of the Preussische Akademie
der Kunst, 1920–32.

**Selected Exhibitions**
1891  Kunstverein, Munich
1923  Kunsthaus, Zurich
1936  Jewish Museum, Berlin
1954  Kunsthalle, Bremen
1979  Nationalgalerie, Berlin and Haus der
      Kunst, Munich
1985  Akademie der Kunst, East Berlin

**Selected Bibliography**
G. Josten. *Max Liebermann*, Dresden 1973
G. Meissner. *Max Liebermann*, Leipzig 1974

223  *Sketches of Jozef Israels*
     signed
     pen and ink  13.5 × 22 cm
     purchased 1959

224  *Dutch Interior*
     signed
     etching  15.5 × 26.5 cm
     presented by Alfred Wolmark

225  *Pastoral scene*
     signed
     etching  21.5 × 25 cm
     presented by Alfred Wolmark

223  Max Liebermann  *Sketches of Jozef Israels*

## Pamina Liebert-Mahrenholz

b.1904 Berlin
lives in London

Studied sculpture at the Vereinigte
Staatsschule am Steinplatz, Berlin,
where she won the Rome Prize and was
established as a sculptor before
emigrating to England in 1939. She
settled in London where she worked as
a china restorer. After many years she
returned to her art and concentrated on
painting and drawing.

**Selected Exhibitions**
1958  Woodstock Gallery, London
1977  Camden Institute, London
1981  Ben Uri Art Society, London
1983  Camden Arts Centre, London
1988  Ben Uri Art Society, London

226  *Two Female Nudes*
     oil on canvas  60.5 × 60.5 cm
     presented by the artist

227  *Reclining Female Nude*
     terracotta  height: 34 cm
     presented by the artist

## Ruth Light

228  *Hasidic Jew*
     inscribed
     charcoal drawing  76 × 56 cm
     presented

## Lippy (Israel-Isaac) Lipshitz

b.1903 Plungian, Lithuania
d.1980 Kiryat Tivon, Israel

Arrived in South Africa with his family
in 1908 and trained as a wood-carver in
Cape Town. He studied sculpture under
Antoine Bourdelle in Paris, 1928–32.
Appointed Assistant Professor of Art at
Cape Town University in 1963, he spent
a year working in Greece in 1966 and
emigrated to Israel in 1978 where he
lived until his death.

**Selected Exhibitions**
1943–54  Gainsborough Galleries,
         Johannesburg
1944  Durban City Art Gallery, South Africa
1948  Galerie Apollinaire, London
1968–9  South African National Gallery,
        Cape Town

**Selected Bibliography**
David Lewis and Lyn Birtles. *Lippy Lipshitz
and his Sculptures*, London 1948
Bruce Arnott. *Lippy Lipshitz*, Cape Town
1969

9 *Figure*
signed and dated 1944
monotype 38.5 × 27.5 cm
presented by Dr Claude Spiers 1957

0 *Figure*
signed and dated 1934
marble height: 40.64 cm
presented

## Alfred Lomnitz (Lom)

b.1892 Eschwege, Hessen, Germany
d.1953 London

Lomnitz studied under the architect and
painter Henry Van de Velde at the
Bauhaus, Weimar and became a member
of the Novembergruppe. He settled in
Berlin in the early 1920s and, after
travelling in Europe, arrived in England
in 1933 where he devoted most of his
time to commercial art.

**Selected Exhibitions**
1926 & 1986 Neumann-Nierendorf Galerie,
    Berlin
1934 Ryman's Galleries, Oxford
1954 Ben Uri Art Society, London
1986 John Denham Gallery, London

**Selected Bibliography**
Alfred Lomnitz. *Never Mind, Mr Lom*, 1941

1 *Flowerpiece*
signed
oil on canvas 60.5 × 50.5 cm
bequeathed to the Society by the artist
1954

2 *Pastorale*
signed and dated 1923
oil on board 73 × 97.5 cm
presented by Cyril J. Ross

3 *Self Portrait*
oil on board 55.5 × 33.5 cm
bequeathed to the Society by the artist
1954

4 *Car Travelling down Tree-lined Path*
watercolour 36 × 24.5 cm
presented by Cyril J. Ross

5 *Design in Ice Blue and Crimson*
watercolour 49 × 34.5 cm
presented by Cyril J. Ross

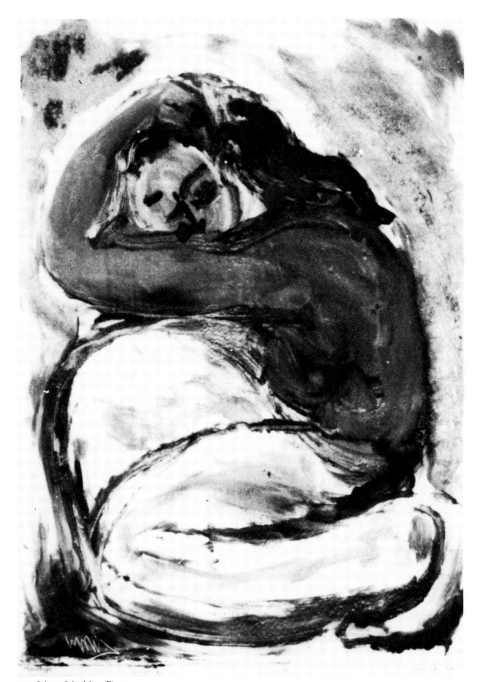

229 Lippy Lipshitz *Figure*

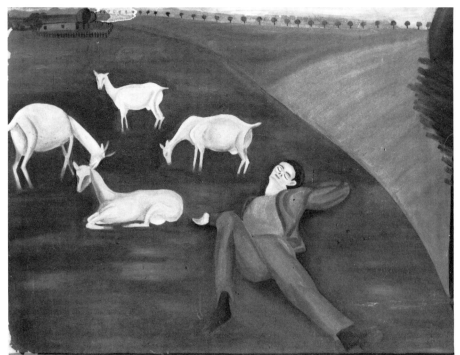

232 Alfred Lomnitz *Pastorale*

233 Alfred Lomnitz *Self Portrait*

238 Alfred Lomnitz *Forest*

**Alfred Lomnitz** (continued)

**236** *Figure study of Male Nude*
watercolour and pencil  41 × 60 cm
presented by Cyril J. Ross

**237** *Figure with Green Bead Necklace*
watercolour  55.5 × 37.5 cm
presented by Cyril J. Ross

**238** *Forest*
signed and dated 1923
watercolour  32.5 × 43.5 cm
presented by Cyril J. Ross

**239** *Girl Behind Barbed Wire*
watercolour  37.75 × 28 cm
presented by Cyril J. Ross

**240** *Home Surrounded by Trees*
watercolour  22.5 × 28.5 cm
presented by Cyril J. Ross

**241** *Still Life with Wooden Crate and Cabbage*
watercolour  32 × 45.5 cm
presented by Cyril J. Ross

*2 Two Trees and Telegraph Pole*
watercolour 34.5 × 28 cm
presented by Cyril J. Ross

*3 View of the Sea from the Hills*
watercolour and pencil 24.5 × 35.5 cm
presented by Cyril J. Ross

*4 View of Tree and Home Suffused with Fiery Light*
watercolour 36 × 24.5 cm
presented by Cyril J. Ross

*5 Woman in Profile with Swans and Houses*
watercolour 52.5 × 41 cm
presented by Cyril J. Ross

*6 Women seated at a Table*
watercolour on newspaper and
collage 44 × 30 cm
presented by Cyril J. Ross

*7 Yellow Shapes with Red Lips*
watercolour 16.5 × 21 cm
presented by Cyril J. Ross

*8 Abstraction of a Man with Moustache*
pencil and pastel 22 × 18 cm
presented by Cyril J. Ross

*9 Design*
pen and ink 23 × 15 cm
presented by Cyril J. Ross

*0 Design with Profile and Eye*
signed and dated 8/11/33
pen and ink 27 × 19.5 cm
presented by Cyril J. Ross

*1 The Dream of the Man with Blue Eyes*
chalk 48 × 36 cm
presented by Cyril J. Ross

*2 Earth, Water, Fire*
chalk 33.5 × 37 cm
presented by Cyril J. Ross

*3 Man, Woman and Child*
signed and dated 29/8/36
ink drawing 35 × 27 cm
presented by Cyril J. Ross

*4 The Street Lined with Trees*
signed
pen and ink 32.5 × 25 cm
presented by Cyril J. Ross

259 Georges Loukomski *Synagogue Interior*

255 *Two Hands Throttling*
signed
chalk 22.75 × 17.5 cm
presented by Cyril J. Ross

256 *Three Women*
chalk 48 × 37 cm
presented by Cyril J. Ross

257 *Crescent Moon, Flowers and Nude Female*
signed
etching and aquatint 25 × 34.5 cm
presented by Cyril J. Ross

## Levy Lomnitz

258 *Two pencil drawings*
signed
pencil 15.5 × 19.5 cm
presented by Cyril J. Ross

## Georges Loukomski (Lukomski)

b. Russia

Prince Loukomski trained as an architect and moved to France after the Revolution. In his native Russia he had been Keeper of the Fine Arts Museum in Kiev. From 1933 he travelled around Europe visiting synagogues and published a book on the subject in 1947.

**Selected Bibliography**
Georges Loukomski. *Jewish Art in European Synagogues*, Tiptree, Essex 1947

**Selected Exhibitions**
1925 Sporting Club de France, Paris
1928 Galeries Georges Petit, Paris
1935 Wildenstein and Company, London
1939 Fine Art Society, London

259 *Synagogue Interior*
signed
charcoal on blue paper 48 × 62.5 cm
presented by Ethel Solomon

73

## Abraham Lozoff

b.1887 Siberia
d.1936?

Sometime during his childhood Lozoff moved to Riga and lived there until 1914 when he went to the United States, from where he travelled to Canada living there for many years and adopting Canadian nationality. He was in Florence and Paris before settling in London in 1920.

260 *Portrait of A. Cherne*
plaster height: 51 cm
presented

261 *Lot and his Daughters*
wood height: 109.22 cm
presented by Lord Sieff 1936

## David Maccoby

b.1925 Sunderland
lives in London

Studied at the Sunderland College of Arts and Crafts, 1941–43 and at the Chelsea School of Art, London, 1946–48. After serving in the Royal Navy during World War II, he travelled extensively in East and West Europe, the United States and the Caribbean Islands. More recently he spent eighteen months in South Africa.

Selected Exhibitions
1951, 1954 & 1975 Ben Uri Art Society, London
1965 Galerie Bernheim-Jeune, Paris
1961 Sunderland Museum and Art Gallery, Durham
1962 New Vision Centre, London
1970 Café Caricature, Greenwich Village, New York
1992 Sternberg Centre for Judaism, London

262 *Spring Equinox*
signed
oil on paper 72.5 × 40 cm
presented

263 Maurice Man *Village Idiots*

## Maurice Man

b.1921 London

Studied at the Willesden School of Art, 1934–38 and at St Martin's, later attending the Académie La Grande Chaumière in Paris. During World War II he designed posters and other propaganda material. Since 1949 he has worked mainly in pastels.

Selected Exhibitions
1958 Kensington Art Gallery
1959 John Whibley Gallery, London
1960 & 1962 Atelier Colin Man, London
1961 Beaux-Arts Gallery, Los Angeles
1964 Mount Gallery, London

263 *Village Idiots*
watercolour and ink 21.5 × 32 cm
presented

## Emanuele Manasse

Manasse's work was exhibited at the Summer Exhibitions at the Royal Academy of Arts, London in 1940 and 1941 at which time he was living in Hampstead.

264 *Head of Louis Golding*
signed
bronze height: 38 cm
(excluding wood base)
purchased 1939
Exhibited:
Royal Academy, London 1940

## D. Mandel

265 *Portrait of Adolph Michaelson*
signed
oil on board 67.5 × 54.5 cm
presented by Mrs Adolph Michaelson

266 *Portrait of Mrs Michaelson*
signed
oil on board 62 × 49.5 cm
presented by Mrs Adolph Michaelson

## Mané-Katz (Emmanuel Katz)

b.1894 Kremenchug, Ukraine
d.1962 Haifa

Intended for the rabbinate, Emmanuel Katz abandoned his studies and entered the Art Academy of Kiev when he was only sixteen. He continued his art studies in Paris and finally settled there in 1921. He spent the war years in the United States, returning to France in 1945, but emigrated to Israel in 1958.

**Selected Exhibitions**
1948  Tel Aviv Museum of Art
1952  Museu de Arte Moderna, São Paulo
1959  Musée Rath, Geneva
1963  Ben Uri Art Society, London

**Selected Bibliography**
Alfred Werner. *Mané-Katz*, Tel Aviv 1959
Robert Aries. *Mané-Katz: The Complete Works*, London 1970

7  *Seascape*
signed and dated 1934
oil on canvas  70.5 × 90.5 cm
presented by the artist

8  *Israel Landscape*
signed and dated 1935
gouache  49 × 64 cm
presented by the artist

9  *The Road to Jordan*
signed and dated 1935
gouache  50 × 65 cm
presented by Dr R. Gainsborough 1949

0  *Algerian Jew*
signed and dated 1934
charcoal  63.5 × 49 cm
presented

267 Mané-Katz *Seascape*

270 Mané-Katz *Algerian Jew*

## Sargy Mann

b.1937 Hythe, Kent
lives in London

Qualified as a mechanical engineer before studying at Camberwell School of Art, 1960–64 and 1967, where he has been teaching since 1968. He has also been on the staff of the Camden Arts Centre, London since 1970 and lectures widely throughout the United Kingdom. In 1985 he was awarded First Prize at 'The Spirit of London' exhibition.

**Selected Exhibitions**
1973  Salisbury Festival of Arts, Wiltshire
1979  Salisbury Playhouse, Wiltshire
1987  Cadogan Contemporary, London

271  *Oaks on One Tree Hill*
signed (verso) and dated 1978
oil on canvas  39.5 × 58 cm
presented by Alistair McAlpine

272  *Untitled*
signed
oil on canvas  59.5 × 49.5 cm
presented by Alistair McAlpine

## Marek (Zulawski)

b.1908 Rome
d.1985 London

The Zulawskis, a Polish family, were in Rome at the time of their son's birth. Marek studied at the Academy of Fine Art, Warsaw and visited Paris in 1935. He settled in London in 1937. Following his death, the Museum Zulawski was opened in Zakopane, Poland in 1987

**Selected Exhibitions**
1946  National Museum, Warsaw
1957  Geffrye Museum, London
1961  Arnolfini Gallery, Bristol
1975  Bedford House Gallery, London
1976  Galeria Zapiecek Desa, Warsaw
1982  Ben Uri Art Society, London
1986  Drian Galleries, London

**273**  *Seated Female Model*
signed and dated 1975
photolithograph 51/100  49 × 38 cm
purchased

## Gerald Marks

b.1921 London
lives in London and France

Studied at the Central School under Bernard Meninsky (*q.v.*) and William Roberts until 1941; resumed his studies in 1946. He was taught art at Camberwell, Heatherley's and South East Essex Schools of Art and was appointed Assistant Lecturer at Croydon College in 1962.

**Selected Exhibitions**
1962  Drian Galleries, London
1991  William Jackson Gallery, London

**274**  *Emerging Image*
signed and dated 1962 (verso)
oil on canvas  76 × 101 cm
purchased 1962

## Margaret Marks

b.1899 Cologne
d.1990 London

Studied in Cologne and Dusseldorf and at the Bauhaus School, Weimar; she also taught in Cologne before setting up a pottery factory, with her husband Gustav Loebenstein, in Berlin in 1924.

She arrived in England in 1936 and settled in Stoke-on-Trent where she painted, taught and again set up a factory which she transferred to London in 1946.

**Selected Exhibitions**
1936  Burslem School of Art, Stoke-on-Trent
1938  Brygos Gallery, London
1960  Ben Uri Art Society, London
1978 & 1984  University College, Cardiff
1985  Bury St Edmunds Art Gallery, Suffolk
1992  John Denham Gallery, London

**275**  *Flowers, Still Life*
signed *c.*1980
watercolour  46 × 36 cm
presented by the artist 1980

**276**  *Composition*
nine ceramic tiles  46 × 46 cm
presented by the artist

## Helena Markson

b.London
lives in Israel

Helena Markson settled in Israel in 1969. She taught at Bezalel and was a Senior Lecturer at Haifa University.

**Selected Exhibitions**
1983  Debel Gallery, Ein Kerem, Israel

**277**  *Faulkner Square*
signed
felt tip pen  36.5 × 49 cm
purchased

## Moshe Maurer

b.1891 Brody, Russia
d.1971 London

Maurer left Russia for Holland in 1914 and settled in Antwerp where he stayed until 1940. He began to paint in 1950, ten years after his arrival in England.

**Selected Exhibitions**
1957  Ben Uri Art Society, London
1965  Galerie Hilt, Basel
1970 & 1971  Mercury Gallery, London
1985  Ben Uri Art Society, London
        (with Perle Hessing, Dora Holzhandler, and Scottie Wilson)

**278**  *UFO in a Russian Village*
signed and dated July 1971
oil on canvas  50 × 60 cm
presented

278  Moshe Maurer  *UFO in a Russian Village*

## Phineas Leopold May

b.1906 Westcliff-on-Sea, Essex
lives in London

At the age of fifteen Phineas May took a postal course at the London School of Cartoonists and later studied part-time at the Central School. Since 1935 he has been involved in Jewish communal service and was Custodian of the Jewish Museum in London until 1991. Whilst serving in the British Army in World War II he produced 400 cartoons which are now preserved at the Imperial War Museum. *A Cartoon History of Anglo-Jewry* was published in 1980 and he has illustrated the three volumes of Michael Dine's *The Jewish Joke Book*, 1986–88.

*Collection of Cartoons*
signed
various dates, media, sizes
presented by the artist 1987

## Rivka Mayer

b.1938 Cannakale, Turkey
d.1990 Israel

Emigrated to Israel in 1948 and studied at Bezalel; later attended St Martin's.

**Selected Exhibitions**
1975  Ben Uri Art Society, London

*Trees*
signed (in Hebrew) and dated 1975
collage  42.5 × 47.5 cm
purchased with the assistance of
Dr Israel Feldman

## Anna Mayerson

b.1906 Austria
d.1984 London

Studied at the Kunstgewerbemuseum, Zurich and at the Art Academy in Vienna. After settling in London in 1938 she studied at the Slade. She lived in Taormina, Sicily, 1949–59.

**Selected Exhibitions**
1940–4  Leger Gallery, London
1942  Modern Art Gallery, London
1946  Redfern Gallery, London
(with Graham Sutherland, Jankel Adler and Ubac)
1961  Galleria Odyssia, Rome
1972  Annely Juda Fine Art, London

281 Anna Mayerson *Untitled*

281 *Untitled*
signed and dated 1960
acrylic on board  122 × 102 cm
presented by Chinita Abrahams-Curiel
1987

## Else Meidner

b.1901 Berlin
d.1987 London

Else Meidner studied in Berlin 1918–25 and spent two years in Cologne before coming to England in 1939. She settled in London, together with her husband Ludwig (*q.v.*), and remained in this country after he returned to Germany in 1952. She was in Darmstadt for one year in 1963.

**Selected Exhibitions**
1949  Ben Uri Art Society, London
(with Ludwig Meidner)
1955  Frankfurter Kunstkabinett, Frankfurt
1959  Beaux-Arts Gallery, London

1964 & 1972  Ben Uri Art Society, London
1969  Justus-Liebig Haus, Darmstadt

**Selected Bibliography**
J. P. Hodin. *Aus den Erinnerungen von Else Meidner*, Darmstadt 1979

282 *Woman with Hat*
oil on board  82 × 67 cm
purchased with the assistance of Ethel Solomon 1950

## Ludwig Meidner

b.1884 Bernstadt, Germany
d.1966 Darmstadt

Studied in Breslau in 1903 and later in Berlin and Paris. He came to England in 1939 and returned to Germany in 1952, living in Frankfurt until 1963 when he moved to Darmstadt.

**Selected Exhibitions**
1949  Ben Uri Art Society, London
(with Else Meidner)

289 Bernard Meninsky *Two Women and a Child*

**Ludwig Meidner** (continued)

1965 Galleria del Levante, Milan and Rome
1985 Kunstverein Wolfsburg, West Germany

**Selected Bibliography**
Gerda Breuer, Ines Wagemann. *Ludwig Meidner, Zeichner, Maler, Literat 1884–1966*, Stuttgart 1991

*Portrait of a Girl*
signed and dated 2/9/22
charcoal on buff paper 70.5 × 53 cm
presented by Cyril J. Ross 1950

## Abraham Melnikov

b.1892 Bessarabia, Russia
d.1960 Haifa

Studied medicine briefly in Vienna before emigrating to the United States where he entered the Chicago Art School. In World War I he served in Palestine with the Jewish Legion. He remained in Palestine, settling in Jerusalem where he founded an art school, until 1934. During his subsequent twenty-five years in London he executed portrait heads of many personalities including Winston Churchill, Ernest Bevin and Mordecai Eliash. He was also a writer of both prose and verse. He returned to Israel shortly before his death.

**Selected Exhibitions**
1936 Beaux-Arts Gallery, London
1982 University of Haifa, Israel

*Adolph Michaelson*
bronze height: 37 cm
(excluding wood base)
commissioned by the Society 1937

*Head of a Yemenite Jew*
signed (with monogram)
bronze height: 37 cm
presented by Mrs R. Samuels

*Torso*
bronze height: 59.7 cm
presented by Mrs R. Samuels

## Bernard Meninsky

b.1891 Karotopin, Ukraine
d.1950 London

Meninsky, born Menushkin, was six weeks old when his family settled in Liverpool where he studied briefly at the School of Art. He was awarded a grant to study in Paris and on his return entered the Slade, but left shortly after to teach drawing in Florence. Subsequently he taught drawing at the Central School and Westminster School of Art until 1939. During World War I he became an Official War Artist. He eventually took his own life.

**Selected Exhibitions**
1919 Goupil Gallery, London
1934–50 Zwemmer Gallery, London
1951–2 New Burlington Galleries, London
1957 Ben Uri Art Society, London
      (with Jankel Adler and Mark Gertler)
1976 Belgrave Gallery, London
1981 Museum of Modern Art, Oxford
      since 1978 Blond Fine Art, London
1990 Belgrave Gallery, London

**Selected Bibliography**
*Mother and Child : 28 Drawings by Bernard Meninsky*, London 1920
John Russell Taylor. *Bernard Meninsky*, Bristol 1990

287 *Portrait of a Girl*
signed
watercolour 48.5 × 43.5 cm
presented by Herbert H. Marks 1957

288 *Family Group*
signed
gouache 54 × 36 cm
purchased 1948
Exhibited:
The Arts Council, London 1947
Camden Arts Centre, London 1985
City Museum and Art Gallery,
Plymouth 1993

289 *Two Women and a Child*
signed and dated 1913
pencil and wash 32.5 × 25.5 cm
presented by Mary Cohen 1948

## Zygmunt Menkes

b.1896 Lvov, Poland
d.1986 New York

Studied at the Institute of Decorative Arts in Lvov and at the Academy of Art in Cracow before moving to Paris in the 1920s. He emigrated to the United States in 1939 and settled in Riverdale, New York.

**Selected Exhibitions**
1928 Le Portique, Paris
1936–54 Associated American Artists'
      Gallery, New York
1941 Durand-Ruel Gallery, New York
1942 Georgette Passedoit Gallery, New York

**Selected Bibliography**
Émile Tériade. *Sigmund Menkes*, Paris, n.d.

290 *The Scroll of the Law*
oil on board 69 × 49 cm
presented

## Renate Meyer

b.1930 Berlin

Renate Meyer came to London as a child and studied at the Regent Street Polytechnic, London. She emigrated to Israel in 1948 and studied at Bezalel. She then returned to London and studied at St Martin's.

**Selected Exhibitions**
1960 Ben Uri Art Society, London

291 *Costume Design*
pen and ink 34 × 22.5 cm
presented by the artist

## Gregoire Michonze

b.1902 Kishineff, Russia
d.1982 Paris

Michonze started his career as an icon painter and some years later, in Bucharest, worked on stage designs. He settled in Paris in 1922, serving in the French Army during World War II and was a prisoner-of-war in Germany for three years.

### Selected Exhibitions
1947 Mayor Gallery, London
1948 French Institute, Edinburgh
1953 Chez Mayo, Paris
1959 Adams Gallery, London
1962 Galerie Paul Vallotton, Lausanne, Switzerland
1985 Musée d'Art Moderne, Troyes

292 *Village People*
signed and dated 1952
oil on canvas 25 × 20.5 cm
presented by J. C. Gilbert 1979

## Mindel

293 *The Village*
oil on canvas 30 × 37.5 cm
purchased 1934

294 Maurice Minkowski *Portrait of Mosheh Oved*

## Maurice Minkowski

b.1881 Warsaw
d.1931 New York

Deaf and dumb from the age of five Minkowski studied for four years at the Academy of Art, Cracow and spent his life portraying the suffering of Jews in his native Poland. His work was exhibited in Antwerp, Dusseldorf and Paris; in 1929 Godfrey Phillips gave him a one-man show.

294 *Portrait of Mosheh Oved*
signed and dated 1924
watercolour 30 × 37.5 cm
presented by Mosheh Oved 1929

295 *Tisha B'av*
signed and dated 1927
watercolour 53.5 × 74.5 cm
purchased 1929

295 Maurice Minkowski *Tisha B'av*

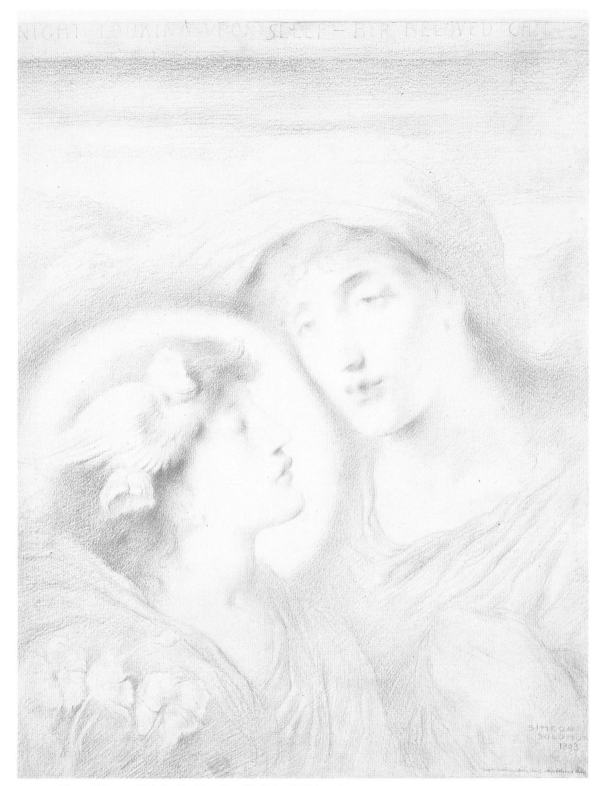

PLATE VII  Simeon Solomon  *Night Looking Upon Sleep Her Beloved Child* cat.384

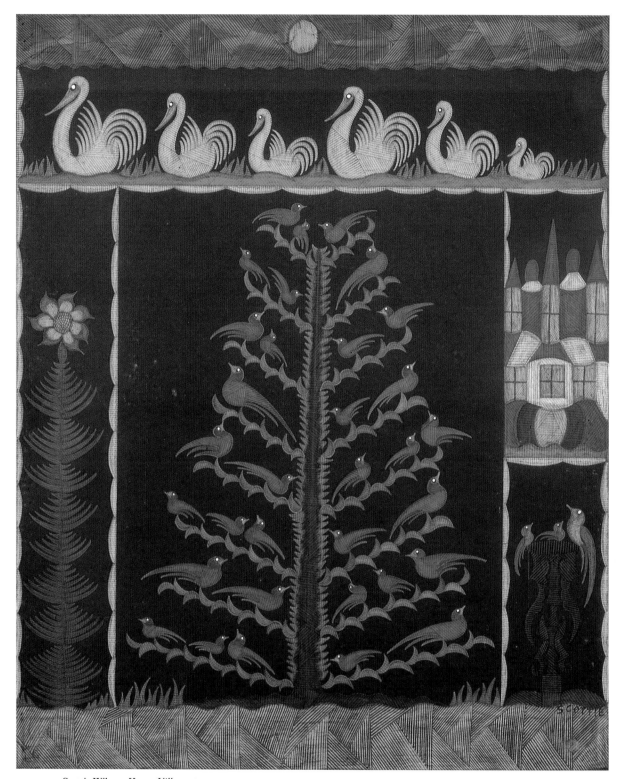

PLATE VIII  Scottie Wilson  *Happy Village* cat.429

## Abraham Mintchine
b.1898 Kiev, Russia
d.1931 La Garde, France

At the age of thirteen Mintchine was apprenticed to a goldsmith, but three years later began painting and moved to Berlin in 1923 where he spent two years. He settled in Paris in 1926 and moved to Provence in 1929.

**Selected Exhibitions**
1929 Galerie Zborowski, Paris
1931 Salon des Tuileries, Paris
1938 Union of Jewish Artists, Paris
1947 Gimpel Fils, London
    (with Jean Lurçat)
1950 Galerie Zak, Paris
1060 & 1964 McRoberts and Tunnard,
    London
1969 Galleria Lorenzelli, Bergamo
1970 Galleria San Fedele, Milan

296 Abraham Mintchine *Landscape*

6 *Landscape*
signed
watercolour and pencil  31 × 19.5 cm
presented by Gimpel Fils 1956

## Mordecai Moreh
b.1937 Baghdad
lives in Paris

Emigrated to Israel in 1951 and entered the Bezalel School of Arts and Crafts, Jerusalem; he continued his studies at the Accademia di Belle Arti, Florence and at the École des Beaux-Arts, Paris. He has concentrated on printmaking since 1962.

**Selected Exhibitions**
1966 Weyhe Gallery, New York
1971 XI Biennal de São Paulo
1972 Kurpfälzisches Museum, Heidelberg
1974 Israel Museum, Jerusalem
1974 Tel Aviv Museum of Art

7 *Wooden Horse*
signed and dated 1983
etching  23.5 × 30 cm
presented by Jonathan Stone 1983

## Adam Muszka
b.1914 Piotrokov, Poland

In Tashkent during World War II, Muszka returned to Poland in 1945 and settled in Lodz. He moved to Paris in 1967.

**Selected Exhibitions**
1971 Ben Uri Art Society, London

298 *Leaving Cheder*
signed
oil on board  60.5 × 49.5 cm
purchased

## Hyam Myer
b.1904 Manchester
d.1978 London

Son of Rumanian immigrants Myer studied at the Slade, 1920–22, continuing his studies in Munich and Paris. Between the wars he had a studio in Southern France and after World War II he taught at the Central, at St Martin's and at the RCA.

**Selected Exhibitions**
1924 Alpine Club, London
    (with Jan Juta, Frank Potter,
    Horace Brodzky, Adrian Daintry)
1928 Warren Gallery, London
1930 Goupil Gallery, London
    (with Dora Crockett)

299 *House Among Trees*
signed and dated 1927
oil on canvas  45.5 × 54.5 cm
purchased 1930

300 *Old Man*
signed and dated 1923
charcoal 62.5 × 51.5 cm
purchased 1930

## Elie Nadelman
b.1882 Warsaw
d.1946 New York

After serving in the Russian Army, Nadelman studied at the Warsaw Art Academy. He settled in Paris in 1904 and in 1914 emigrated to the United States, making his home in New York.

**Selected Exhibitions**
1949 Museum of Modern Art, New York
1967 Zabriskie Gallery, New York
1975 Whitney Museum of American Art,
    New York

**Selected Bibliography**
William Murrell. *Elie Nadelman*, New York 1923
L. Kirstein. *Elie Nadelman Drawings*, New York 1949
L. Kirstein. *Elie Nadelman*, New York 1973

301 *The Swan*
signed and numbered 150
pencil and grey wash  22 × 19 cm
presented

## Abraham Newman

b.1907 Liverpool

Studied at the Liverpool School of Art and the RCA, 1927–35. Served in the RAF during World War II.

**Selected Exhibitions**
1975 Alexander Postan Fine Art, London
1979 Academy of Arts, Liverpool and Atkinson Art Gallery, Southport
1982 Ben Uri Art Society, London

302 *Portrait of Janet*
signed
gouache and watercolour 54 × 36 cm
presented by the artist

## Erna Nonnenmacher

b.1889 Berlin
d.1980 London

Studied in Berlin and Brunzlau before emigrating to England in 1938.

303 *Maternity*
signed with monogram
plaster height: 41.3 cm
presented by Ethel Solomon

304 *Head of a Woman*
signed
terracotta height: 35 cm
presented by Ethel Solomon

305 *Maternity*
terracotta height: 40 cm
presented by Ethel Solomon

## Avraham Ofek

b.1935 Bourgas, Bulgaria
d.1990 Jerusalem

Emigrated to Israel in 1949 and settled in Kibbutz Ein Hamifratz; studied at the Accademia di Belle Arti, Florence 1958–60 and travelled in Europe and the United States. In 1962 he was appointed Lecturer at Bezalel and in 1976 became Professor of Art at the University of Haifa.

**Selected Exhibitions**
1957 Bezalel National Museum, Jerusalem
1959 Palazzo Strozzi, Florence
1970 Artists' House, Jerusalem
1972 XXXVI Biennale di Venezia
     Tel Aviv Museum of Art
1973 Jewish Museum, New York

307 Joseph Oppenheimer *Piccadilly Circus*

1974 Ben Uri Art Society, London
1988 Herzliya Museum
1989 Artists' House, Jerusalem

**Selected Bibliography**
A. Ronen. *Avraham Ofek: The Murals at Kfar Uriah*, Jerusalem

306 *Figure Study*
signed
etching 2/70 12 × 15.5 cm
presented by the artist

## Joseph Oppenheimer

b.1876 Wurzburg, Germany
d.1966 Montreal, Canada

Oppenheimer studied in Munich and spent periods of time in Italy, France and Canada. He moved to England in 1896 and taught at the London School of Arts. He set up studio in Berlin during the interwar years and was a member of the Berlin and Munich Secession. He returned to England in 1933. A portrait painter, he exhibited regularly at the Royal Academy and the Royal Society of Painters.

**Selected Exhibitions**
1957 & 1963 O'Hana Gallery, London
1990 David Bathurst, London

307 *Piccadilly Circus*
signed
mixed media 39 × 50 cm
presented by the artist

## Emil Orlik

b.1870 Prague
d.1932 Berlin

Studied privately and at the Academy of Art, Munich, 1889–93. Whilst maintaining studios in Prague, 1897–1904 and Vienna 1904–05, he travelled frequently in Europe and made an extensive visit to Japan in 1900. He settled in Berlin in 1905.

**Selected Exhibitions**
1970 Wilhelm-Lehmbruck Museum der Stadt Duisburg
1980 & 1982 Galerie Glöckner, Cologne
1982 Museum der Stadt, Bad Hersfeld, West Germany
1986 Margaret Fisher, London

308 *Head of a Man*
signed
lithograph 31 × 26 cm

308 Emil Orlik *Head of a Man*

## Gerald Ososki

b.1903 London
d.1981 London

Born in the East End of London, Ososki won a scholarship to the RCA where he studied from 1922–26. He ran a successful decoration and restoration business and only became free to pursue his career in painting in 1970.

**Selected Exhibitions**
1929 & 1930 Claridge Gallery, London
1972 & 1973 Mall Galleries, London
1982 The artist's home, Hampstead, London
1983 Alpine Gallery, London
1987 Ben Uri Art Society, London

*Bella*
signed and dated 1928
oil on canvas 90 × 70 cm
presented by Barnett Freedman CBE 1950

309 Gerald Ososki *Bella*

## Mosheh Oved

b.1885 Poland
d.1958 London

On arrival in England *c*.1902, Edouard Goodack changed his name to Good but became known as Mosheh Oved. After a year or two working for a watch-repairer in London he opened his own shop, Cameo Corner, in Museum Street. He became an authority on cameos and was especially interested in antique watches and clocks. He was also a writer and poet, and a founder-member of the Ben Uri Art Society.

**Selected Bibliography**
Mosheh Oved. *Visions and Jewels*, London 1923 (reprinted 1952)
Mosheh Oved. *Gems and Life*, London 1925

310 *Head*
bronze with green patina
height: 36.83 cm
presented by the artist

311 *Menorah*
bronze with gilt patina   height: 40.64 cm
presented by the artist

## David Peretz

b.1906 Bulgaria
d.1979 France

Studied at the Academy of Fine Arts, Sofia before settling in Paris in 1947. He was awarded the Premier Prix d'Israel in Paris in 1952 and sometime later settled in Toulon.

**Selected Exhibitions**
*c*.1952  Galerie Bernheim, Paris
1955  Redfern Gallery, London
1958 & 1962  Crane Kalman Gallery, London
1959  Le Musée, Toulon, France

312 *A View of a Village in a Landscape*
signed and dated 1955
oil on canvas  45 × 54 cm
presented by Manusia Gildesgame 1982

313 *Landscape Near Varre*
signed and dated 1956
oil on canvas  49 × 64 cm
presented by Manusia Gildesgame 1982

313 David Peretz *Landscape Near Varre*

## Leopold Pilichowski

b.1866 Pila bei Sieradz, Poland
d.1933 London

Painter of Jewish types and genre scenes, Pilichowski was taught to draw by his relation Samuel Hirszenberg (*q.v.*). Lived for a time in Paris, studied with Benjamin Constant. Exhibited in Paris, London, New York and Warsaw. Awarded Legion of Honour. Came to London in 1914. President of the Ben Uri Art Society 1926–32.

**Selected Exhibitions**
1926  Whitechapel Art Gallery, London
1927  Warsaw

314 *Hear O Israel*
signed
oil on board  30 × 20.5 cm
purchased 1924

315 *Old Man in a Blue Smock*
oil on canvas  59.5 × 49 cm
presented

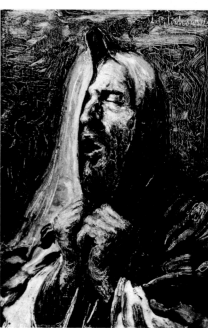

314 Leopold Pilichowski *Hear O Israel*

315 Leopold Pilichowski *Old Man in a Blue Smock*

316 Leopold Pilichowski *A Floral Tribute*

*A Floral Tribute*
signed and dated 1931
pastel  53 × 36 cm
presented

*The Pipe Smoker*
signed
etching  26 × 13 cm
presented

## Lena Pillico

b.1884
d.1947 Oxford

Lena Pillico was the wife of Leopold Pilichowski (*q.v.*). She was a prominent member of the Seven and Five Society 1920–35 along with Ben Nicholson and Henry Moore.

318 *Outhouses*
signed
oil on canvas  49 × 64 cm
presented

## Jacob Pins

b.1917 Höxter, Germany
lives in Israel

Emigrated to Palestine in 1936 and studied with Jacob Steinhardt in Jerusalem in 1941. He was on the staff of Bezalel from 1956. He visited Japan in 1962 and formed an important collection of Japanese prints, now in the Israel Museum.

**Selected Exhibitions**
1945–56  Ben Baruch Gallery, Tel Aviv
1953  Boston Public Library, Massachusetts
1960  Bezalel National Museum, Jerusalem
        Mercury Gallery, London
1969  Israel Galerie, Amsterdam
1974  Magnes Museum, Berkeley, California
1979  Ben Uri Art Society, London
1985  Israel Museum, Jerusalem
1989  Höxter-Corvey Museum, Germany
1993  Herzliya Museum of Art

319 *The Cock*
signed and dated 1954
woodcut print 1/38  53.5 × 28.5 cm
presented by Dr Alec Lerner

## Camille Pissarro

b.1830 St Thomas, Virgin Islands
d.1903 Paris

Was sent to Paris in 1842 to be prepared to enter the family business. He returned to St Thomas in 1848 and later travelled in South America, painting and drawing. He settled in Paris in 1855 and moved to Eragny, near Gisors, Normandy in 1884.

**Selected Exhibitions**
1980–1  Hayward Gallery, London,
         Grand Palais, Paris and
         Museum of Fine Arts, Boston, Mass.
1984  Isetan Museum of Art, Tokyo
1993  Royal Academy of Arts, London

**Selected Bibliography**
H. Gunther. *Camille Pissarro*, Munich/
Vienna/Basel 1954
J. Rewald. *Pissarro*, London/New York 1963
K. Adler. *Camille Pissarro: A Biography*,
London 1978
R. Shikes and P. Harper. *Pissarro: His Life
and Work*, New York/London 1980
Christopher Lloyd. *Camille Pissarro*,
Geneva/London 1981

320 *Scène de Ferme*
stamped with monogram
pen and ink  11.5 × 20 cm
presented by Alexander Margulies 1949
Exhibited:
Jewish Museum, Paris 1957
Portland Gallery, London 1993, cat.9

## Lucien Pissarro

b.1863 Paris
d.1944 Hewood, Somerset

Son of Camille (*q.v.*), Lucien had little formal training in art, but painted with his father and briefly studied wood-engraving in 1884. He settled in England in 1890, spending several months of each year in France. In 1894 he founded the Eragny Press.

**Selected Exhibitions**
1913  Carfax Gallery, London
1922–46  Leicester Galleries, London
1935  Manchester City Art Gallery
1954  O'Hana Gallery, London
1963  Arts Council Gallery, London
1977 & 1983  Anthony d'Offay, London

**Selected Bibliography**
Camille Pissarro. *Letters to his Son, Lucien*,
New York/London 1943
Anne Thorold. *Catalogue of the Oil Paintings
of Lucien Pissarro*, limited edition, London
1943
W. S. Meadmore. *Lucien Pissarro: Un Cœur
Simple*, London 1962

321 *The Pagoda, Kew*
signed (with monogram) and dated 1919
oil on canvas  52 × 42.5 cm
presented by Ethel Solomon

## Fay Pomerance

b.1912 Birmingham
lives in Sheffield

Studied at the Birmingham School of
Art, 1929–32 and at the Sheffield College
of Art in the 1960s. She has travelled in
Europe and Scandinavia and paid several
visits to Israel.

**Selected Exhibitions**
1947  Sheffield International Centre
1952  Archer Gallery, London
1956–81  Ben Uri Art Society, London
1962  Sheffield University Library Gallery
1963  Laing Art Gallery, Newcastle upon
        Tyne
1983  St James's Church, Piccadilly, London

322  *Lucifer Reviews Sodom*
signed and dated 1959
gouache  49 × 59.5 cm
presented by the artist

## Adèle Reifenberg

b.1893 Berlin
d.1986 London

Studied in Weimar, 1911–15 and lived in
Berlin before leaving Germany with her
husband, the painter Julius Rosenbaum
(*q.v.*), in 1939. They settled in London
where they established an art school.

**Selected Exhibitions**
1950  Ben Uri Art Society, London
        (with Julius Rosenbaum and
        Ruth Collet)
1961  Ben Uri Art Society, London
        (with Erich Doitch and
        Emmanuel Levy)
1983  Margaret Fisher, London

323  *Eastbourne at Dawn*
signed
oil on board  48 × 67 cm
presented by the artist 1981

323  Adèle Reifenberg  *Eastbourne at Dawn*

## Steffa Reis

b.1931 Berlin
lives in Tel Aviv

Steffa Reis came to England as a child in
1937 where she studied at Harrow
School of Art, London. She was in
Egypt and Cyprus before emigrating to
Israel in 1957 when she joined the Safed
Artists' Colony.

**Selected Exhibitions**
1974  Municipal Cultural Centre, Kfar Saba,
        Israel
1976  Ben Uri Art Society, London
1978  Nora Art Gallery, Jerusalem
1981  Soho Art Gallery, New York
1982  Cité États Nationale des Arts, Paris
1986  Gallery 10, London

324  *Landscape*
signed
acrylic on canvas  36 × 59 cm
presented by the artist

## Lotti Reizenstein

b.1904 Nuremberg
d.1982 London

Studied in Nuremberg and Berlin and,
after her arrival in London in 1936, at
St Martin's where she was taught by
Kokoshka.

**Selected Exhibitions**
1949–83  Ben Uri Art Society, London
        (1956 with Eric Doitch and
        Fritz Kramer)
        (1978 with Ruth Collet and
        Frances Baruch)
        (1983 with Jack Bilbo and
        Henry Sanders)
1960  Italian State Tourist Office, London
1966  Galerie Trojanski, Dusseldorf
1976  Margaret Fisher, London
1987  Ben Uri Art Society, London
        (with Iris Blain)

325  *Evening in Taormina, Sicily*
signed
oil on board  53 × 62.5 cm
bequest of the artist

326  *Flowers in a White Vase*
signed
oil on canvas  60 × 50 cm
bequest of the artist

*The Holy Family*
oil on canvas  49.5 × 39.5 cm
bequest of the artist

*The Gate*
signed
watercolour  44 × 60 cm
bequest of the artist

*Still Life with Fruit and Flowers*
signed (with monogram) and dated 1945
watercolour  57 × 76 cm
bequest of the artist

*Piccadilly Circus*
signed
coloured crayons  30 × 40 cm
bequest of the artist
Exhibited:
Camden Arts Centre, London 1986

## Claude Rogers OBE
b.1907 London
d.1979 London

Studied at the Slade, 1925–28, and was
a founder-member of the Euston Road
School, together with William
Coldstream and Victor Pasmore. He was
part-time lecturer at the Camberwell
School of Arts and Crafts in 1945 and
from 1948–63 was visiting lecturer at the
Slade. He was president of the London
Group, 1952–65 and Professor of Fine
Art at the University of Reading 1963–
72. In 1959 he was awarded the OBE.

### Selected Exhibitions
1940–60  Leicester Galleries, London
1955  Hatton Gallery, Newcastle upon Tyne
1973  Whitechapel Art Gallery, London
1975  Fischer Fine Art, London
1978–9  Bury St Edmunds Art Gallery,
       Suffolk
1984  Gillian Jason Gallery, London
1992–3  Ben Uri Art Society, London and
       tour

*Piazza Signoria Florence*
signed and dated 1951
pencil drawing  24.5 × 18.5 cm
purchased

335  Marcel Ronay  *Night Scene in Capri*

## Maurice Mancini Roith
b.1900 London
d.1958 London

Worked as a scene painter at Covent
Garden Opera House whilst studying
under Walter Sickert and Bernard
Meninsky. He became a businessman,
but continued to paint.

### Selected Exhibitions
1979  Ben Uri Art Society, London (aboard
      the *Tattershall Castle* on the Thames)

332  *Collection of 9 Paintings*
oil on canvas (various sizes)
presented by the artist's widow

333  *Still Life with Rooftops*
oil on board  40.5 × 51 cm
presented by the artist's widow

## M. Rom

334  *Barnyard Scene*
signed and dated 1919
oil on canvas  21.5 × 30.5 cm
presented by W. L. Goldstein 1986

## Marcel Ronay
b.1910 Budapest
lives in Woodford Halse, Northants

Ronay's family left Budapest when
Marcel was a child and moved to Berlin
before settling in Vienna where he
received his education and served an
apprenticeship with a master carver. He
later studied at the Kunstgewerbeschule.
Ronay has spent most of his life working
in the family business designing and
decorating porcelain jewellery, the
majority of his art work having been
completed prior to his arrival in England
in 1936. His work has been exhibited at
the Vienna Secession and at the Royal
Academy of Arts, London.

### Selected Exhibitions
1986  Ben Uri Art Society, London

335  *Night Scene in Capri*
oil on canvas  78 × 67 cm
presented by the artist 1986

## Willi Rondas

b. Brussels

After early musical studies Rondas trained as an architect in Paris and practised in the Belgian Congo, returning to Paris in 1931. He arrived in England in 1939 and later settled in London.

**Selected Exhibitions**
1948 Leicester Galleries, London
1961 Galerie d'Egmont, Brussels
     Ben Uri Art Society, London
1966 John Whibley Gallery, London

336 *St Helen's Cottage, Hampstead*
signed and dated 1950
oil on gesso 56 × 42 cm
presented by
Mr and Mrs Pierre Gildesgame

337 *Vale of Health*
oil on board 55 × 84.5 cm
presented by Ethel Solomon

336 Willi Rondas *St Helen's Cottage, Hampstead*

# Joe Rose BEM

b.1915 Woldenberg, Germany
lives in Tasmania

Joe Rose was in a concentration camp prior to leaving Germany for England in 1939. He studied at the Hausdorf Art School, Berlin and after serving in the British Army obtained a Diploma of Art in London. In 1957 he emigrated to Australia where he lived for seventeen years, returning to London in 1972 in which year he was awarded the British Empire Medal for services to art.

## Selected Exhibitions

1962–66 Barry Stern Galleries, Sydney, Australia
1965 Quantas Gallery, New York
1972 Fieldborne Galleries, London
1977 Ben Uri Art Society, London
1978 Galerie 3 + 2, Paris
1980 Obelisk Gallery, London
1982 Wilma Wayne Gallery, London (with Michel de Saint Ouen)
1986 Artists' House, Jerusalem
1987 Ben Uri Art Society, London
1993 Freeman Gallery, Tasmania

## Selected Bibliography

Michael Bullock. *Alchemies: Joe Rose*, limited edition, London, Sydney, Vancouver, n.d.

*The Frailty of All Things*
signed and dated 1976
oil on canvas 11 × 74.5 cm
presented by the artist 1979

*Celestial Body*
signed and dated 1977
charcoal and white chalk 100 × 74.5 cm
purchased

# Julius Rosenbaum

b.1897 Neuenburg, Germany
d.1956 The Hague

Rosenbaum studied in Paris, Munich and in Berlin, under Lovis Corinth. Forbidden to paint by the Nazis he taught woodwork and metalwork at Jewish schools until able to leave Germany for England in 1939. On his arrival in London he found work repairing houses and restoring china until, together with his wife, painter Adèle Reifenberg (*q.v.*), he established an art school.

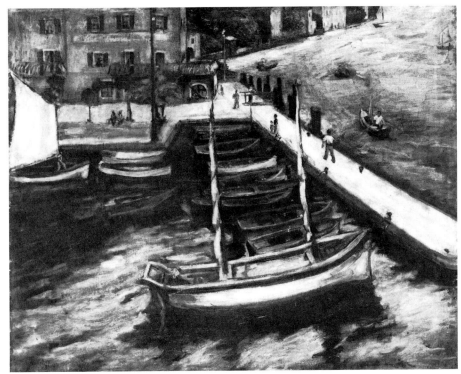

340 Julius Rosenbaum *Harbour*

## Selected Exhibitions

1950 Ben Uri Art Society, London (with Adèle Reifenberg and Ruth Collet)
1957 & 1968 Ben Uri Art Society, London

340 *Harbour*
signed and dated 1936
oil on canvas 69.5 × 85 cm
presented by the artist's widow

341 *Portrait of Charlotte*
signed and dated 1945
oil on canvas 79.5 × 52 cm
presented by Dr Alec Lerner and Lord Marks 1950
Exhibited:
Camden Arts Centre, London 1986

342 *Florence*
signed and dated 1905
watercolour 24 × 30 cm
presented by the artist's widow

343 *Boy with a Basket*
signed (on mount) and dated 1904
etching and drypoint 16.5 × 11.5 cm
presented by the artist

341 Julius Rosenbaum *Portrait of Charlotte*

## Cyril Joshua Ross OBE

b.1892 London
d.1973 London

Cyril Ross, a successful businessman and philanthropist, was self-taught in art and only began painting at the age of forty. He was treasurer of the Ben Uri Art Society for many years.

**Selected Exhibitions**
1945 Whitechapel Art Gallery, London
1951 Galerie Bernheim Jeune, Paris
1952 Royal Society of Painters in Water Colours, London
1954 Royal Institute Galleries, London
1968 & 1972 Ben Uri Art Society, London

**344** *Portrait of Alfred Wolmark*
signed
oil on board  37 × 29 cm
presented by the artist

## Joseph Ross

b.1911 Holland
lives in Tel Aviv

Ross emigrated to Palestine in 1935. His cartoons have appeared in numerous journals and newspapers including *Haaretz* and *The Jerusalem Post*.

**Selected Exhibitions**
1950 & 1975 Ben Uri Art Society, London
1967 Museum of the History of Tel Aviv
1978 Tel Aviv Municipality

**345** *Portraits of Notable Jewish Personalities*
signed
cartoon drawings and coloured lithographs
various sizes
presented by the artist

**346** *Two Rabbis*
signed (in Hebrew)
pen and wash  28 × 20.5 cm
presented by the artist

344  Cyril Joshua Ross  *Portrait of Alfred Wolmark*

347  Anthony Rossiter  *Head of a Child : Annalisa*

## Anthony Rossiter

b.1926
lives in Litton, Somerset

After serving in the Welsh Guards during World War II Rossiter studied at Chelsea Polytechnic, 1947–51. He travelled in the United States on a scholarship in 1962.

**Selected Exhibitions**
1959 Galerie de Seine, Paris
1967 Reading Museum and Art Gallery and Bath Festival of Arts
1968–72 John Wibley Gallery, London
1971 Christ Church, Oxford
1972 Hambledon Gallery, Blandford, Dorset

**Selected Bibliography**
Anthony Rossiter. *The Pendulum*, autobiography, London 1966
Anthony Rossiter. *The Golden Chain*, London 1970

**347** *Head of a Child : Annalisa*
signed and dated 23 August 1960
pencil drawing  18 × 13.5 cm
presented

## Sir William Rothenstein

b.1872 Horton, Yorkshire
d.1945 Far Oakridge, Gloucestershire

Studied at the Slade before going to Paris for four years where he entered the Académie Julien. He settled in London in 1894 and during the years 1906–12 travelled in Italy, India and the United States. He was appointed Official War Artist in both World Wars I and II, and was principal of the RCA, 1920–35. He was knighted in 1931.

**Selected Exhibitions**
1891 Boulevard Malesherbes, Paris (with Charles Conder)
1930 XVII Biennale di Venezia
1950 Tate Gallery, London
1990 Max Rutherston, London

**Selected Bibliography**
John Rothenstein. *Modern English Painters*, London 1957
Robert Speaight. *William Rothenstein*, London 1962
*Men and Memories. Recollections of William Rothenstein* 2 vols, London 1932

**348** *Portrait of Moritz Rothenstein*
(the artist's father)
signed and dated 1896 (in the stone)
lithograph  35 × 44.5 cm
presented by
Mr and Mrs Barry Fealdman

## Annette Rowdon

b.1931 Berlin
lives in London

Annette Rowdon's family left Germany
in 1938 and after two years in Stockholm
settled in the United States. She studied
German literature at Bryn Mawr
College, Pennsylvania and sculpture at
the Accademia di Belle Arti, Rome.
Having moved to London, she entered
the Central School. She was Artist-in-
Residence at Wilson College,
Chambersburg, Pennsylvania, 1978,
Assistant Professor of Art, Marlboro
College, Vermont, 1980–85 and since
1985 has been teaching at Chelsea
School of Art and the Leisure Centre,
Hammersmith. She spent eight months
in West Berlin in 1983 and lives for
several months each year in Pietrasanta,
Italy where she works and teaches and
where she supervises the casting of her
bronzes.

### Selected Exhibitions
1967 Alwin Gallery, London
(with Richard Ewen and Jason Monet)
1977 Galerie Aix, Stockholm
1978 Comfort Gallery, Haverford,
Pennsylvania
1979 Ben Uri Art Society, London
1983 Künstlerhaus Bethanien,
Berlin-Kreuzberg
1986 Ben Uri Art Society, London
(with Peter Baer)

*Spiral*
signed and dated 1985
lithograph 2/4  37 × 46.5 cm
purchased 1986

## Romulo Rozo

*Head of Betty Ross*
signed, inscribed and dated 1943,
Mexico
bronze  height: 50.5 cm
presented by the artist's estate

## Reuven Rubin

b.1893 Galatz, Rumania
d.1974 Caesarea, Israel

Left Rumania and studied at the Bezalel
Academy of Fine Arts, Jerusalem in
1912 and at the École des Beaux-Arts

351  Reuven Rubin  *Self Portrait 1937*

and the Académie Collaressi, Paris,
1913–14. He also studied in Italy and
returned to Rumania for a short while
before settling in Palestine in 1922. He
worked on stage and costume designs for
Habimah and other theatrical companies
and was co-founder of the Association of
Painters and Sculptors.

### Selected Exhibitions
1920 Anderson Gallery, New York
1932 Tel Aviv Museum of Art
1962 Wildenstein and Company, New York
1966 Israel Museum, Jerusalem and
Tel Aviv Museum of Art

### Selected Bibliography
Alfred Werner. *Rubin*, Tel Aviv 1958
Reuven Rubin. *My Life: My Art*, New York
1969
Sara Wilkinson. *Reuven Rubin*, New York
1971

351 *Self Portrait 1937*
signed and dated 1937 (in Hebrew and
English)
oil on canvas  91 × 64 cm
purchased
Exhibited:
Rubin Museum, Tel Aviv 1993

## Albert Daniel Rutherston

b.1881 Bradford, Yorkshire
d.1953 Switzerland

Brother of William Rothenstein (*q.v.*), he studied at the Slade, 1898–1902. He served in Palestine during World War I and from 1923–27 was editor of *Contemporary British Artists*. He was Ruskin Master of Drawing at Oxford University, 1929–48 and a visiting lecturer at Camberwell School of Arts and Crafts, London.

**Selected Exhibitions**
1910 Carfax Gallery, London
1921–34 Leicester Galleries, London

**Selected Bibliography**
Reginald Gleadowe. *Albert Rutherston*, London 1925

352 *Landscape at Grasse*
signed and dated 1910
watercolour 37 × 26.5 cm
Provenance:
Leicester Galleries, London
presented by Ethel Solomon

## Issachar Ryback

b.1897 Elizabethgrad, Russia
d.1935 Paris

Studied in Kiev before moving to Moscow in 1919, where he designed sets and costumes for Moscow's Jewish Arts Theatre. After five years in Berlin he settled in Paris, in 1926.

353 *Le Repos*
signed
oil on canvas 49 × 60 cm
purchased 1935

354 *The Cock*
signed
watercolour 34 × 50 cm
purchased 1935

353 Isaachar Ryback *Le Repos*

## Ralph Sallon MBE

b.1899 Sheps, Poland
lives in London

The Sallon family came to England when Ralph was four years old and settled in London's East End. At the age of fourteen he spent one term at Hornsey School of Art. After serving in the Pioneer Corps and the Jewish Battalion in World War II he began his career as a cartoonist settling in Durban, South Africa where he worked for the *Natal Mercury*. He returned to London after two years and studied at St Martin's. He worked free-lance and then for the *Daily Herald*, moving to the *Daily Mirror* in 1948 where he remained until 1965. He was awarded the MBE in 1977.

355 *Portrait of Herbert Morrison*
signed
brush drawing with
watercolour 35.5 × 24 cm
presented

## Freda Salvendy

b.1887 Novemesto nad Vahom,
Czechoslovakia
d.1968 Malvern, Worcestershire

Studied privately under Egger-Lienz in Vienna and later in Paris. She had numerous exhibitions before leaving Europe for England in 1938.

**Selected Exhibitions**
1940 Laing Art Gallery and Museum,
Newcastle upon Tyne

356 *Prague*
watercolour 35.5 × 45.5 cm
presented

## Samuel R. Samuel

*Portrait of Rosalind Adler*
oil on canvas  126 × 85 cm
presented

## Henry Sanders
## (Helmut Salomon)

b.1918 Dresden
d.1982 London

Sanders left Germany for Holland in
1933 and settled in England in 1936. He
studied at the Hornsey School of Art,
London, prior to World War II. After
serving in the British Army, he travelled
extensively in Europe.

**Selected Exhibitions**
1954–9  Ben Uri Art Society, London
1963–5  Queenswood Gallery, Highgate,
          London
1983  Ben Uri Art Society, London (with
          Jack Bilbo and Lotti Reizenstein)

*Hampstead Heath*
signed
oil on board  48 × 59 cm
purchased 1954

*Two Young Girls Seated Side by Side*
signed and dated 24/7/68
oil on board  122 × 76 cm
presented

*Amsterdam*
signed
gouache  45 × 64.5 cm
purchased

## Pat Schaverien

b.1951, London
lives in London

Studied at the Hornsey School of Art,
London 1970–74 and the Slade, 1974–
76. She set up a printmaking studio in
Clerkenwell and in 1977 received an Arts
Council of Great Britain award.

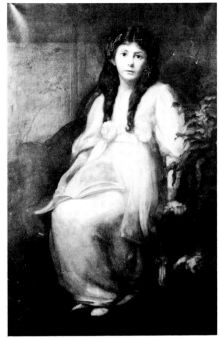

357  Samuel R. Samuel *Portrait of Rosalind Adler*

**Selected Exhibitions**
1977  Everyman Cinema Gallery,
          Hampstead, London
1979  National Film Theatre, London
1982  Ben Uri Art Society, London
          (with Goodman and Shukman)
1984  Woodlands Art Gallery, Blackheath,
          London
1990  Ben Uri Art Society, London
          (with members of the Printers Inc.
          Workshop)

361  *The Swimming Pool*
signed and dated 1982
etching and aquatint  31 × 38.5 cm
presented by Alexander Margulies 1981

## Melitta Schiffer

b.Trieste, Italy
lives in Ein Hod, Israel

Studied in Italy and later at the
Bauhaus, Weimar, emigrating to
Palestine in 1936.

**Selected Exhibitions**
1955  Tel Aviv Museum
1962  Ben Uri Art Society, London
          (with Shraga Weil)
1966  Foyer Damian, Tel Aviv

362  *Italian Landscape*
watercolour  37.5 × 55 cm
presented by the artist

## Benno Schotz

b.1891 Arensburg, Estonia
d.1984 Glasgow

Studied engineering at Darmstadt,
Germany and at Strathclyde University
on his arrival in Glasgow in 1912. He
worked in the drawing offices of a
shipyard during World War I and
attended evening classes at Glasgow
School of Art, where, in 1938, he became
Head of Sculpture and Ceramics. He
became a full-time sculptor in 1923 and
was appointed Queen's Sculptor-in-
Ordinary for Scotland in 1963.

**Selected Exhibitions**
1930 & 1938  Alex Reid and Lefevre, London
1945  Scottish Gallery, Edinburgh
1955  Bezalel National Museum, Jerusalem
1961–2  Glasgow Art Gallery
1971  Royal Scottish Academy, Edinburgh
          and Art Gallery and Museum,
          Aberdeen
1978  Glasgow Art Gallery and Museum

**Selected Bibliography**
Benno Schotz. *Bronze in my Blood: The
Memoirs of Benno Schotz*, Edinburgh, 1981

363  *Dr Alec Lerner*
bronze with green patina  height:
40.5 cm (excluding marble base)
presented by Dr Alec Lerner

## Zygmund Schreter

b.1896 Lodz, Poland

Studied in Berlin before settling in
France in 1934.

364  *Landscape*
oil on board  23 × 30 cm
presented by the artist 1955

## Arthur Segal

b.1875 Jassy, Rumania
d.1944 London

Studied in Berlin, Munich, Paris and
Italy, before settling in Berlin in 1904.
At the outbreak of World War I he was
in Ascona, Switzerland where he stayed
until 1920. He returned to Berlin and left
again in 1933 for Majorca where he spent
three years. In 1936 he arrived in
London and opened a painting school
which was temporarily transferred to
Oxford during the early years of the war.

**Selected Exhibitions**
1920  Galerie Altmann, Berlin
1925  Galerie Neumann, Berlin,
   Novembergruppe
1947 & 1950  Coolings Gallery, London
1955  RBA Galleries, London
1973  Ben Uri Art Society, London
   Adelphi Club, London
1974  Kunsthaus, Zurich
1975  Dundee City Art Gallery
1978  Fischer Fine Art, London
1987  Kölnischer Kunstverein, Cologne

**Selected Bibliography**
Ernestine Segal. *The Life and Work of Arthur
Segal, 1875–1944*, London 1955

365  *Halen: La Ciotat (Harbour Scene)*
signed and dated 1929
(verso: signed again)
oil on canvas  68.5 × 88.5 cm
Exhibited:
The Cooling Galleries, London 1950
Kölnischer Kunstverein, Cologne 1987

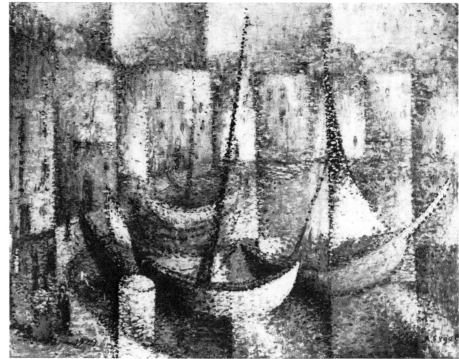

365  Arthur Segal  *Halen: La Ciotat (Harbour Scene)*

## Bruno Simon

b.Vienna
lives in Bergamo, Italy

Began his studies in Freiburg under
Julius Bissier; in Paris he worked with
Aristide Maillol and spent some time in
Florence before settling in London. He
spent World War II in Australia and has
travelled extensively in Europe, mainly
in Greece and Israel, the United States,
Mexico and the Far East. He settled in
Bergamo in 1967.

**Selected Exhibitions**
1951  Ben Uri Art Society, London
   (with Michel Kikoine and
   Zechariahu Erlichman)
1971  Goethe Institute, Milan

**Selected Bibliography**
Bruno Simon. *Sculpture: Graphics: Poems*

366  *Head of a Boy*
plaster  height: 24.13 cm
(excluding wood base)
purchased 1952

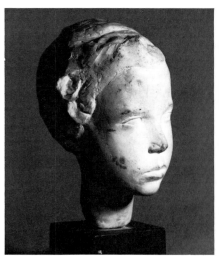

366  Bruno Simon  *Head of a Boy*

367  *Head of a Girl*
signed (with monogram) and dated 1946
terracotta  height: 22.25 cm
(excluding stone base)
purchased

368 Maurice Sochachewsky *Gail*

369 Maurice Sochachewsky *Welsh Village*

# Maurice Sochachewsky

b.1918 London
d.1969 Kent

Growing up in London's East End, he won a scholarship to St Martin's when only fourteen. He spent eight months in Wales and served with the Royal Welsh Fusiliers losing an eye as a result of wounds suffered in Normandy. He visited Israel in 1949 and lived the last years of his life in Kent.

**Selected Exhibitions**
*c.*1930 Bloomsbury Gallery, London
1953 & 1969 Ben Uri Art Society, London

*Gail*
oil on canvas 45 × 29 cm
presented by the artist

*Welsh Village*
oil on board 76.5 × 97.5 cm
presented by the artist

*Arab Café, Jaffa*
signed and dated 5 November 1949
pen, ink and wash on paper 24 × 37 cm
presented by Helen Taylor 1954

370 Maurice Sochachewsky *Arab Café, Jaffa*

95

**Maurice Sochachewsky** (continued)

371 *Fish Lake, Kfar Blum*
signed and dated 1949
pen, brush, ink and wash   23 × 39.5 cm
presented by the artist

372 *Main Street : Rishon Le Zion*
signed and dated 1949
pen and ink   24 × 34.5 cm
presented by the artist

373 *Portrait of an Old Man*
signed
charcoal   39.5 × 30 cm
presented by the artist

374 *View of Romema, Sheik Badet, Jerusalem*
signed and dated 12 November 1949
pen and ink   23.5 × 37 cm
presented by the artist

# Max Sokol

b.1895 Warsaw
d.1973, London

Studied in Stettin and Berlin. In 1926 he
went to Jerusalem and worked in the
sculpture department at Bezalel. He
emigrated to England in 1937.

375 *Devotion*
signed (with monogram)
wood   height: 113.03 cm
purchased 1948

376 *Head of Joseph Leftwich*
signed (with monogram)
plaster   height: 33 cm
(excluding wood base)
presented

377 *Moses*
signed
plaster   height: 94 cm
purchased 1951

378 *Portrait of Alfred Wolmark*
signed
wood   height: 47 cm
purchased 1939

372 Maurice Sochachewsky *Main Street : Rishon Le Zion*

373 Maurice Sochachewsky *Portrait of an Old Man*

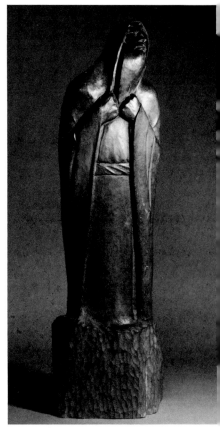

375 Max Sokol *Devotion*

## Gilbert Bernard Solomon

b.1891
d.1954

After studying at the Slade, 1907–11, Solomon spent two years in Paris, returning to England to serve in the Royal Air Force during World War I. In World War II he was appointed Art Director of the Design Section on Civilian Camouflage and for a few years prior to his death was Vice-President of the Royal Society of British Artists.

**Selected Exhibitions**
1959  Ben Uri Art Society, London

*Hay Wagons*
watercolour  33 × 47 cm
presented by Ethel Solomon 1956

## Simeon Solomon

b.1840 London
d.1905 London

Brother of artists Abraham and Rebecca, Solomon was brought up in Bishopsgate, East London and studied at Carey's Academy and the RA Schools. In the 1860s he travelled in Italy. A member of the Pre-Raphaelite Brotherhood, he spent his last years in St Giles Workhouse, Holborn, dying from alcoholism.

**Selected Exhibitions**
1906  Royal Academy of Arts, London
1966  Durlacher Brothers, New York
1985  Geffrye Museum, London
    (with Solomon family)

**Selected Bibliography**
Julia Ellsworth Ford. *Simeon Solomon: An Appreciation*, New York 1908
Lionel Lambourne. *Abraham Solomon and Simeon Solomon*, Transactions of the Jewish Historical Society of England, XXI, pp.274–286
Simon Reynolds. *The Vision of Simeon Solomon*, Stroud, Gloucestershire 1984

*Dawn*
signed (with monogram) and dated 1897
pencil drawing  40 × 25 cm
purchased with the assistance of Mosheh Oved 1918

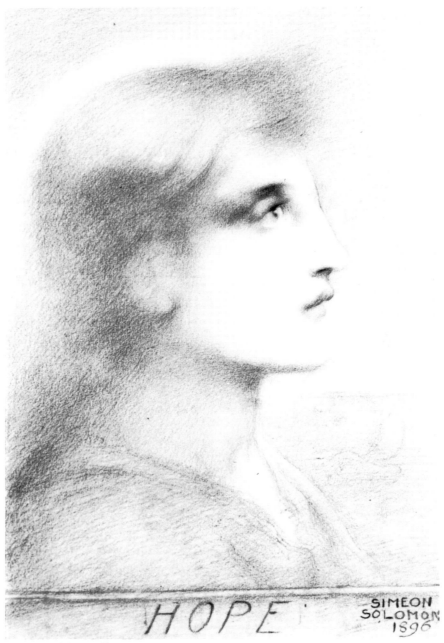

383  Simeon Solomon *Hope*

381  *II Crépuscule du Matin*
inscribed
pencil drawing  38.5 × 30 cm
purchased with the assistance of Mosheh Oved 1918

382  *Head of a Girl*
signed (with monogram) and dated 1888
red chalk  36.5 × 26.5 cm
presented by Ethel Solomon

383  *Hope*
signed and dated 1896
pencil drawing  38 × 27.5 cm
purchased with the assistance of Mosheh Oved 1918

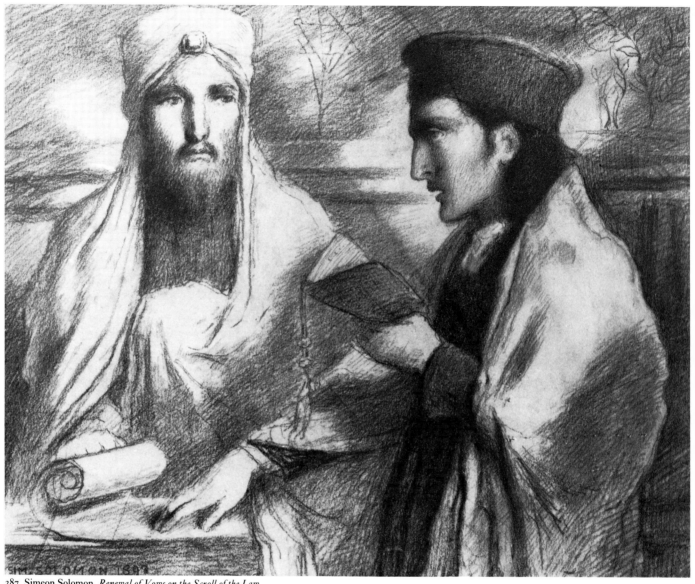

387  Simeon Solomon  *Renewal of Vows on the Scroll of the Law*

**Simeon Solomon** (continued)

COLOUR PLATE VII

384  *Night Looking Upon Sleep Her Beloved
Child*
signed and dated 1893
red chalk  58.5 × 50.5 cm
purchased with the assistance of Mosheh
Oved 1918
Exhibited:
Geffrye Museum, London 1985
Tokyo Shinbum, Japan 1987

385  *Night Looking Upon Sleep Her Beloved
Child*
signed and dated 1895
watercolour and charcoal  28.5 × 39 cm
purchased with the assistance of Mosheh
Oved 1918
Exhibited:
City Museum and Art Gallery,
Plymouth 1993

386  *Profile of a Girl*
signed and dated 1894
pastel  40.5 × 33.5 cm
purchased with the assistance of Mosheh
Oved 1918

387  *Renewal of Vows on the Scroll of the Law*
signed and dated 1893
charcoal on buff paper  38.5 × 48 cm
purchased with the assistance of Mosheh
Oved 1918

*Requiem et Pacem Nobis Dom*
signed and dated 1893
red chalk   36 × 26.5 cm
purchased with the assistance of Mosheh
Oved 1918

*Terra*
signed and dated 1895
red chalk   35 × 25 cm
purchased with the assistance of Mosheh
Oved 1918

*The Rabbi*
signed and dated 1893
charcoal on blue paper   52 × 34.5 cm
purchased with the assistance of Mosheh
Oved 1918
Exhibited:
Tokyo Shinbum, Japan 1987

*Giotto Di Bondone*
inscribed
charcoal and brown wash   33 × 38.5 cm
purchased with the assistance of Mosheh
Oved 1918

*Thou Shalt Not Tempt*
inscribed charcoal   33.5 × 27.5 cm
purchased with the assistance of Mosheh
Oved 1918

## Solomon J. Solomon RA

b.1860 London
d.1927 Birchington, Kent

Solomon J. Solomon studied variously,
in London at Heatherley's Art School,
1876, and at the RA Schools, in Paris
and Munich. After travelling in Italy,
Spain and North Africa, he settled in
London. In 1906 he became the second
Jewish Royal Academician, was
President of the Royal Society of British
Artists, 1918 and the first President of
the Maccabeans. A Lieutenant-Colonel
in the Royal Engineers during World
War I, he was an early creator of the
camouflage system used in that war and
subsequently in World War II. He was
President of the Ben Uri Art Society
from 1924–26.

**Selected Exhibitions**
1946  Ben Uri Art Society, London
      (with Lily Delissa Joseph)
1990  Ben Uri Art Society, London

393  Solomon J. Solomon
*The Field: The Artist's Daughter on a Pony* (detail)

**Selected Bibliography**
Olga Somech Phillips, *Solomon J. Solomon:
A Memoir of Peace and War*, London 1933

393  *The Field: The Artist's Daughter
      on a Pony*
      signed (with monogram)
      oil on canvas   146 × 184 cm
      presented by Mrs S. J. Solomon 1937

394  *Mischa Elman Playing the Violin*
      oil on canvas   75 × 62 cm
      presented by Mrs Ewen Montagu (the
      artist's daughter) 1957
      Exhibited:
      Camden Arts Centre, London 1985

395  *Portrait of Gertrude Salaman* (the artist's
      niece)
      oil on canvas   14 × 64 cm
      presented by the children of Dr
      Redcliffe N. Salaman FRS and his
      second wife Gertrude.

## Frederick Solomonski

b.c.1914 Berlin
lives in the USA

Solomonski was a pupil of Max
Liebermann (*q.v.*), before his arrival in
England in the late 1930s. He became a
cantor and went to Cuba as an assistant
rabbi, later moving to the United States.

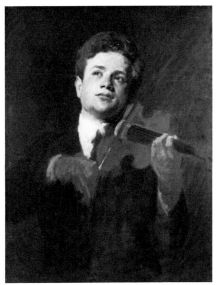

394  Solomon J. Solomon
*Mischa Elman Playing the Violin*

He was the first curator of the Ben Uri
Art Society in Portman Street, 1944.

396  *Elijah*
      signed
      etching   35 × 24 cm
      presented by Mrs R. Samuels 1951

## Agathe Sorel

b.1935 Budapest
lives in London

Agathe Sorel studied in Budapest before
leaving Hungary for England in 1956
and then studied at Camberwell School
of Arts and Crafts. She lived in Paris for
two years 1958, where she attended
Atelier 17 and then spent two years in
the United States and Mexico on a
fellowship. Since her return to London
she has been visiting lecturer at
Camberwell, Canterbury and
Goldsmiths Schools of Art.

**Selected Exhibitions**
1965  Curwen Gallery, London
1967  Arleigh Gallery, San Francisco
1972  Ben Uri Art Society, London
1974  Camden Arts Centre, London
1978  Robertson Galleries, Ottawa
1981  Printmakers Council Gallery, London
1985  Ben Uri Art Society, London
      (with Sylvia Finzi)

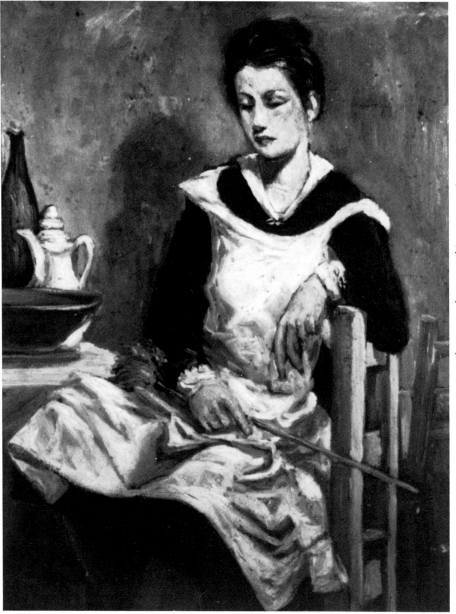

398 Eugen Spiro *(?) Seated Girl*

Paris. He was in hiding in Southern France during the Occupation and emigrated to the United States soon after hostilities had ceased. He settled in the state of New York.

**Selected Exhibitions**
1943 & 1945 St Etienne Gallery, New York
1978 Galerie von Abercorn, Cologne

**Selected Bibliography**
Wilko von Abercorn. *Eugen Spiro – Spiegel seines Jahrhunderts*, Germany 1990

398 *(?) Seated Girl*
oil on board 61 × 49 cm

## A. S. Stern

399 *House Tops*
signed
oil on canvas 39.5 × 56.5 cm

400 *Head of a Woman*
signed
charcoal 48.5 × 39 cm

401 *Shylock and Tubal*
signed
charcoal 33 × 43 cm

## Käthe Strenitz

b.1923 Gablonz, Czechoslovakia
lives in London

Käthe Strenitz studied in Prague at the Officina Pragensis under Hugo Steiner and after obtaining a British Council Scholarship, at the Regent Street Polytechnic, London. She arrived in England in 1939 and settled in London in 1943.

**Selected Exhibitions**
1961 Ben Uri Art Society, London
1977 Phoenix Gallery, Lavenham, Suffolk
1978 Shaw Theatre Gallery, London
1990 Boundary Gallery, London

402 *Village*
signed
watercolour 40 × 52.5 cm
presented

**Agathe Sorel** (continued)

397 *On the Farm*
signed
mixed media A/P 80 × 58 cm
presented by the artist 1985

## Eugen Spiro

b.1874 Breslau, Germany
d.1972 New York

Spiro studied in Breslau and Munich, 1892–94, then lived in Berlin for two years before settling in Paris in 1906. He returned to Germany in 1914 and stayed there until 1935 when he went again to

399 A.S. Stern *House Tops*

401 A.S. Stern *Shylock and Tubal*

# Hermann Struck

b.1876 Berlin
d.1944 Haifa

Struck studied at the Academy of Fine Arts, Berlin, 1895–1900; travelled extensively in Europe and visited the United States before settling in Palestine in 1922. He was one of very few Germans to be elected a member of the Royal Society of Painters, Etchers and Engravers, 1902. In 1908 he produced a book on the art of etching.

**Selected Exhibitions**
1944  Ben Uri Art Society, London
       Margaret Fisher, London

**Selected Bibliography**
Karl Schwarz. *Das Graphische Werk von Hermann Struck*, Berlin 1911
Martin Birnbaum. *Jacovleff and Other Artists*, New York 1946

403  *Head of a Lady*
signed
lithograph  20.5 × 14 cm

404  *Head of a Man*
signed and dated 1928
etching 30/50  22 × 19 cm

405  *Head of an Old Man*
signed and dated 1928
lithograph  31 × 23 cm

406  *Portrait of a Boy*
signed
lithograph  20.5 × 13.5 cm

407  *Portrait of a Rabbi*
signed and dated 1905
inscribed
etching  21 × 14.5 cm

408 A. Susser *The Artist's Brother*

## A. Susser

**408** *The Artist's Brother*
signed
charcoal 39 × 27 cm

## Natan Szpigel

b. Poland
d.1943

Szpigel was interned inside the Lodz
Ghetto after 1940, where he made many
sketches. He was killed in 1943, either in
Lodz or in Chelmno.

**409** *Woman Knitting*
signed
oil on canvas 92 × 77.5 cm
presented by Jack Green

**410** *Head of an Old Woman*
signed and dated 1929
watercolour 34 × 30 cm

**411** *Houses in Venice*
signed
watercolour over pencil 32 × 47 cm

**412** *The Old Jewish Cemetery*
signed
watercolour 36 × 54 cm

409 Natan Szpigel *Woman Knitting*

411 Natan Szpigel *Houses in Venice*

*Street*
signed
watercolour  38 × 52 cm

# R. Theyer

*Landscape*
signed and dated 1972
collage  36 × 55 cm
presented by the artist

# Willy Tirr

b.1915 Stettin, Germany
d.1991 Leeds

Tirr, mostly self-taught, arrived in
England in 1938. He lectured at Leeds
College of Art and was Head of Fine
Arts at Leeds Polytechnic from 1968–80.
In 1984 he spent some time at the
University of Wollongong, Australia as
artist in residence.

**Selected Exhibitions**
1958  New Vision Gallery, London
1965  Ben Uri Art Society, London
1969  Galerie Riehentor, Basel
1982  Elizabethan Exhibition Gallery,
       Wakefield
1988  University Gallery, Leeds
1990  Gallery North, Kirkby Lonsdale
1992  Ben Uri Art Society, London
       Leeds Polytechnic Gallery

*Acid Browns*
oil on canvas  126 × 169.5 cm
presented by the artist

# Edward Toledano

b.New York
lives in London

Toledano studied at Yale University
before settling in London in 1964. he
attended the Sir John Cass School of
Art, London, 1979–82 and St Martin's
in 1983.

**Selected Exhibitions**
1975  Victoria Art Gallery and Museum,
       Bath
1977–86  Ben Uri Art Society, London
1978  Camden Arts Centre
1979 & 1987  University of Surrey, Guildford
1980  Glanmire Gallery, Cork, Eire
1988  Business Design Centre, Islington,
       London

417  Fred Uhlman  *Tightrope Dancer*

416  *Single Image*
signed
lithograph 20/150  49.5 × 64 cm
presented by Chinita Abrahams-Curiel
1986

# Fred (Manfred) Uhlman

b.1901 Stuttgart
d.1985 London

Uhlman studied law in Germany and
practised there until 1933. On his arrival
in England in 1939 he took up art, a
subject in which he had no formal
training. He settled in London where he
lived, in Hampstead, until his death.

**Selected Exhibitions**
1960  King Street Gallery, Cambridge
1970  New Grafton Gallery, London
1973  Camden Arts Centre, London
1981  Hereford City Art Gallery

**Selected Bibliography**
Fred Uhlman. *The Making of an Englishman*,
London 1960

417  *Tightrope Dancer*
signed and dated 1943
oil on board  25 × 34 cm
presented by Denys Sutton 1952

# Lesser Ury

b.1861 Birnbaum, Posen
d.1931 Berlin

Ury moved to Berlin with his family in
1873. He studied in Brussels and
Dusseldorf, then spent periods of time in
Paris, Volluvet, Belgium and Munich
before settling in Berlin in 1887. He
visited Italy in 1890.

**Selected Exhibitions**
1931  Nationalgalerie, Berlin
1961  Tel Aviv Museum of Art
1962  Bezalel National Museum, Jerusalem
1981  Galerie Pels-Leusden, Berlin

**Selected Bibliography**
Karl Schwarz. *Lesser Uri*, Berlin 1920
Adolph Donath. *Seine Stellung in der
Modernen Deutschen Malerei*, Berlin 1921

418  *The Stream*
signed
pastel  34 × 49 cm
purchased 1946

419  *Two Figures in a Park*
signed
lithograph 3/30  27.5 × 19 cm
purchased 1959

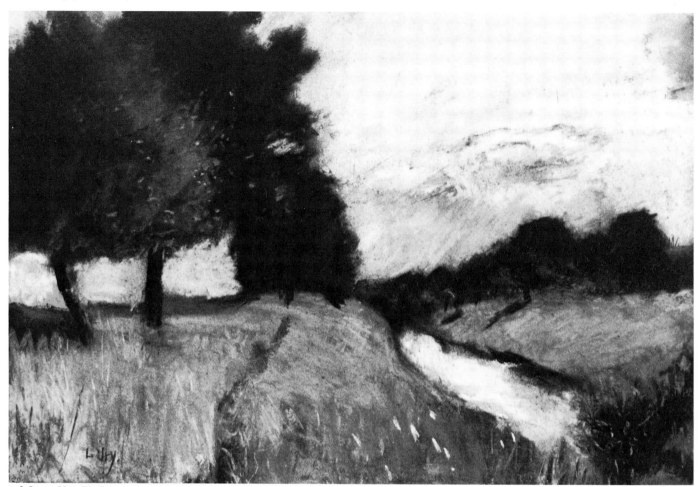

418 Lesser Ury *The Stream*

## Salomon Van Abbe

b.1883 Amsterdam
d.1955 England

The Van Abbe family were diamond-dealers who came to England in 1888. Salomon studied at the Central School and worked first as a newspaper illustrator, later becoming a portraitist. He illustrated many books and made etchings of court settings sometimes using the pseudonym C. Morse.

*A Cavey Barn*
signed (in the plate)
drypoint etching  27.5 × 21 cm
purchased 1982

## Marcel Vertès

b.1895 Hungary
d.1961 Paris

Vertès left Hungary for Vienna in 1921 and later settled in Paris. Shortly before World War II he moved to New York where he worked for *Harper's Bazaar* and designed costumes and sets for the New York Ballet Theatre.

**Selected Exhibitions**
1979  Hamilton Gallery, London

*One Moment Please!*
signed (in the stone)
lithograph  25 × 79 cm
presented by
Mr and Mrs Barry Fealdman 1987

## (Victor Weisz) Vicky

b.1913 Berlin
d.1966 London

Weisz studied in Hungary and in Berlin before arriving in England in 1935, having travelled through Hungary and Czechoslovakia. He also used the pseudonym Vicky Smith. In 1966 he took his own life.

**Selected Exhibitions**
1988  National Portrait Gallery, London

422  *A Collection of 29 Cartoons*
signed
various media and sizes
*Titles*: Chinese Mushrooms, Knight, How to Quit Jordan, Marpel's Fog, Halt, San Francisco Cable Car, Negro, Constitution, De Gaulle, Winter of Discontent, East of Suez, Arab, Beggar Bombay, A Writer outside a Post Office, Nerve, Donkeys in Delhi, Les Folies D'Élysée, Epitaph, Charlemagne, Tandem, Family, Berlin, No Coloureds, Every Inch of Russia, Drama Awards, Time, Leader of the Flock, Road Signs, Modern Railways.

## Mark Wayner

b.1888 Lomza, Russia
d.1980 Saffron Walden, Essex

Mark Wayner's family settled in Whitechapel in 1893. He won a scholarship to Birkbeck College in 1902 and studied for a short time at the Slade. He exhibited in the Jewish Section of 'Twentieth Century Art', the 1914 exhibition at Whitechapel Art Gallery. Volumes of his 'Celebrities in Caricature' were published in 1931 and 1940. He lived for some years in Sheffield.

**Selected Exhibitions**
*c.*1955  Galerie Apollinaire, London
1964  Assembly Rooms, Sheffield

423  *Head of a Gypsy*
signed
pastel  diameter 47 cm
presented by Miss B. Berman 1985

424  *Celebrities in Caricature*
dated 1931
photolithographs, a volume
37 × 25.5 cm

425  *Two Chinamen*
signed
mixed media  35.5 × 32.5 cm
presented by Alfred Wolmark 1946

## Shraga Weil

b.1918 Nitra, Czechslovakia
lives in Israel

Studied at the Art Academy in Prague, 1937–39 and at the Académie des Beaux-Arts, Paris, 1952–53. He arrived in Israel after World War II and settled in Kibbutz Ha-Ogen where he still lives. His bronze and copper reliefs and wall and ceiling paintings can be seen on many public buildings in Israel and the United States.

**Selected Exhibitions**
1962  Ben Uri Art Society, London
       (with Melitta Schiffer)
1986–7  Safrai Fine Art, Jerusalem

426  *The Ram*
signed
lithograph A/P  47 × 31.5 cm

## Ivor Weiss

b.1919 London
lives in Colchester

Ivor Weiss's parents came to England from Rumania. He studied at Heatherley's School of Art, in Malta and at St Martin's. In 1951 he settled in the United States where he taught. He later returned to England, continued to teach, but also began designing jewellery, mosaics and stained-glass windows.

**Selected Exhibitions**
1952 & 1963  Museum of Fine Art,
       Montgomery, Alabama
1963–8  O'Hana Gallery, London
1980  Ben Uri Art Society, London

427  *Men Praying (Four Rabbis)*
signed and dated 1972
linocut 15/25  32.5 × 43 cm
presented anonymously 1983

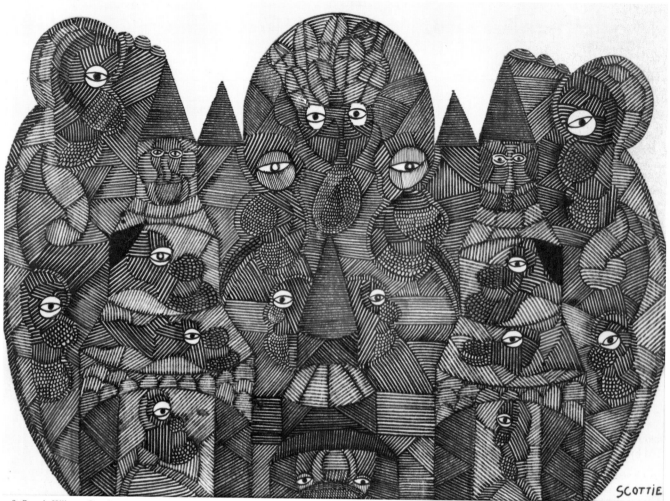

428 Scottie Wilson *Greedies*

## Scottie Wilson (Louis Freeman)

b.1890 Glasgow
d.1972 London

One of many children of a working-class family, Scottie Wilson left school at the age of nine to help support the family. In 1906 he volunteered for the Army serving in India, South Africa and on the Western Front. In the early 1930s he travelled to Canada and spent fourteen years there setting up a business in Toronto. It was at this time that he started drawing and his first one-man exhibition took place in Toronto in 1943. He returned to England in 1945.

### Selected Exhibitions

1945 Arcade Gallery, London
1947 Galerie Maeght, Paris
1949–52 Gimpel Fils, London
1962 Ben Uri Art Society, London
1966 Brook Street Gallery, London
1972, 1977 & 1993 Fieldborne Galleries, London
1981 Scottish Gallery, Edinburgh
1986 Third Eye Centre, Glasgow
Mayor Gallery, London
Gillian Jason Gallery, London
1986–7 Hastings Museum and Art Gallery, Sussex

### Selected Bibliography

Mervyn Levy. *Scottie Wilson*, London 1966
George Melly. *It's All Writ Out for You: The Life and Work of Scottie Wilson*, London 1986

428 *Greedies*
signed *c*.1945
pen and coloured ink 27.5 × 37 cm
presented by Mr and Mrs Robert Lewin 1987
See: Mervyn Levy. *Scottie Wilson*, Brook Street Gallery, London 1966, p.43
*Art and Artists*, October 1974, vol.9, no.7, p.9

COLOUR PLATE VIII
429 *Happy Village*
signed *c*.1952
coloured crayons 63.5 × 51 cm
presented by Mr and Mrs Robert Lewin 1987

430 Alfred Adrian Wolfe *The Old Philosopher*

431 Alfred Adrian Wolfe *The Arts Committee Meeting*

# Alfred Adrian Wolfe (Wolfstein)

Lived and exhibited in London.

*The Old Philosopher*
signed (with monogram)
watercolour 29.5 × 20.5 cm
presented by Anna Wolfe 1982

*The Arts Committee Meeting*
signed (with monogram) and dated 1917
pen and ink 18 × 22.5 cm
presented by Anna Wolfe 1982

# Alfred Wolmark

b.1877 Warsaw
d.1961 London

Wolmark was six years old when his family arrived in England and settled in London's East End. He attended the RA Schools for a brief period in 1895, where he was awarded a silver medal for drawing, but preferred to work at the British Museum studying old master drawings and antiquities. Before 1912 he spent long periods away from London. He lived in Devon in the late 1890s and spent three years in Poland from 1903, partly in Cracow. In 1910 he went to Brittany where he stayed for two years. His work included theatre designs for two Diaghilev ballets, pottery and stained-glass windows.

**Selected Exhibitions**
1905 Bruton Gallery, London
1919 Barreiro's Galerie, Paris
1920 Kevorkian Galleries, New York
1925 Galerie Charpentier, Paris
1928 Lefevre Gallery, London
1947 Leicester Galleries, London
1948 & 1952 Ben Uri Art Society, London
1975 Fine Art Society, London
1985 Belgrave Gallery, London

432 *Men of Old*
signed (with monogram)
oil on canvas 49.5 × 40 cm
purchased 1930

433 *Oxfordshire Landscape*
signed and dated 1941
oil on board 48.5 × 64 cm
on permanent loan

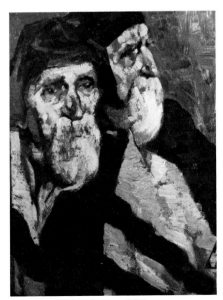

432 Alfred Wolmark *Men of Old*

**Alfred Wolmark** (continued)

434 *Portrait of Mrs Herbert Cohen*
oil on canvas 74 × 62 cm
presented by Ethel Solomon
(a portrait of her mother) 1956

435 *Portrait of J. Seres*
signed and dated 1937
oil on canvas 76 × 63 cm
commissioned by the Society 1937

436 *Still Life*
signed and dated 1930
oil on panel 36 × 44.5 cm
presented by Lord Sieff 1936

437 *Tulips and Daffodils*
signed and dated 1919
oil on panel 68 × 42.5 cm
purchased 1930
Exhibited:
Ferens Art Gallery, Hull 1975

438 *Fourteen Book Illustrations*
signed and dated 1925
watercolour, pen and ink
various sizes
purchased with the assistance
of Lord Sieff 1935

439 *Israel Zangwill*
signed and dated 1925
pen and ink 25.5 × 22 cm
presented by the artist
Exhibited:
Camden Arts Centre, London 1985

440 *Portrait of Leopold Gottlieb*
signed and dated 1917
pen and ink 33 × 25 cm
presented by the artist 1951

439 Alfred Wolmark *Israel Zangwill*

## Judith Yellin-Ginat

b.Jerusalem
lives in Israel

Studied at the Bezalel School of Arts & Crafts, Jerusalem and at the Central School, also with S. W. Hayter at Atelier 17, Paris. She has illustrated many children's books and taught in Jerusalem. Since 1944 she has been Senior Teacher at the David Yellin Teacher's College, Jerusalem. David Yellin was her grandfather.

**Selected Exhibitions**
1954–5 Ben Uri Art Society
1961, 1969, 1974 The Artists' House, Jerusalem

*Road to Jerusalem*
signed (in Hebrew) and dated 1971
etching 25/50 32.5 × 20.5 cm
presented by the artist

442 Archibald Ziegler *Embankment at Chelsea*

## Archibald Ziegler

b.1903 London
d.1971 London

Ziegler studied at the Central School, the RA Schools and the RCA. He travelled widely in Europe and the United States. In 1932 he executed murals at Toynbee Hall, London and from 1938 was visiting lecturer at St Martin's.

**Selected Exhibitions**
1932 Whitechapel Art Gallery, London
1935 Adams Gallery, London
1937 Wertheim Gallery, London
1946 Arcade Gallery, London
1948 Leger Gallery, London
1950 Berkeley Gallery, London
1950, 1955, 1959 & 1968 Ben Uri Art Society, London
1964 Arthur Jeffries Gallery, London
1965 Vinciton Gallery, Brighton
1971 Kenwood, the Iveagh Bequest, London

442 *Embankment at Chelsea*
signed and dated 1936
oil on board 58 × 71.5 cm
presented by Ethel Solomon 1937

443 *Portrait of Professor Norman Bentwich*
signed
oil on canvas 52 × 42 cm
presented by Sam Trilling 1948

444 *The Red Lilies*
signed
oil on board 120 × 74 cm
purchased

445 *Safed*
signed
oil on canvas 39.5 × 50.5 cm
purchased 1950

446 *A View near Hambledon Hill*
signed
oil on canvas 36.5 × 44.5 cm
presented by
Mr and Mrs Pierre Gildesgame

448 Archibald Ziegler *Self Portrait*

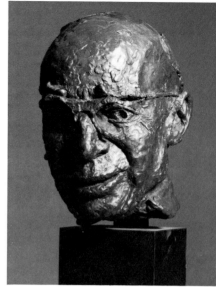

449 Archibald Ziegler *Norman Bentwich*

**Archibald Ziegler** (continued)

**447** *Portrait of a Woman*
signed
pastel on green paper  48 × 36.5 cm
presented by the artist

**448** *Self Portrait*
signed and dated 30th December 1948
pen and ink  47 × 36 cm
presented by the artist

**449** *Norman Bentwich*
bronze  height: 28 cm
(excluding marble base)
purchased

## Dahlia Ziegler

b.1940 London
lives in London

Daughter of Archibald Ziegler (*q.v.*), she
studied at Central School. She has
worked as a graphic artist, designer and
art therapist.

**Selected Exhibitions**
1970 Everyman Cinema, London

**450** *Tree*
signed
lithograph 2/3  40 × 40 cm
purchased

# Additions to the collection since 1987

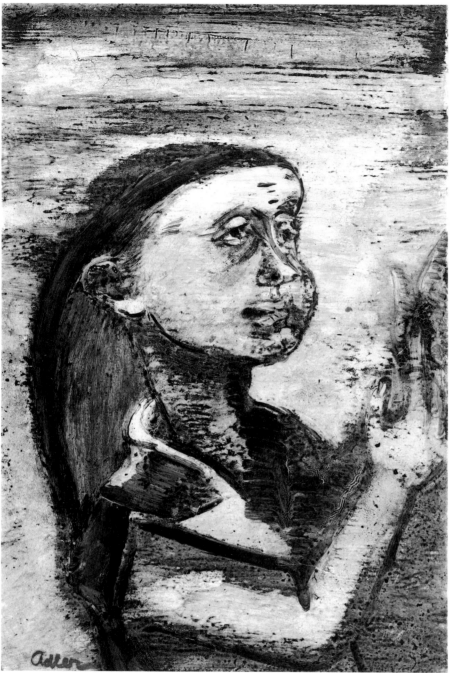

452 Jankel Adler *Portrait of a Woman*

## C. Adler

451 *Olive Tree*
signed
drypoint etching A/P 39.5 × 27.8 cm
presented by the artist

## Jankel Adler

(see cat. no.2)

452 *Portrait of a Woman*
signed (verso signed and numbered xii)
acrylic on paper mounted on board
56 × 38 cm
presented by Chinita Abrahams–Curiel
1994 in memory of her husband Conrad

453 *Portrait of a Man in a Cap*
signed (verso signed and numbered xiii)
acrylic on paper mounted on board
56 × 38 cm
presented by Chinita Abrahams–Curiel
1994 in memory of her husband Conrad

## Ellen Alt

b.1954 Buffalo, New York
lives in Jerusalem

Studied at New York University and
Massachusetts College of Art before
emigrating to Israel in 1991, where she
works as a community artist organising
arts projects throughout the country.

**Selected Exhibitions**
1982 80 Washington Square East Galleries,
New York
1988 Ward-Lawrence Gallery, New York
1989 Jadite Gallery, New York
1992 American Cultural Center, Jerusalem
1993 Ben Uri Art Society
(with Harry Levene)

454 *Mem*
1989 signed
mixed media on paper 38 × 50.8 cm
purchased 1993

454 Ellen Alt *Mem*

## Manfred Altman
(see cat. no.7)

*The Enchanted Castle*
1982 signed
pastel on paper 30 × 44.6 cm
presented by the artist 1993

*Allegro*
1987 signed
gouache on board 79 × 52.5 cm
presented by the artist 1993

## Arie Alweil
(see cat. no.10)

457 *Landscape*
signed in Hebrew
oil on canvas 60.2 × 77.7 cm
presented by the artist

## Anonymous

458 *Head of a Man*
charcoal drawing 66 × 52 cm

## Anonymous

459 *German Farm Kitchen*
oil on canvas 24 × 31.5 cm
presented by Peter W. Johnson 1988

## Sydney Arrobus

b.1901 London
d.1990 London

Studied at Heatherley School of Art
1925–30. Practised as commercial artist.
War-time sketch books and watercolours
acquired by Imperial War Museum.

**Selected Exhibitions**
1953 Walker Gallery, London
1956 Royal Scottish Society, Edinburgh
1958 Woodstock Gallery, London
1968 Cooling Gallery, London
1977 Camden Arts Centre
1980 Burgh House, London
1988 Shaw Theatre, London

**460** *Lake Como*
signed and titled
watercolour on paper 23 × 42.5 cm
presented by the artist 1988

**461** *Beach Scenes*
signed and inscribed *Korlula 64*
pen, ink and ballpoint with collage
70.4 × 35.4 cm
presented by Alice Schwab 1990

## Frank Auerbach

(see cat. nos.18–19)

**462** *JYM*
signed and dated 1985
etching A/P 17.6 × 14.7 cm
presented by the artist 1994

**463** *Catherine*
signed and dated 1989
etching A/P 17.7 × 14.7 cm
presented by the artist 1994

**464** *David*
signed and dated 1989
etching A/P 17.7 × 14.7 cm
presented by the artist 1994

**465** *Julia*
signed and dated 1989
etching A/P 17.7 × 14.7 cm
presented by the artist 1994

**466** *Geoffrey*
signed and dated 1990
etching A/P 17.9 × 14.7 cm
presented by the artist 1994

**467** *Jake*
signed and dated 1990
etching proof 17.6 × 14.7 cm
presented by the artist 1994

**468** *Michael*
signed and dated 1990
etching A/P 17.7 × 14.7 cm
presented by the artist 1994

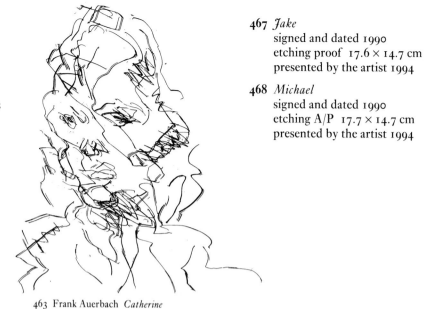

463 Frank Auerbach *Catherine*

467 Frank Auerbach *Jake*

473 Judy Bermant *Chaim Resting*

## Helen Bar-Lev

b.1942 New York
lives and works Artists' Colony, Safed

Studied at New York University and
Cooper Union in New York. In 1973
she emigrated to Israel and studied in
Jerusalem. Settled in Safed in 1989.

### Selected Exhibitions
1981–5 Artists' House, Jerusalem
1987 Galerie Edison, The Hague
1988 Gerard Behar Centre, Jerusalem

*Jewish Quarter, Safed*
signed in Hebrew and English and
dated 1986
pen, brush and wash on
paper 31.9 × 45.8 cm
presented by the artist 1989

## Hans von Bartels

b.1856 Hamburg
d.1913 Munich

Painter noted for marine subjects.

470 *Three Dutch Fisher Girls*
oil on board 102 × 79.5 cm
bequeathed by Miss Stephanie Ellen
Kohn 1990 in memory of her parents
Franz and Margarethe Kohn (née
Schottlander) and her brother Ludwig
who perished in the Holocaust.

## Carole Berman

b.1952 London
lives in London

Worked for Sotheby's in London and
New York 1974–9 and then studied
History of Art at University College,
London. Studied Fine Art at Chelsea
and Wimbledon Schools of Art. She is
Chair of the Ben Uri Art Committee.

471 *Rose Window*
1993
pen, ink and watercolour on Khadi
paper 44.5 × 81.2 cm
presented by the artist 1994

## Judy Bermant

b.1939 London
lives in London

Studied at St Martin's from 1955–8 and
printmaking at the Camden Institute.
Married to author and journalist Chaim
Bermant and has illustrated many of his
book-jackets. Designed the stained glass
windows for Shomrai Hadath
Synagogue, Hampstead in 1989.

### Exhibitions
1981 Ben Uri Art Society, London (with
Ruth Jacobson and Nigel Konstam)
1985 Henny Handler, St John's Wood,
London
1987 Sternberg Centre for Judaism, London
1991 Boundary Gallery, London
(with Sam Herman)

472 *Old City Panorama*
1987 signed
drypoint etching with aquatint 4/10
10.4 × 54 cm
presented by the artist 1993

473 *Chaim Resting*
1990–91 signed
watercolour on paper 40.6 × 50.7 cm
presented by the artist 1993

# Lazar (Eliezer or Léon) Berson

b.1882 Skopichky, Russia
d.1954 Southern France

Studied painting in St Petersburg and
then in Paris, where he lived for several
years in Montparnasse. Exhibited at the
Salon d'Automne in 1911 and 1912.
Came to London in 1914. Wrote for the
Yiddish Newspaper 'Di Tsayt'. In 1915
founded the Jewish National Decorative
Art Association 'Ben Ouri'. Over one
hundred members joined the Society
which had its base in Berson's studio in
London's Notting Hill. In 1916 Berson
suddenly left London and apparently
had no further contact with the Society.

474 *Design with Deer*
*c.*1915 signed in Yiddish
pen and coloured ink on paper
32.3 × 25.6 cm
presented by Celia Spencer 1993 in
memory of her parents Judah and Dinah
Beach, Founder Members of the
Society.

475 *Design for the Ben Uri Art Society*
*c.*1915 signed in Yiddish
pen and coloured ink on paper
32.3 × 25.6 cm
presented by Celia Spencer 1993 in
memory of her parents Judah and Dinah
Beach, Founder Members of the
Society.

476 *Design with Decorative Vessels from the
Ben Uri Collection*
*c.*1915 signed and inscribed in Yiddish
'*The Group of the Ben Ouri Decorative
Arts*'
pen, ink and pencil on paper
27 × 35.7 cm
presented by Celia Spencer 1993 in
memory of her parents Judah and Dinah
Beach, Founder Members of the
Society.

474 Lazar Berson *Design with Deer*

476 Lazar Berson *Design with Decorative Vessels from the Ben Uri Collection*

## Edith Birkin

b.1928 Prague, Czechoslovakia
lives in Hereford

Birkin spent the war years in the Lodz
Ghetto, Auschwitz and Belsen. She
came to England in 1946. She began to
study History of Art and Art in the
1970s with the desire to record her
wartime experiences on canvas. Her
work was included in the Anne Frank
exhibition in Manchester in 1987.

**Selected Exhibitions**
1984  Coventry Cathedral
1989  Ben Uri Art Society, London

*Liberation Day*
signed and dated 1987
acrylic on canvas  59.5 × 77 cm
presented by the artist 1989

## Harry Blacker (Nero)
(see cat. no.34)

*Head of a man*
c.1935–6 signed
pen and ink on board  9.2 × 9.2 cm
presented by the artist 1988

*East End Backyards 1931*
signed with monogram
linocut 3/10  36.5 × 27.5 cm
presented by the artist

## Naomi Blake
(see cat. no.35)

*Abraham and Isaac*
signed
bronze resin  height: 48 cm
presented by the artist 1990

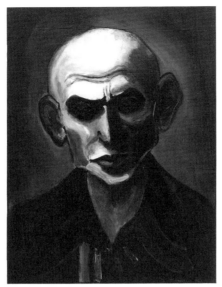

477  Edith Birkin  *Liberation Day*

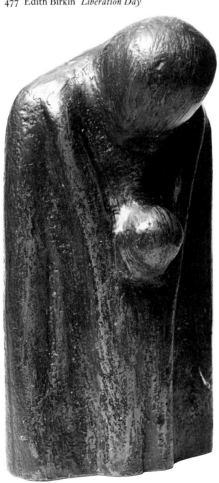

480  Naomi Blake  *Abraham and Isaac*

## Ya'akov Boussidan

b.1939 Port Said, Egypt
lives in London

Emigrated to Israel with his family in
1949 and settled in Kiryat Ono. Joined
Kibbutz Givat Haim in 1954 under the
auspices of Youth Aliyah who provided
a grant for him to study art. In 1959 he
won the first prize for Youth Aliyah
graduate artists. In 1966, he was
awarded a Rothschild Foundation
Scholarship to study printmaking at
Goldsmiths College. Renowned for his
work as a calligrapher and printmaker,
copies of his hand-made books are to be
found in public collections in Israel,
Europe and the United States. In 1990
he received the Jesselson Award for
Judaica from the Israel Museum.

**Selected Exhibitions**
1977  Ben Uri Art Society, London
1980  Gallery Y, New York
1984  New York Public Library
1987  Stern Gallery, Tel Aviv
1991  Ben Uri Art Society, London
        (with Ayala Friedman)

**Ya'akov Boussidan** (continued)

**481** *Ketubah*
signed on central page
silkscreen print – 5/350  eight pages
presented by Sam Alper OBE 1991

## Sir Frank Brangwyn RA
b.1867 Bruges
d.1956 Ditchling

Worked for William Morris designing
tapestries 1882–4. Decorative schemes
executed include the Rockefeller Centre,
New York and the Royal Exchange,
London. Took up printmaking 1900.
Elected RA in 1919 and knighted 1941.
Museums devoted to his work in Bruges
and Orange, Southern France.

**482** *Old Men in a Synagogue*
1931 signed with monogram
drypoint  17.6 × 13.9 cm
presented by H.J. Stern 1993

**483** *Sermon in the Synagogue*
1931 signed with monogram
drypoint  17.2 × 15.2 cm
presented by H.J. Stern 1993

481  Ya'akov Boussidan  *Ketubah*

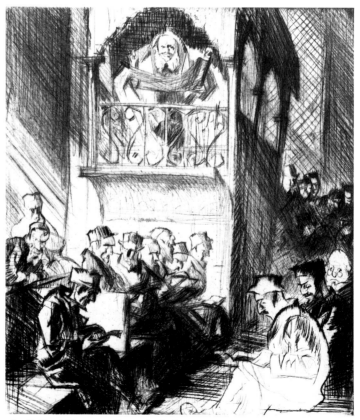

483  Sir Frank Brangwyn  *Sermon in the Synagogue*

486 Bernard Cohen *Untitled*

488 Arnold Daghani 'King David' from the *Portfolio of Drawings, Watercolours and Collages*

## G. Buchner

b.1858 Ampfling, Bavaria
lived and worked in Munich

*Portrait of a Young Girl*
signed
oil on canvas  24 × 19 cm
bequeathed by Miss Stephanie Ellen Kohn 1990 in memory of her parents Franz and Margarethe Kohn (née Schottlander) and her brother Ludwig who perished in the Holocaust.

## Joseph Budko

b.1888 Plonsk, Poland
d.1940 Jerusalem

Studied at Vilna School of Art and in Berlin with Hermann Struck. Emigrated to Palestine 1933, Director of Bezalel School 1940. Illustrated books by Peretz, Aleichem and Bialik amongst others. Also produced illustrated Hagadah.

**Selected Bibliography**
H. Friedeberger. *Joseph Budko*, Berlin 1929

485 *Listen to Those That Ask*
signed in Hebrew and English
etching  18 × 13 cm
presented by Carmel Gradenwitz 1987

## Bernard Cohen
(see cat. no.66)

486 *Untitled*
signed and dated 1965
screenprint 49/75 *V*  56 × 76 cm
presented by Alice Schwab 1993

## Meta Cohn-Hendel

b.1883 Berlin
d. *c.*1970 California

Landscape painter and graphic artist. Left Berlin 1933 and lived in Italy until 1938. After brief time in England, settled in California.

487 *Tree in Blossom*
signed and dated 9 March 1958
dedicated to Hanna
pen and ink  34.5 × 41.5 cm
presented by Anne Marie Mayer 1988

## Arnold Daghani
(see cat. no.71)

488 *Portfolio of Drawings, Watercolours and Collages*
various sizes and dates
presented by Carola Grindea 1986

# Sonia Delaunay

b.1885 Gradizhsk, Ukraine
d.1979 Paris

Adopted by a wealthy uncle and grew up
in St Petersburg. Studied at the
University of Karlsruhe, 1903–5. Moved
to Paris 1905 and settled in
Montparnasse 1906. First married the
German art critic and dealer Wilhelm
Uhde 1908, and then the French painter
Robert Delaunay in 1910. Began making
collages and posters. Spent World War
I in Spain and Portugal, returning to
Paris 1921. Worked as a designer of
clothes, textiles and theatrical costumes.
Spent World War II in the South of
France, primarily in Grasse, returning to
Paris in 1945. Awarded the Légion
d'Honneur 1975.

**Selected Exhibitions**
1908  Galerie Notre-Dame-des-Champs,
        Paris
1932  Galerie Zak, Paris
1953  Galerie Bing, Paris
1962, 1968  Galerie Denise René, Paris
1967, 1968, 1975, 1976  Musée National
        d'Art Moderne, Paris
1979  Musée National d'Art Moderne,
        Tokyo
1980  Albright-Knox Art Gallery, Buffalo

**Selected Bibliography**
André Lhote. *Sonia Delaunay: Ses peintures,*
*ses objets, ses tissus simultanés, ses modes*, Paris
1925
Sonia Delaunay. *Tapis et Tissus*, Paris 1931
Arthur A. Cohen. *Sonia Delaunay*, New
York 1975

**489** *Illustration from Rythmes et Couleurs:*
An artist's book by Jacques Damase with
illustrations by Sonia Delaunay. 1966
pochoir 62/90  53.4 × 76 cm
presented by Robert Lewin 1993

489  Sonia Delaunay  *Illustration from Rythmes et Couleurs*

## Shmuel Dresner

b.1928 Warsaw
lives in Middlesex

Brought to England in 1945 from
Theresienstadt with the help of CBF.
He spent 1945–9 in sanitariums where
he began painting. He studied at
Heatherley School of Art in 1949 and at
Central School in 1953.

**Selected Exhibitions**
1962 & 1966  St Martin's Gallery, London
1975  Ben Uri Art Society, London
1980  Galerie Roche, Hendstedt
1981  Galerie Slavia, Bremen

*Ruined Cities*
signed and dated 1961–2
series of three etchings, various sizes
presented by the artist 1993

*The Ghost Town*
signed and dated '82
collage 53 × 53 cm
presented by the artist 1993
Exhibited: Bremen and Oldenburg 1985

## Amy Drucker

(see cat. no.76–9)

*Senorita Campistegni*
watercolour  37.5 × 28 cm

## Edgar Duchin

b.1909 London
d.1991 London

Practised as a solicitor. Took to painting
late in life. Founder Chairman of
Solicitors Art Group

**Selected Exhibitions**
1987  Margaret Fisher Gallery

*Earthquake Village, Bussana Vecchia*
signed and dated 1969
oil on canvas  39 × 49.5 cm
presented by the artist 1988

491  Shmuel Dresner  *The Ghost Town*

## Henry Edion
## (Heinrich Edelstein)

b.1905 Vienna
d.1987 London

Captured by the Nazis 1940 and spent
four years in concentration camps.
There, was encouraged to paint by
fellow prisoner, German Expressionist
Gert Wollheim. Went to Paris after the
war and studied at the Atelier Grande
Chaumière. Moved to Australia to join
an elder brother. Travelled to Canada
and USA in 1955 but plans to exhibit
there interrupted when his wife
developed cancer. Moved to England for
her treatment and settled in London.

**Selected Exhibitions**
1958  Juster Gallery, New York
1958  Galeries Monique de Groot, Montreal
1961  William H. Schab Gallery, New York
1962 & 1993  Crane Kalman Gallery,
       London
1994  Ben Uri Art Society, London

494  *Golden Calf*
signed, titled and dated 1968
mixed media on paper  38 × 53.5 cm
presented by Paul and Mary Rees and
Pat and Alex Gilmour 1993

495  Henry Edion  *Rocketry*

495  *Rocketry*
signed, titled and dated 1970
pen and ink on paper  50.7 × 35.2 cm
presented by Paul and Mary Rees and
Pat and Alex Gilmour

498 Hans Feibusch *Three Messengers*

## Sir Jacob Epstein
(see cat. no.86–90)

**496** *Sholem Asch*
bronze 1953 height: 37 cm
on loan from Dr J. E. Beckman

## Hermann Fechenbach
(see cat. no.92 and 92a)

**497** *Allegorical Design*
signed and dated '22
woodcut 28.5 × 39.5 cm
presented by Alice Schwab 1988

## Hans Feibusch
(see cat. no.93)

**498** *Three Messengers*
signed with monogram and dated '88
gouache on paper 35 × 27.5 cm
presented by the artist 1994

499 Sandra Fisher *Meier Appelfeld*

## Sandra Fisher

b.1947 New York City
lives in London

Studied at the Chouinard Art School,
California Institute of the Arts, Los
Angeles from 1965–8 and in 1971 moved
to London. Two of her paintings were
commissioned by London Underground
and have been reproduced as posters.
She has collaborated with American poet
Thomas Meyer on three publications.
She is married to R. B. Kitaj (*q.v.*)

**Selected Exhibitions**
1982  Coracle Press Gallery, London
1987  Victoria Miro Gallery, London
1989, 1991  Odette Gilbert Gallery, London
1993  Lefevre Gallery, London

*Meier Appelfeld*
signed and dated 1990
monotype  30.2 × 25 cm
presented by the artist 1993

## Else Fraenkel
(see cat. no.102)

*Head of a Girl*
signed and dated 1924
bronze  height: 31 cm

## Henry Glicenstein
(see cat. no.119–23)

*Self Portrait*
signed
etching  17.5 × 14.7 cm
purchased 1921

*Illustrations to the Book of Samuel*
signed
etchings, series of twelve, various sizes
purchased 1921

*13 Sheets of Portrait Sketches*
all signed and stamped *Atelier
Glicenstein*
six dated London 1923, one dated
London 1921–4
pen or pencil on paper
presented by Hugo Dreyfuss 1993

502  Henry Glicenstein  *Illustration to the Book of Samuel*

502  Henry Glicenstein  *Illustration to the Book of Samuel*

505 Nina Grey *Flame of Remembrance*

506 Nina Grey *Africa*

124

## Phyllis Gorlick-King

(see cat. no.124)

*Alms No. 1*
signed and dated '81
oil on canvas  76 × 76 cm
presented by the artist 1987

## Nina Grey

b.1907 Lvov
lives in London

Grey and her family moved to Vienna in
1915 as refugees. She studied at the
College for Jewish Teachers and then
taught from 1928–39. She came to
London with her husband in 1939, and
studied sculpture first at Hornsey School
of Art and then at St Martin's. The
bronze cast of *Flame of Remembrance* was
presented to Yad Vashem in 1980.

**Selected Exhibitions**
1962  Ben Uri Art Society, London
1963  Foyles Art Gallery, London

*Flame of Remembrance*
plaster  height: 86 cm 1961
presented by the artist 1992

*Africa*
signed
plaster  height: 91.5 cm
presented by the artist 1992

## Leo Haas

(see cat. no.127)

*Terezin-Theresienstadt*
signed and dated 1945/66
drypoint and aquatint, series of 10,
various sizes

  1  *A Transport has Arrived*
  2  *Ghetto*
  3  *Children on the Way to Auschwitz*
  4  *Make Way for the Superman Commander*
  5  *How Many Calories are there in
     Potato Peelings?*
  6  *For Health's Sake*
  7  *Life – the Market Place*
  8  *Counting the People : 'There Must be Order'*
  9  *SS Dog*
 10  *Jew Ghetto*

No. 3 exhibited Manchester City Art
Gallery 1987

507  Leo Haas  *Children on the Way to Auschwitz*

507  Leo Haas  *Ghetto*

## Henri Hayden
b.1883 Warsaw
d.1970 Paris

Having originally studied engineering, Hayden enrolled at the Fine Arts Academy in Warsaw in 1905. He settled in Paris in 1907, and later became a French citizen. Forced to flee occupied Paris in 1942, he did not return until 1944 when he found his studio ransacked and works stolen. He continued to live and work in Paris until his death.

### Selected Exhibitions
1911 Galerie Druet, Paris
1923 Galerie Zborowski, Paris
1933 Galerie Zak, Paris
1960 Musée de Lyon
1959, 1961, 1965 Waddington Galleries, London
1968 Musée National d'Art Moderne, Paris
1979 Musée des Beaux-Arts, Rennes

### Selected Bibliography
Jean Selz. *Henri Hayden*, Geneva 1962

**508** *Still Life*
signed and dated 1968
lithograph 63/75  54 × 70 cm
presented by Stern Art Dealers 1993

## Patrick Hayman
b.1915 London
d.1988 London

Hayman lived in New Zealand from 1936–47, returning to England where he lived in Cornwall from 1950–3. He then moved back to London and founded and edited *The Painter and Sculptor: A Journal of the Visual Arts*. From 1965–70 he taught part-time at Croydon College of Art.

### Selected Exhibitions
1951–2 Robin Nance Gallery, St Ives
1956 Piccadilly Gallery, London
1963 Beaux-Arts Gallery, London
1973 Whitechapel Art Gallery, London
1984 New Zealand House Gallery, London
1985 Mendel Art Gallery, Saskatoon, Canada
1986 Blond Fine Art
1990 Camden Arts Centre and Tour

### Selected Bibliography
Patrick Hayman. *Painted Poems*, London 1988

COLOUR PLATE IX

**509** *The Gods Look Down on Us*
signed and dated 1972
oil on canvas  60 × 37.5 cm
presented by Mrs Barbara Hayman, the artist's widow 1990

## Joseph Hecht
(see cat. no.132–4)

**510** *Cockatoo*
signed
etching 21/35  21.8 × 11.7 cm
presented by Robert Lewin 1994

## Julie Held
b.1958 London
lives and works in London

Studied at Camberwell School of Art from 1977–81 and at the RA Schools from 1982–5. Currently teaches at the Camden Institute, Barnet College of Further Education and at the University of Wolverhampton.

### Selected Exhibitions
1990 Wilson Hale Gallery, London
1993 Piccadilly Gallery, London

COLOUR PLATE X

**511** *Commemoration*
oil on canvas  152.4 × 106.5 cm
purchased 1993

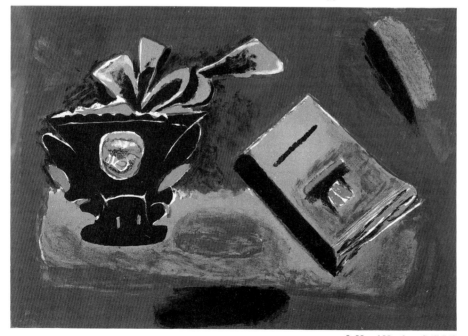

508  Henri Hayden  *Still Life*

510  Joseph Hecht  *Cockatoo*

## Josef Herman OBE RA
(see cat. no.140–1)

*Two Seated Figures*
(verso: Postcard from Israel addressed
to Mr and Mrs G. Delbanco)
1953
pen and ink  9.5 × 14.5 cm
presented by Gustav Delbanco 1988
Exhibited: The Arches, Glasgow 1990

*Figure Studies*
pen, ink and wash  22 × 16 cm
presented by Rose and Bernard
Gillinson 1991

*Miners*
pen, ink and wash  25.5 × 20.5 cm
presented by Rose and Bernard
Gillinson 1991

*Musicians*
(from A Memory of Memories)
pen, ink and wash on paper
17.5 × 22.2 cm
presented by Henny Handler 1993
Illustrated in Christopher Davies.
*Herman: The Early Years in Scotland
and Wales*, Dyfed 1984, p.69

## Eugen Hersch
b.1887 Berlin
d.1967 London

Studied at the Berlin Königliche
Kunstakademie. After graduation he
won the Rome Prize and spent 1910–12
in Italy. Returned to Berlin where he
achieved success as a portrait painter.
War artist during First World War.
Emigrated to England in 1939. Interned
at Huyton, Liverpool 1940. Worked as
artist and teacher.

*Self Portrait Sketch*
oil on canvas laid on panel  42 × 37 cm
presented by John Denham 1991
Exhibited: John Denham Gallery,
London 1990 cat.10

*Self Portrait*
signed and dated 1964
oil on canvas  61 × 51 cm
presented by John Denham 1991
Exhibited: John Denham Gallery,
London 1990 cat.18

514  Josef Herman  *Miners*

515  Josef Herman  *Musicians*

## Lilian Holt

(see cat. no.151)

**518** *Ronda and Tajo*
signed and dated 1956
charcoal on paper  65 × 97 cm
presented by Dinora Davies-Rees 1988

## Dora Holzhandler

b.1928 Paris
lives in London

Holzhandler's family, who were Polish
emigrés, moved from Paris to London in
1934. She studied at the Sorbonne and
then at the Anglo-French Art Centre,
London.

**Selected Exhibitions**
1960  Chenil Gallery, London
1962  Portal Gallery, London
1971–7  Langton Gallery, London
1985  Crane Kalman Gallery, London
1987, 1989, 1990, 1992  Rona Gallery,
     London
1990  Festival of Jewish Culture, Glasgow

COLOUR PLATE XI

**519** *Jewish Family in the Snow*
signed and dated '93
oil on board  41.3 × 31.5 cm
presented by the artist 1993

## Hava Intrator-Barak

b.1941 Kazakhstan
lives in Tel Aviv

Intrator-Barak is the grand-daughter of
two Hassidic Rabbis. She and her family
emigrated to Israel in 1950. She studied
philosophy at Tel Aviv University and
since graduating in 1968 has had 16 one-
person shows.

**Selected Exhibitions**
1960  Katz Gallery, Tel Aviv
1973, 1975, 1978, 1980  Engel Gallery,
     Jerusalem
1981  Artists' House, Tel Aviv
1990  Dixon Gallery, University of London
1993  Ben Uri Art Society, London

**520** *Jerusalem*
signed in Hebrew
watercolour  45.6 × 61.6 cm
presented by the artist 1992

521  Hava Intrator-Barak  *Walls and Domes*

**521** *Walls and Domes*
(verso: pencil sketch)
1983 signed in English and Hebrew
watercolour  48 × 59.4 cm
presented by the artist 1993

## Susanna Jacobs

b.1966 London
lives in London

Studied at Camberwell School of Art
1985–6 and the Slade 1986–90.

**Selected Exhibitions**
1992–3  Gruzelier Modern and
     Contemporary Art, London
1993  Vargas, London

**522** *Portrait of Catherine Eastman*
1993 signed
drypoint A/P 4/6  22.6 × 17.6 cm
presented by the artist 1994

522  Susanna Jacobs  *Portrait of Catherine Eastman*

PLATE IX Patrick Hayman *The Gods Look Down on Us* cat.509

PLATE X  Julie Held *Commemoration*  cat.511

523 Ruth Jacobson *Memorials to a Vanished People*

524 Aileen Jampel *Birds*

# Ruth Jacobson
(see cat. no.158)

*Memorials to a Vanished People*
1990 signed
etching 3/20  24.5 × 29.5 cm
presented by the artist 1993

# Aileen Jampel
b.London
lives in London

Studied at Hornsey College of Art, Sir John Cass School of Art and the Camden Institute. Exhibits regularly at Printmakers' Council exhibitions, at the Mall Galleries and at the Ben Uri Art Gallery.

*Birds*
signed and titled
etching and aquatint A/P  24 × 35 cm
presented by the artist 1988

525 Paul Jeffay *Grief*

# Paul Jeffay
b.1898 Glasgow
d.1957 Paris

Studied at Glasgow School of Art 1912–14. Volunteered to serve in First World War. Moved to Paris 1918 and exhibited at the Salon des Indépendants. Regularly visited his wife's family in Warsaw 1933–9 and sketched the Jewish population. These later used for *Visages du Ghetto*. Fled to England 1940 and returned to Paris to find his studio had been looted and much of his work stolen or destroyed.

525 *Visages du Ghetto*
artist's portfolio of 14 prints
etchings, example *X*, various sizes
presented by the grandsons of Paul Jeffay 1994

1 *Grief*
signed and dated Warsaw 1935 in the plate

2 *A Wise Man*

3 *A Taxing Problem*
signed and dated Warsaw 1933 in the plate

4 *Rabbi Mendelson*
signed, titled and dated Warsaw 1936 in the plate

5 *Meditation*

527 Shlomo Katz *Ten Plagues*

**Paul Jeffay** (continued)

6 *Who is Right?*

7 *Sabbath*

8 *Prayer*
signed and dated 1935 in the plate

9 *Workers at Rest*

10 *Relaxation*
signed in the plate

11 *The Light of the Torah*
signed and dated '33 in the plate

12 *Talmudic School*
signed and dated 1933 in the plate

13 *Mendel*
titled in the plate

14 *The Heavens are Open*

**Josef Karpf**
b.1900 Galicia, Poland
d.1993 London

Studied at Vienna School of Art by night
whilst taking a degree in economics at
the University of Vienna by day. Spent
part of the Second World War in a
labour camp in Siberia. Came to London
after the war and studied life drawing at
Regent Street Polytechnic and Camden
Arts Centre. An active member of the
Ben Uri Council for many years.

526 *Still Life with Skull*
oil on board   38.4 × 51 cm
presented by Mrs N. Karpf, the artist's
widow 1994

**Shlomo Katz**
b.1937 Lodz, Poland
lives in Tel Aviv

Emigrated to Israel 1945. Settled on
Kibbutz Mishmar Haemek. Studied
Ecole des Beaux Arts, Paris. Has
exhibited several times in the USA and
in Canada.

527 *Ten Plagues. From the Passover Portfolio*
signed and titled
serigraph A/P  69.5 × 81.5 cm
presented by Jacob Adler 1988

## Helen Keats
(see cat. no.171–3)

*St Catherine's Monastery*
signed and titled
etching and aquatint A/P  37.5 × 49.5 cm
purchased 1990

*Early Morning at the Treasury*
oil on canvas  101.5 × 122 cm
presented by Andrew Potter 1990

## R. B. Kitaj
b.1932 Ohio, USA
lives in London

Studied at Cooper Union, New York
from 1950–1, the Academy of Fine Art,
Vienna from 1951–2, the Ruskin School
of Drawing, Oxford from 1953–9 and
RCA from 1959–61. Married to artist
Sandra Fisher (*q.v.*).

**Selected Exhibitions**
1965  Los Angeles County Museum of Art
1967  Cleveland Museum of Art
1967  Stedelijk Museum, Amsterdam
1970  Kestner Gesellschaft, Hannover
        and tour
1974, 1979–80  Marlborough Gallery, New
        York
1977  Ikon Gallery, Birmingham
1977, 1980, 1985  Marlborough Fine Art,
        London
1981–82  Hirshhorn Museum, Smithsonian
        Institute, Washington and tour
1994  Tate Gallery, London

**Selected Bibliography**
R. B. Kitaj. *First Diasporist Manifesto*,
Thames and Hudson, London 1989
Mario Livingstone. *R. B. Kitaj*, Phaidon,
Oxford 1985

*Self Portrait with Cap*
*c.*1976 signed
lithograph 10/50  76 × 56.5 cm
presented by the artist 1993

528  Helen Keats  *St Catherine's Monastery*

530  R. B. Kitaj  *Self Portrait with Cap*

531 Clara Klinghoffer *Sleeping Girl*

532 Heinz Koppel *Sennen*

533 Adam Kops *The Dancer*

## Clara Klinghoffer
(see cat. no.180)

531 *Sleeping Girl*
c.1919 signed
pen, ink and wash on paper 35 × 28 cm
presented by Henny Handler 1993

## Heinz Koppel
b.1919 Berlin
d.1980 London

Studied in Berlin and Prague. Came to
London in 1937 and studied with Martin
Block (*q.v.*). Settled in Liverpool in 1964
where he established the Doulais Art
Centre. Senior Lecturer at Liverpool
College of Art for several years.

**Selected Exhibitions**
1988 Gillian Jason Gallery, London

532 *Sennen*
1960 signed
oil on canvas 61 × 91 cm
presented by Frank Auerbach 1994

## Adam Kops
b.1956 London
lives in London

Studied at Wimbledon School of Art
1982–3 and St Martin's 1984–7.

**Selected Exhibitions**
1988, 1992, 1994 Kingsgate Gallery,
        London
1988–9 Camden Galleries, London

533 *The Dancer*
steel height: 38 cm 1991
purchased 1991

## Fred Kormis
(see cat. no.182)

534 *Prophet*
plaster height: 38.5 cm (excluding
wooden base)
presented by Willi Soukop RA 1992

534 Fred Kormis *Prophet*

## Leon Kossoff
(see cat. nos.185–6)

*Christ Church, Spitalfields, Spring*
signed and dated 89/92
etching and aquatint 1/25
59.4 × 40.5 cm
presented by the artist 1993

535 Leon Kossoff *Christ Church, Spitalfields, Spring*

537 Jacob Kramer *Portrait of Harold Laski*

## Jacob Kramer
(see cat. no.189–96)

**536** *The Gypsy*
c.1937 signed
oil on canvas  76 × 63.5 cm
presented by Rose and Bernard
Gillinson 1991
Exhibited: Leeds City Art Gallery 1960
cat. no.41

**537** *Portrait of Harold Laski*
signed, titled and dated '44, inscribed *To
John from Jacob*
lithograph  40 × 32 cm
presented by Alice Schwab 1990

538 Ansel Krut *The Paschal Lamb*

# Ansel Krut

b.1959 Cape Town, South Africa
lives in London

Studied at the University of the Witwatersrand, Johannesburg 1979–82, the Cité Internationale des Arts, Paris 1982–3, and the RCA 1983–7. Lived and worked in Rome 1987–90 and the USA 1991–2.

**Selected Exhibitions**
1984 Shell Gallery, Johannesburg
1989–90 Fischer Fine Art, London
1993–4 Gillian Jason Gallery, London

*The Paschal Lamb*
1990
oil on board 34 × 26 cm
presented 1993

# Rudolph (Rudi) Lehmann

b.1903 Berlin
d.1977 Givatayim, Israel

Studied sculpture and ceramics at the Berlin School of Arts and Crafts. In 1933 emigrated to Israel where he established a sculpture studio in Jerusalem. A founder of the Ein Hod Artists' Village. Lived in Givatayim from 1959 until his death. Winner of the prestigious Dizengoff prize in 1952 and in 1966.

**Selected Exhibitions**
1942 Schlosser Gallery, Jerusalem
1953 Dizengoff Museum, Tel Aviv
1954 Bezalel Museum, Jerusalem
1959 The Artists' House, Jerusalem
1974 Ben Uri Art Society, London
1991 Israel Museum, Jerusalem

539 Rudolph Lehmann *Donkey*

539 *Donkey*
signed in Hebrew and dated 1965
woodcut 15 × 10 cm
presented by Ya'akov Boussidan 1974

# Menachem Lemberger

540 *Village by the Sea*
signed in Hebrew and English
pastel on paper 32 × 34 cm
presented by the artist

541 *Head*
signed in Hebrew and English
woodcut A/P 26 × 23 cm
presented by the artist

542 *Hand*
signed in Hebrew and English
woodcut A/P 21 × 23 cm
presented by the artist

# John Lessore

b.1939 London
lives in London

Studied at the Slade 1957–61 and in 1961 was awarded the Abbey Miner Travelling Scholarship to Italy. Taught at the Norwich School of Art 1978–96 and at RA Schools 1965–90.

**Selected Exhibitions**
1965 Beaux-Arts Gallery, London
1969 Ashgate Gallery, Farnham
1981, 1994 Theo Waddington, London
1983, 1985 Stoppenbach and Delestre, London
1986 The Sternberg Centre for Judaism, London
1990 Nigel Greenwood Gallery, London

543 *Denis Lucas*
signed with monogram
etching 5/35 25 × 19.8 cm
presented by James Hyman 1994
Exhibited: Royal Academy Summer
Exhibition 1990 cat. no.182

# Ben Levene RA

(see cat. no.221)

544 *Still Life*
c.1965–6
oil on canvas 75.5 × 105 cm
presented

# Margaret Levinson

b.1926 Bournemouth
lives in Bournemouth

Studied at Bournemouth College of Art. Specialises in coloured etchings of London's East End in the 1930s.

**Selected Exhibitions**
1978 Ben Uri Art Society, London
1979–80 Lichfield Gallery, Bournemouth
1982 & 1986 Medici Galleries, London
1985 Andover Museum and tour
1986 Dean Galleries, San José, USA
1990 Poole Arts Centre

545 *The Mill*
c.1988 signed
etching and aquatint A.P. 34.6 × 22.7 cm
presented by the artist 1993

## Emmanuel Levy

(see cat. nos.213–18)

**546**  *The Artist's Mother*
signed and dated 1926
oil on canvas  66 × 50 cm
presented by Mr and Mrs Ray 1993

**547**  *Head of a Woman*
signed and dated 1963
oil on board  81 × 122.5 cm
presented by Bernard and Vicky
Sternfield 1993

**548**  *Nude*
oil on board  123 × 91 cm
presented by Bernard and Vicky
Sternfield 1993

## Isaac Lichtenstein

(see cat. nos.220–2)

**549**  *Country Scene*
signed
drypoint  13.5 × 17 cm
purchased 1988

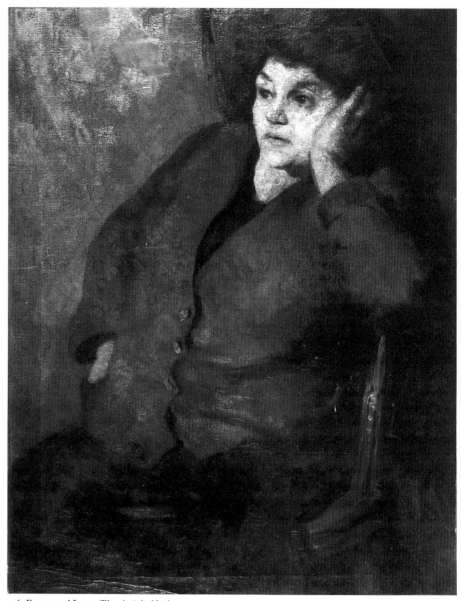

546  Emmanuel Levy  *The Artist's Mother*

# Max Liebermann
(see cat. nos.223–5)

*Woods at Scheveningen*
signed
etching   19 × 26.5 cm
bequeathed by Miss Stephanie Ellen
Kohn 1990 in memory of her parents
Franz and Margarethe Kohn (née
Schottlander) and her brother Ludwig
who perished in the Holocaust.

# Ephraim Moses Lilien
b.1874 Drohobycz, Galicia
d.1925 Badenweiler, Germany

Apprenticed to a sign-writer before
studying at Cracow Academy of Art in
1890 and then at Vienna and Munich.
He moved to Berlin in 1894. A chief
contributor to *Die Jugend*, the periodical
that gave its name to the *Jugendstil*. He
joined the Zionist movement in 1900 and
was a delegate to the Zionist Congress
with Martin Buber. He first visited
Palestine in 1906 and was a co-founder
and teacher at Bezalel.

**Selected Exhibitions**
1900  Leipzig
1909  Vienna
1924  Berlin (opened by Chaim Weizmann)
1928  New York
1981, 1987  Michael Hasenclever, Munich
1990  Tel Aviv Museum

**Selected Bibliography**
Lothar Brieger. *E. M. Lilien*, Berlin 1902
Stefan Zweig. *E. M. Lilien : Sein Werk*, 1903

*The Palms of Sakkarah*
signed, monogram in plate
etching   23.5 × 17.5 cm
presented by the artist's family 1993

*Samaritan High Priest*
signed
etching   37.4 × 28.8 cm
presented by the artist's family 1993

550  Max Liebermann  *Woods at Scheveningen*

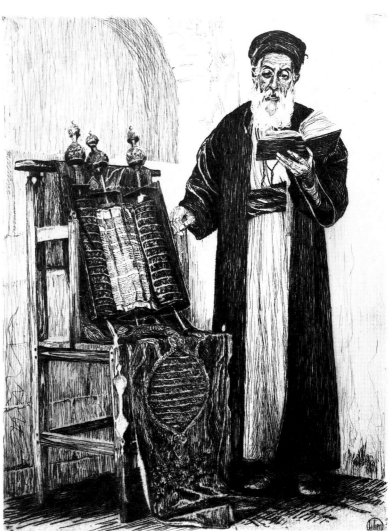

552  Ephraim Moses Lilien  *Samaritan High Priest*

## Estelle Lovatt

b.1963 London
lives in London

Studied at Harrow School of Art 1981–2
and Byam Shaw School of Art 1982–3.
Teaches Art and History of Art at
Camden School of Art. Has exhibited at
the Royal Academy, the Royal Festival
Hall and the Mall Galleries.

**553** *In the Shade*
charcoal and pencil on paper
56 × 47.5 cm
presented by the artist 1991

## Jona Mach

b.1917 Breslau, Germany
lives in Jerusalem

Emigrated to Israel in 1935 with Youth
Aliyah and settled on Kibbutz Moaz
Haim. Studied art with Jacob Steinhardt
in Jerusalem from 1940, and moved
there in 1951. A co-founder of the
Kibbutz Artists' Association. Taught
Art at the Hebrew University and was
supervisor for Art and Education at the
Ministry of Education. Has exhibited in
the USA, Canada, England and Italy.

**554** *Townscape*
signed
lithograph 40.5 × 35 cm

## Margaret Marks

(see cat. nos.275–6)

**555** *Leff Poushnoff, Pianist*
*c.*1933 signed
lithograph 25 × 33 cm
presented by Harold Marks 1989

**556** *Dr Barnett Stross* MP
*c.*1936 signed
lithograph 45 × 32.2 cm
presented by Harold Marks 1989

553 Estelle Lovatt *In the Shade*

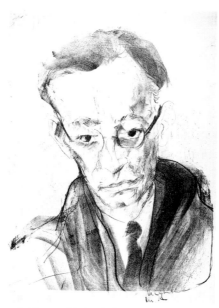

556 Margaret Marks *Dr Barnett Stross* MP

**557** *Landworker at Uga*
signed and dated 1981
pen, ink and pastel 37 × 48 cm
presented by Harold Marks 1989

**558** *London River*
*c.*1965 signed
oil on board 63 × 44 cm
presented by Harold Marks 1989

**559** *Evening in the Lakes*
*c.*1950 signed
pen, ink and watercolour 30 × 48 cm
presented by Harold Marks 1989

**560** *St Paul's Bay, Malta*
*c.*1975
oil on board 41.5 × 60.5 cm
presented by Harold Marks 1989

**561** *Spanish Peasants*
signed
pen, ink and pastel 20 × 28 cm
presented by Harold Marks 1989

## Henry Mathews

b.1912 Berlin
d.1991 Bournemouth

A dress designer and manufacturer who
turned to art late in life. His images
explore the works of the great composers
and often include extracts from scores.

**Selected Exhibitions**
1991 Library Gallery, Poole (retrospective)

**562** *Kol Nidre*
signed
hand-coloured linocut A/P 51 × 41 cm
presented by Mrs Rita Mathews, the
artist's widow 1992

## Else Meidner

(see cat. no.282)

**563** *Portrait of Bearded Man*
signed with monogram
oil on board 45 × 47 cm
presented by Professor J. P. Hodin 1989

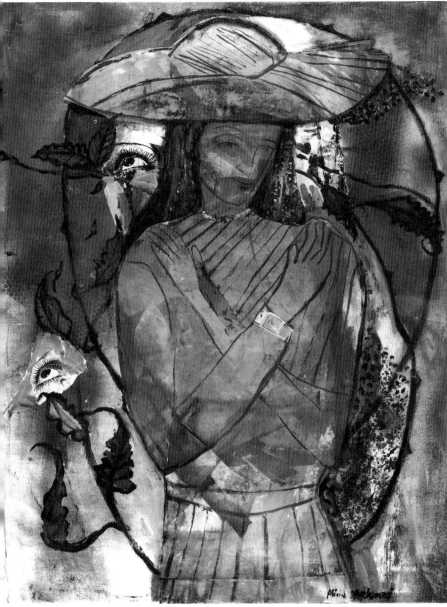

564 Alicia Melamed Adams *Tears*

565 Dinora Mendelson *The Gates of Paradise, Susa*

## Alicia Melamed Adams

b.1927 Drohobycz, Poland
lives in London

Studied at St Martin's and Sir John Cass
School of Art in London and the Académie
de la Grande Chaumière, Paris.

**Selected Exhibitions**
1988 Galerie Salambo, Paris
1991 Mermaid Theatre, London
1993 The City Gallery, Leicester

564 *Tears*
signed
mixed media and collage on
canvas 80 × 64 cm
presented by the artist 1993

## Dinora Mendelson

b.1924
lives in Sunbury-on-Thames

Daughter of Lilian Holt (*q.v.*) by her
first marriage to Jacob Mendelson. Step-
daughter of David Bomberg (*q.v.*).
Studied at the Borough Polytechnic and
was a member of the Borough Group
and the Borough Bottega.

**Selected Exhibitions**
1981 Ben Uri Art Society, London

565 *The Gates of Paradise, Susa*
signed and dated 63
oil on canvas 61 × 51 cm
presented by the artist

566 Klaus Meyer 'Family Photograph' (in memoriam 1942)

## Klaus Meyer

b.1918
lives in London

Emigrated to UK in 1938. Studied at
Central School with Henryk Gotlib, and
at the Slade. Taught at Hornsey College
of Art and Kilburn Polytechnic.

**Selected Exhibitions**
1958 & 1968 Everyman Cinema, London
1978 Oxford Polytechnic
1982 Curwen Gallery, London
1988 Camden Arts Centre, London
1991 Primrose Gallery, London

566 'Family Photograph' (in memoriam 1942)
signed, titled and dated 1982
woodcut and linocut 49 × 37 cm
presented by the artist 1989

## Renate Meyer

(see cat. no.291)

567 Costume Design for Young Boy
pen and ink 35 × 25 cm
presented by the artist

568 Young Girl
pen and ink 33 × 19 cm
presented by the artist

## Daniel Moiseiwitsch

b.1919 Odessa, Russia
d.1944 Italy

The Moiseiwitsch family came to
England in 1921 and settled in London.
Daniel studied at the Davenant
Foundation School and then at
St Martin's. He was killed in action in
Italy in 1944. Three of his drawings
were acquired by the Victoria and Albert
Museum in 1947 on the recommendation
of David Bomberg (q.v.).

569 Untitled (the Pianist)
pen, ink and watercolour 35.4 × 24.5 cm
presented by Victoria Moiseiwitsch, the
artist's sister 1993

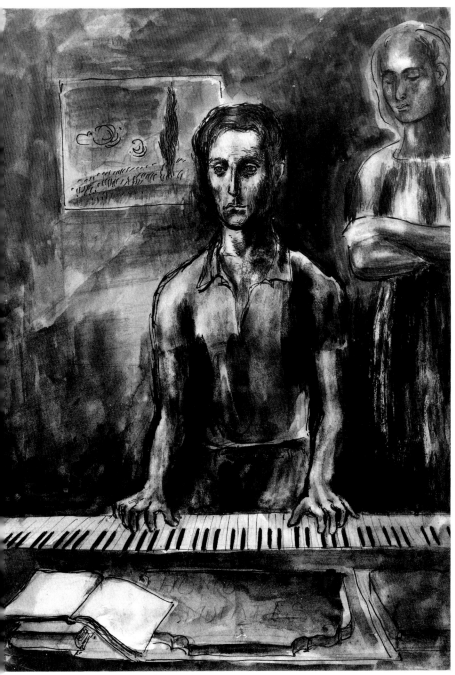

569 Daniel Moiseiwitsch *Untitled (the Pianist)*

## Isaac Monteiro

b.Antwerp
lives in Freeport, New York

Monteiro and his family went to live in
Brazil in 1941. He studied at the Fine
Arts National Academy, Rio de Janeiro
in 1960 and then came to Europe where
he lived 1960–3. In 1961 he represented
Brazil at the Biennale Young Painters of
the World in Paris. Returned to Brazil
and emigrated to the USA in 1965.
Became a US citizen in 1972.

### Selected Exhibitions
1960  Penguin Gallery, Rio de Janeiro
1962  Verena Müller Gallery, Bern
1980  K. Mason Gallery, New York
1981 & 1982  Lynn Kettler Gallery, New York

570 *Stupidity is M . . . . .?*
signed and dated 91.
Inscribed '*The Proper Set Up!?*'
oil on panel  20 × 27.5 cm
Presented by the artist 1993

## Jacqueline Morreau

b.1929 Milwaukee, Wisconsin
lives in London

Studied at Chouinard Art School, Los
Angeles and later with Rico LeBrun.
She also qualified as a medical illustrator
at the University of California Medical
School, San Francisco. Has lived in
London since 1972. Was an organiser of
the controversial exhibition '*Women's
Images of Men*' 1980. A major
retrospective of her work at the Ferens
Art Gallery, Hull is planned for 1995.

### Selected Exhibitions
1988  Ferens Art Gallery, Hull
1989–90  Odette Gilbert Gallery, London
1993  Philip Graham Contemporary Art,
       London
1993–4  Isis Gallery, Leigh-on-Sea

571 *Psyche's Journey to the Underworld*
from the folio of 10 prints '*Disclosing
Eros*'
signed and titled 1993
etching  24.5 × 29.5 cm
presented by the artist 1994

572 Hyam Myer *Hooded Woman*

## Hyam Myer

(see cat. no.299–300)

572 *Hooded Woman*
signed and dated 54
pen, ink and wash  56 × 38.3 cm
presented by Alice Schwab 1990

## Emil Orlik

(see cat. no.308)

573 *Head of a Man*
signed
lithograph  31 × 26 cm

## Mosheh Oved

(see cat. no.310–11)

574 *Chanukiah with Doves*
bronze height: 36.8 cm
on loan from Mrs G. L. Mamlok
and family 1988

575 *Collection of Six Heads*
bronze

  1 *Genius*
    height: 36.8 cm

  2 *Vision*
    height: 37 cm

574 Mosheh Oved *Chanukiah with Doves*

  3 *Sabbath Rest*
    verdigris  height: 36 cm

  4 *The Inflictor Inflicted*
    height: 42 cm

  5 *Untitled*
    height: 37 cm

  6 *Dawn*
    height: 41 cm

on loan from Mrs G. L. Mamlok
and family 1988

576 *Designs for Commemorative Rings*
pencil, pen and ink on paper
46 × 29.8 cm
on loan from Mrs G. L. Mamlok
and family
Exhibited: Spink and Sons Ltd 1992

577 *Designs for Commemorative Rings*
pencil, pen and ink on paper
45.5 × 29 cm
on loan from Mrs G. L. Mamlok
and family
Exhibited: Spink and Sons Ltd
1992

576 Mosheh Oved *Designs for Commemorative Rings*

142

## Abel Pann

b.1883 Kreslawska
d.1963 Jerusalem

Son of a Rabbi. Studied Vilna Academy 1895 and then at the Académie Julien with Bougereau and Toulouse-Lautrec. Travelled to Odessa, Vienna and Palestine 1913–14. Taught at Bezalel 1914–18. Lived in Paris 1920. Best known for his scenes of Russian pogroms and for Jewish subjects.

*Yeshiva Boy*
signed
lithograph  72 × 54 cm
presented by Irving Grose 1993

## Jules Pascin
## (Julius Mordecai Pincas)

b.1885 Vidin, Bulgaria
d.1930 Paris

Moved with family to Bucharest in 1892. Studied 1903–4 at Heymann Art School in Munich. Worked as illustrator for periodicals including *Jugend*. In 1905 moved to Paris and adopted the name Pascin. Emigrated to the USA in 1914 to evade conscription and became an American citizen. Returned to Paris 1920. Committed suicide in his Paris studio in 1930.

**Selected Exhibitions**
1907  Galerie Paul Cassirer, Berlin
1923  Brummer Gallery, New York
1930  Galerie Georges Petit, Paris
1958  Israel Museum, Jerusalem
1966–7  University Art Museum, Berkeley, California
1970  Musée de Genève
1984  Grande Galerie, Odakyu, Tokyo

**Selected Bibliography**
Horace Brodsky. *Pascin*, London 1946
Alfred Werner. *Pascin*, New York 1963
Yves Henin. *Pascin; Catalogue Raisonné: Peintures, Aquarelles, Pastels, Dessins*, Paris 1984

*Menu for the Penguin Club II*
c.1917
etching  24 × 19 cm
presented by Barry and Anne Fealdman on the occasion of their 80th birthdays 1993

578  Abel Pann  *Yeshiva Boy*

143

## Lois Peltz

b.1936 Wallasey, Cheshire
lives in London

Studied at Wallasey School of Art.
Moved to London 1958. Works as a
graphic designer and illustrator. Vice-
Chair of the Ben Uri Art Society.

**Selected Exhibitions**
1991–3 David Tilleke Fine Art, London

**580** *On the Bus*
*c*.1956
gouache on paper  27.5 × 16.5 cm
presented by the artist 1993

## Suzanne Perlman

b.1923 Budapest, Hungary
lives in London

Studied at Columbia University, New
York, St Martin's, London and San
Miguel de Allende, Mexico. Studied
with Oskar Kokoschka in Salzburg.

**Selected Exhibitions**
1969 Upper Grosvenor Galleries, London
1980 Curaçao Museum
1986 Sternberg Centre for Judaism, London
1987 Budapest Jewish Museum
1993 Boundary Gallery, London

**581** *Synagogue, Curaçao*
signed
photographic lithograph  45 × 68 cm
presented by the artist 1989

## Zoltan Perlmutter

b.1922 Deva, Rumania (then
Transylvania)
lives in Düsseldorf and Knokke,
Belgium

Studied at the Academy of Fine Arts,
Bucharest. Spent three years in labour
camps during World War II. Emigrated
to Israel in 1950. Has had numerous
exhibitions in Israel, Europe, the USA
and Canada.

**Selected Exhibitions**
1944 Fine Art Museum, Bucharest
1953 Safrai Gallery, Jerusalem
1961 Blecher Gallery, Tel Aviv
1962 & 1964 Galerie Denise, Antwerp
1965, 1967, 1969, 1984 Nagy Elena Gallery,
 Montreal
1972 O'Hana Gallery, London
1988 Jewish Community, Berlin

**582** *Haifa Street*
signed
oil on paper  55 × 37 cm
presented by Manfred Altman 1993

## John Philipp

b.*c*.1872 Hamburg
d.1938 Hamburg

Professor Philipp was a painter and
engraver.

**583** *Albert Einstein*
signed by Einstein and the artist, dated
1929 in the plate
etching numbered 15  28 × 24.5 cm
presented by the artist

## Leopold Pilichowski
(see cat. no.314–17)

**584** *Portrait of Theodore Herzl*
signed
oil on canvas  91 × 55.5 cm
on loan from Charles Rotenberg 1988

**585** *Portrait of Elkan Adler*
signed and dated London 1914
oil on canvas  45.7 × 25.5 cm
presented by A.A.E.E. Ettinghausen 1993

586 Jacob Pins *Two Men*

## Jacob Pins
(see cat. no.319)

**586** *Two Men*
signed in Hebrew and English and dated
1982
woodcut  23 × 15.5 cm
presented by Alice Schwab 1993

144

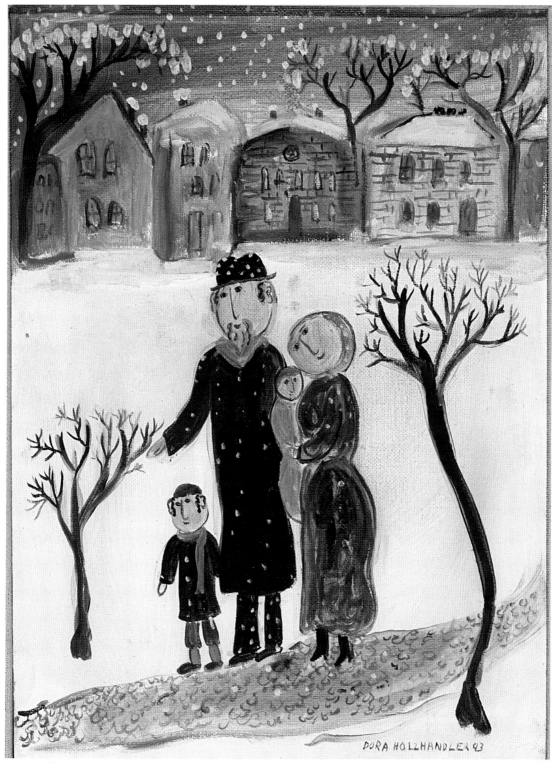

PLATE XI  Dora Holzhandler  *Jewish Family in the Snow*  cat.519

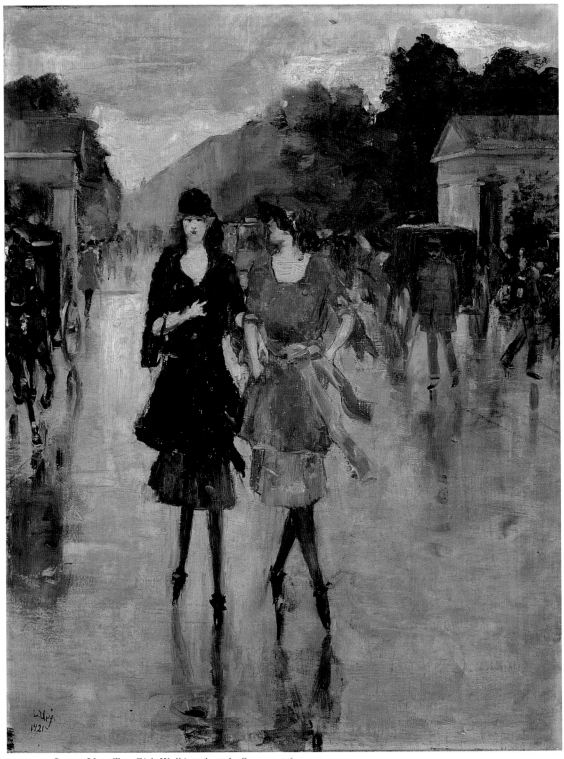

PLATE XII  Lesser Ury  *Two Girls Walking along the Street*  cat.629

## Lélia Pissarro

b.1963 Paris
lives in London

Great-granddaughter of Camille
Pissarro (*q.v.*). Studied with her
grandfather and father and at art school
in Tours. Moved to London 1988.

**Selected Exhibitions**
1993  Portland Gallery, London (Four
          Generations of the Pissarro Family)

*The Son of Mr Uri Visiting the Cotel*
1993–4 signed, and titled on reverse
pastel  25.5 × 36 cm
presented by the artist 1994

## Adèle Reifenberg

(see cat. no.323)

*Portrait of the Artist's Sister*
oil on canvas  46 × 36 cm
presented by Leinster Fine Art Ltd 1991

## Zsuzsi Roboz

b.Budapest
lives in England

Studied at the Regent Street Polytechnic
and the RA, 1953–4 and from 1955
studied drawing with Pietro Annigoni in
Florence. Well-known for her portraits
and lithographs of the ballet.

**Selected Exhibitions**
1958  Walker Gallery, London
1959 & 1968  Galerie André Weil, Paris
1963 & 1965  Upper Grosvenor Gallery,
          London
1967, 1970, 1973  O'Hana Gallery, London
1977  Curwen Gallery, London
1983 & 1984  Royal Festival Hall, London

*Rehearsal at Donmar Studios*
signed, titled and dated 1977
lithograph 9/25  55 × 75.5 cm
presented by Leinster Fine Art Ltd 1991

## Claude Rogers OBE

(see cat. nos.331)

*The Combine Harvester*
c.1965
oil on canvas  40 × 50 cm
presented by Crispin Rogers, the artist's
son 1994

587  Lélia Pissarro  *The Son of Mr Uri Visiting the Cotel*

591  Maurice Mancini Roith  *Snow on the Downs*

## Maurice Mancini Roith

(see cat. no.332–3)

591  *Snow on the Downs*
      signed on front
      signed and titled on reverse
      watercolour  31 × 38 cm
      presented by the artist's widow

592  *Landscape with Trees*
      watercolour  25.4 × 35.6 cm
      presented by the artist's widow

593  *Snowscape*
      watercolour  25.5 × 35.6 cm
      presented by the artist's widow

594  *Piglets*
      watercolour  30 × 39.8 cm
      presented by the artist's widow

595 Marcel Ronay *Spanish Woman*

## Marcel Ronay
(see cat. no.335)

**595** *Spanish Woman*
pen and ink 17 × 29 cm
presented by the artist

## Joe Rose
(see cat. nos.338–9)

**596** *Bottle Woman*
signed and dated 1982
papier mâché and glass height: 49 cm
presented by the artist 1990

597 Michael Rothenstein *The Love Machine*

## Michael Rothenstein RA
b.1908 London
d.1993 London

Son of the painter Sir William Rothenstein (*q.v.*). Studied at Chelsea School of Art 1923 and Central School 1924–7 where he was taught by Bernard Meninsky (*q.v.*). Began printmaking in the 1950s. In 1957 worked with Stanley William Hayter at Atelier 17 in Paris. Elected ARA in 1977 and RA 1984.

**Selected Exhibitions**
1953 Redfern Gallery, London
1969 Kunstnere Hus, Oslo
1972 Bradford Art Gallery
1974 ICA, London
1976 National Museum, Onikern, Lagos
1984 & 1989 Angela Flowers Gallery, London
1986–7 Redfern Gallery, London
1989 Stoke-on-Trent Museum and tour
1990, 1992–3 Flowers East, London
1992 Royal Academy of Arts, London

**Selected Bibliography**
Tessa Sidey. *The Prints of Michael Rothenstein*, Scolar Press 1993

**597** *The Love Machine*
1970 signed
metal relief plate A/P 66 × 71.5 cm
presented by the artist 1990

**598** *The Shooting of George Wallace*
*c.*1973 signed
photo screenprint A/P 4/7 51 × 72 cm
presented by the artist 1990

## Sir William Rothenstein
(see cat. no.348)

**599** *Sir Arthur Wing Pinero*
signed and dated '97 on the stone
lithograph 38 × 25.2 cm
presented by Barry and Anne Fealdman 1994

146

## Alfred Russo

b.1868 Vienna
d.1959 London

Studied in Leipzig, Berlin, Munich and
Paris. Active in Berlin as a portrait
painter and restorer. Later took up
etching and involved in production of
postcards. Emigrated to England in 1939
after which he undertook little art work.

*Besigheim/Neckar*
signed and titled
etching  9.3 × 13.3 cm
presented by Mrs N. Campbell 1987

*Country Barn*
signed
etching  9.8 × 14.8 cm
presented by Mrs N. Campbell 1987

## Irene Scheinmann

b.1933 Baghdad, Iraq
lives in London

Studied at Brown University, USA and
in England and France. Worked at the
Atelier '63 in Paris from 1968–80. An
elected member of TRACE, the Paris-
based printmaking association and of the
California Society of Printmakers. She
has exhibited extensively both in Great
Britain and abroad.

**Selected Exhibitions**
1975  University of Salford
1981  Richmond Gallery, Surrey
1990  Camden Galleries, London
1986  Radann Gallery, New York

*All Around Me Wilderness I See*
1991 signed
etching A/P  46 × 63 cm
presented by the artist 1993

*Danse Macabre*
1991 signed
etching A/P  46.5 × 63 cm
presented by the artist 1993

*Wasteland*
1991 signed
etching 3/75  46.5 × 63 cm
presented by the artist 1993

603  Irene Scheinmann  *Danse Macabre*

## Daniel Schinasi (Ashkenasi)

b.1933 Alexandria, Egypt
lives in Nice, France

Moved to Italy in 1956. Studied at the
Ecole des Beaux-Arts, Paris. Taught at
the Schools of Art at Pisa and Neuchâtel,
and then founded his own art school in
Cecina. Well-known for his mural
painting.

605  *Homage to Ben Gurion*
signed, titled in Italian and dated 1988
(1986 in the stone)
inscribed *To the Ben Uri Art Society*
lithograph 28/80  23.8 × 27.2 cm
presented by the artist 1989

606  *Blessing at the Entrance to Jerusalem*
signed and titled in Italian
lithograph 80/100  23.8 × 27.2 cm
presented by the artist 1989

## Pamela Silver

b.1948 Johannesburg
lives in Jerusalem

Grew up in Bulawayo, Zimbabwe.
Studied at Cape Town University,
1966–9, Goldsmiths College 1970.
Emigrated to Israel 1973.

**Selected Exhibitions**
1981  Sieff and Marcus Community Centre,
      Jerusalem
1984  Alon Gallery, Jerusalem
1988  Artists' House, Jerusalem
      Ben Uri Art Society, London

607  *Thinking*
signed and dated 87
watercolour on paper  56 × 37 cm
presented by the artist 1988

608  *Zinnias*
signed and dated '88
watercolour on paper  53.8 × 37.2 cm
presented by Chinita Abrahams-Curiel
1988

609 D. Simkovitz
*Circular Design for the Ben Uri*

## D. Simkovitz

A founder member of the Ben Uri Art Society

**609** *Circular Design for the Ben Uri*
*c*.1915 signed on reverse
pen and coloured inks  45 cm diameter

## Maurice Sochachewsky

(see cat. nos.368–74)

**610** *Old City, Jerusalem*
signed
oil on canvas  50.5 × 70.6 cm
presented by Barbara Grahame 1993

## Willi Soukop RA

b.1907 Vienna
lives in London

Studied by night at the Vienna Arts and Crafts School whilst working as an apprentice engraver by day. In 1928 gave up his apprenticeship to study sculpture at the Academy of Fine Art, Vienna. Came to England 1934 where he worked at Dartington Hall and taught at Dartington Art School. Interned and sent to Canada 1940. On his return taught at Blundells School until 1945. Taught at Chelsea School of Art 1947–72 and as Master of Sculpture at the RA Schools 1969–82. Elected ARA in 1963 and RA in 1969.

611 Willi Soukop *Pola Nerenska*

**Selected Exhibitions**
1938  Storran Gallery, London
1945  Dartington Hall, Devon
1979  University College, Swansea
1991  Belgrave Gallery, London
1994  Royal Academy of Arts, London

**611** *Pola Nerenska*
*c*.1937 signed
cement on a marble base  height: 36 cm
presented by the artist 1992

## Bette Spectorov

b.1939

Studied at Oxford, the Courtauld Institute of Art, and Hunter College, New York. Taught at the City University of New York. Since 1981 has taught History of Art at Middlesex University.

**Selected Exhibitions**
1989  Ben Uri Art Society, London

**612** *Objet d'Art*
signed and dated 89
oil on wood  71 × 81 cm
presented by the artist 1989

## Eugen Spiro
(see cat. no.398)

*Girl with a Rose*
signed and dated 10
oil on canvas 57 × 46 cm
bequeathed by Miss Stephanie Ellen
Kohn 1990 in memory of her parents
Franz and Margarethe Kohn (née
Schottlander) and her brother Ludwig
who perished in the Holocaust.

## Bernard Stern
b.1920 Brussels
lives in New York

Studied Académie Royale des Beaux-
Arts, Brussels 1935–7 and the Antwerp
Académie 1937–9. Came to the UK in
1940 and studied at St Martin's.

**Selected Exhibitions**
1972 Drian Gallery, London
1973 Galeria de Arte, Caracas, Venezuela
     The Modern Art Gallery, Jaffa, Israel
1975 Petit Palais, Musée d'Art Moderne,
     Geneva
1977 Carlton Gallery, New York
1979 National Theatre, London
1981 Leinster Fine Art, London
1981 Camden Arts Centre, London
1993 Century Gallery, London

**Selected Bibliography**
J. P. Hodin. *Bernard Stern Paintings and
Drawings*, London 1972

*Tcheco with Guitar*
signed and dated 1974
drypoint and aquatint proof 40 × 28 cm
presented by Holgar Braasch 1993

613 Eugen Spiro *Girl with a Rose*

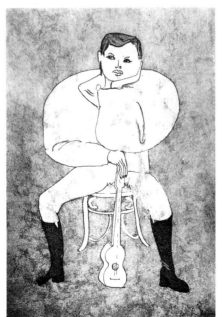

614 Bernard Stern *Tcheco with Guitar*

## Carole Steyn
b.1938 Manchester
lives in London

Studied at the Académie Julien 1953 and
St Martin's 1954–6. Studied sculpture at
Camden School of Art 1968. Produces
abstract sculpture from a wide range of
organic materials.

**Selected Exhibitions**
1971, 1975, 1981, 1985 Drian Galleries,
     London
1987 Jablonsky Galleries, London
1991 Galerie Harounoff, London

615 *The Beach Box*
signed and dated 1991
mixed media 16.5 × 16 cm
presented by the artist 1994

618 Käthe Strenitz *Pensive Woman*

619 Hermann Struck *Woman with Child*

## Käthe Strenitz
(see cat. no.402)

**616** *Woman Resting*
signed
pencil on paper 41.5 × 59 cm
presented by the artist

**617** *Seated Woman*
signed
pencil on paper 59 × 41.5 cm
presented by the artist

**618** *Pensive Woman*
signed
pencil on paper 59 × 41.5 cm
presented by the artist

## Hermann Struck
(see cat. nos.403–7)

**619** *Woman with Child*
lithograph 19 × 12.5 cm

620 Glenn Sujo *Figure Study for Roma, the Fountain*

# Glenn Sujo

b.1952 Buenos Aires, Argentina
lives in London and New England, USA

Moved with his family to Caracas,
Venezuela in 1953 and attended painting
classes at the Museo de Bellas Artes.
Studied in England and the USA 1964–9.
Studied at the Slade, University College
London and the Courtauld Institute of
Art. Has taught painting and art history
extensively throughout the British Isles
and briefly in the USA. In 1985 was
appointed curator of the Arthur
Andersen Collection of Contemporary
British Art. In 1991 was visiting artist at
Haifa University, Israel.

**Selected Exhibitions**
1973, 1990  Museo de Bellas Artes, Caracas
1975  Galeria Monte Avila, Bogota
1982  ICA, London and tour
    MOMA, Oxford (with Stephen
    Farthing)
1983  Anne Berthoud Gallery, London
1988  Benjamin Rhodes Gallery, London
1990  Mapping Art Gallery, Sheffield
1993  Harris Museum and Art Gallery,
    Preston and tour

620  *Figure Study for Roma, the Fountain*
signed and dated '85
conté chalk, charcoal on
paper  59.7 × 84.5 cm
presented by Carole Berman and the
artist 1994

621 Willy Tirr *Flight III*

## Willy Tirr
(see cat. no.415)

**621** *Flight III*
*c.*1983 signed
watercolour 75.8 × 55.7 cm
presented by Mrs Erika Tirr, the artist's
widow 1993

## Ben Tobias
b.1901 Montreal, Canada
d.1985

Moved to France 1921. Travelled
around Europe selling his paintings to
finance his upkeep. Went back to
America 1940. Returned to Europe 1960
for exhibitions of his work at galleries in
London and Paris.

**Selected Exhibitions**
1948 Philippe Reichenbach, New York
1960 Leicester Galleries, London
1962 Philippe Reichenbach, Paris

**622** *Café Zeus, Berlin*
signed and titled on reverse
oil on panel 18.5 × 23.5 cm
presented by Henry Tobias Cassels, the
artist's son 1989

622 Ben Tobias *Café Zeus, Berlin*

## Ottilie Tolansky

b.1912 Vienna
d.1977

Studied at the Reinmann Schule and then the Berlin Academy of Fine Arts. Came to England in 1933 and studied at Manchester Municipal School and after 1946 at Hammersmith Art School. Exhibited regularly at the Royal Academy and the New English Art Club.

**Selected Exhibitions**
1979  The Mall Galleries, London
1989  The Hurlingham Gallery, London

623  *Girl in Red Shirt*
oil on canvas  125 × 64 cm
presented by Jon Tolansky, the artist's son 1990

## Edward Toledano
(see cat. no.416)

624  *The Far City*
1982 signed
lithographic crayon  50 × 64.8 cm
presented by the artist 1993

624 Edward Toledano *The Far City*

625 Walter Trier *Dancing Girls*

## Walter Trier
b.1890 Prague, Czechoslovakia
d.1951 Craigleith, Canada

Studied in Prague and Munich 1905–9 and moved to Berlin 1910. Contributed to *Dame, Uhu, Berliner Illustrierte*. Member of the Berlin Secession. Moved to London 1936. Contributed to *Life, Daily Herald, Picture Post*. Emigrated to Canada 1947. Illustrated *Emil and the Detectives* and other books by Kästner.

**Selected Exhibitions**
1980–1 Art Gallery of Ontario and tour

625 *Dancing Girls*
signed
pen and ink 39 × 25 cm
presented by Kurt Maschler 1992

626 *Market Woman*
signed
pen and ink 19 × 17.5 cm
presented by Kurt Maschler

## Devi Tuszynski
b.1915 Brzeziny, Poland
lives in Paris

Studied art in Lodz. Joined the army and took part in the defence of Warsaw. Spent the war in labour camps. Most of his family were killed in the Holocaust. Went to Paris in 1948 and studied at the Académie de la Grande Chaumière. Best known for his miniatures but has also designed posters, scenery and costumes for the theatre, illustrated poems and novels.

**Selected Exhibitions**
1954, 1964, 1965 Museum of Modern Art, Haifa
1958, 1962 Ben Uri Art Gallery, London
1969 Victorian Artists' Gallery, Melbourne, Australia
1978 Centre Pompidou, Paris
1980 Musée des Beaux-Arts, Caen
1982 Alliance Française, Singapore

627 *Les Ponts de Paris*
signed and dated 1954 in the plate
lithograph 33 × 25 cm
presented by the artist

628 *Capricorn*
signed and dated 57
pen and ink 33 × 24.8 cm
presented by the artist

## Lesser Ury
(see cat. nos.418–19)

COLOUR PLATE XII
629 *Two Girls Walking along the Street*
signed and dated 1921
oil on canvas 65 × 50 cm
bequeathed by Miss Stephanie Ellen Kohn 1990 in memory of her parents Franz and Margarethe Kohn (née Schottlander) and her brother Ludwig who perished in the Holocaust.

## Mark Wayner
(see cat. nos.423–5)

630 *Three Musicians*
gouache on card 39 × 50.7 cm
presented by Dr and Mrs Kenneth Sanders 1989

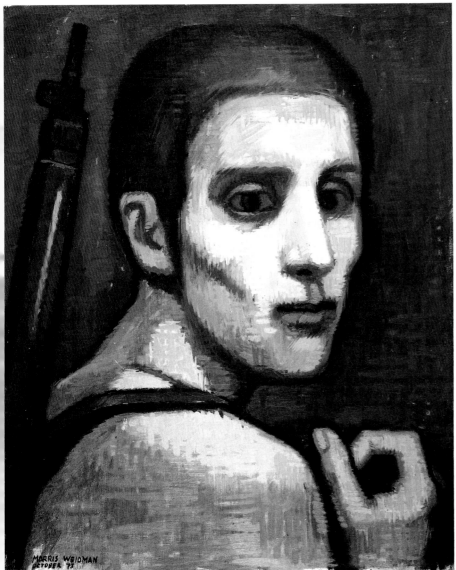

632 Morris Weidman *Israeli Soldier*

## Morris Weidman

b.1912 London
d.1992 Tunbridge Wells, Kent

Studied at Camberwell School from
1926–9 and RCA 1929–32. Worked with
Bainbridge Copnall on sculptural reliefs
at the Royal Institute of British
Architects' building in Portland Place
1932–4. Taught art at Northgate
Grammar School, Ipswich and Wirral
Grammar School. Moved to Tunbridge
Wells after the war and taught at
Tunbridge Wells School of Art until his
retirement.

631 *Auschwitz – A Cry of Grief without End*
oil on board 65.2 × 47.1 cm
presented by the Weidman family 1993

632 *Israeli Soldier*
signed and dated October 73
oil on canvas 61 × 51 cm
presented by the Weidman family 1993

## Harry Weinberger

b.1924 Berlin
lives in Leamington Spa, Warwickshire

Came to England 1939 and studied at
Chelsea School of Art 1947–52 with
Martin Bloch (*q.v.*). Has taught painting
in London, Reading and Manchester
and was Head of Painting at Lanchester
Polytechnic, Coventry until 1983.

**Selected Exhibitions**
1956  Ben Uri Art Society, London
1974  Warwick Gallery
1976  Camden Arts Centre, London
1990 & 1992  Duncan Campbell Fine Art,
      London

**633**  *In Winter, Manchester*
signed with monogram
acrylic on canvas  64 × 93 cm
presented by the artist 1990

633  Harry Weinberger  *In Winter, Manchester*

## Zalman Winer

b.1934 Gateshead
lives in London

Born and raised in the orthodox Jewish
community of Gateshead. Studied art
and architecture at Durham University.
Studied etching at Central School in
1978.

**Selected Exhibitions**
1986  Ben Uri Art Society
      (with Hazel Alexander)
1988  Ben Uri Art Society

**634**  *Portrait of an Old Man*
signed
lithograph A/P  35.5 × 29.4 cm
presented by the artist 1988

## Monica Winner

b.1933 London
lives in London

Studied at the Camden Institute,
Sir John Cass College of Art and
Hertfordshire College of Art and
Design. She exhibits regularly at the
Mall Galleries, Camden Arts Centre
and the Ben Uri Art Society.

**Selected Exhibitions**
1986  Crest Gallery,
      Totteridge
1987  Ben Uri Art Society
      (with Helen Keats)
1992  Birmingham
      University

**635**  *Portrait of a Lady*
signed with monogram
and dated 87
charcoal on paper
101 × 75.5 cm
presented by the artist
1993

635  Monica Winner  *Portrait of a Lady*